Edited by John Davies

CITIES ON THE EDGE

Istanbul Marseilles Gdańsk Bremen Naples Liverpool

Ali Taptik Philippe Conti Wojtek Wilczyk

CITIES ON

Sandy Volz Gabriele Basilico John Davies

THE EDGE

First published 2008 by
Liverpool University Press
4 Cambridge Street
Liverpool
L69 7ZU

Translators
Turkish – Cem Ülgen
French – Teresa Bridgeman
Polish – Waldemar Łyś
German – Sabine Voss
Italian – Alessia Paoletti

British Library Cataloguing-in-Publication data
A British Library CIP record is available

ISBN 978-1-84631-186-4

Designed by AW @ www.axisgraphicdesign.co.uk
Printed and bound by EBS, Verona

Cover: Beetham West Tower, Liverpool, John Davies

Contents

Önsöz Avant Propos Przedmowa Vorwort Prefazione

Foreword 6
Phil Redmond

13

Ali Taptik 13

Philippe Conti 27

27

Wojtek Wilczyk 41

41

Sandy Volz 55

55

Gabriele Basilico 69

69

John Davies 83

83

Sınırda Fotoğraflar La photographie des marges Fotografia na krawędzi
Fotografie geht an die Grenzen Fotografia di Frontiera

Photography on the Edge 98
Franco Bianchini

Sanatçı Biyografileri Présentation des artistes Noty biograficzne
Künstler-Biografien Biografie degli artisti

Artists' biographies 116

Foreword

The photography project that culminates in both this publication and a major photographic exhibition during autumn 2008 is a central element of the Cities on the Edge programme, the main theme of which is 'people and places', something intrinsic to the history of any port city. Although the project was commissioned by Liverpool Culture Company, its development owes a great deal to the internationally renowned photographer John Davies. John is known particularly for his rural and urban landscapes, and he has worked all over the world. He has been instrumental in shaping the project and agreed to take up the challenge of curating both this book and the exhibition.

'Cities on the Edge' is a major strand of our cultural celebrations during Liverpool`s year as European Capital of Culture, and is our major transnational project. We deliberately set out to find a group of European port cities which in one way or another (and often in many ways) resembled Liverpool. The main criterion was that none of the ports should be a capital city. Those selected are a sextet of world-famous cities, all historic, culturally diverse, passionate; but also cities that have problems such as loss of industry, poverty, unemployment and the whole range of social problems that accompany such things. In short they are cities 'on the edge' – edgy cities.

The network we have created is made up of Liverpool, Marseilles, Naples, Bremen, Gdansk and Istanbul. They are indeed a set of world-famous and edgy cities, both at the same time. They each possess a special identity in their own countries, and are all commonly viewed as city states, islands within their nation. They all have magnificent architecture next to areas of serious deprivation. They have humour. They are creative and, of course, they share a passion for football.

Across the 2008 programme we are sharing cultural events with our partner cities. We are inviting both acclaimed and up and coming artists as well as arts organisations from Liverpool, the wider North-West, and the home countries of our partner cities to work with us. Indeed, this has been a central notion for this publication which has meant having the luck to work with six photographers originating from or near to our six partner cities.

Over the course of the year our key aims are to highlight the cultural diversity and richness that exists in these remarkable cities, while at the same time raising awareness across the arts and the wider public alike. To this end we are exchanging ideas with young people about theatre and music, holding conferences, commissioning exhibitions and books, hosting 'rebel' lectures and live music events, collaborating on film projects and much more. Our hope is that the enthusiasm and drive of partner cities will ensure that this network will live on way beyond 2008 as each of these edgy cities takes the lead in organising a programme of events in the same vein as Liverpool.

Phil Redmond
Creative Director and Deputy Chairman
Liverpool Culture Company

Sonbahar 2008'de açılacak fotoğraf sergisi ve bu yayınla neticelenecek olan fotoğraf projesi, ana fikri herhangi bir liman şehrin tarihinin içkin bir parçası olan "insanlar ve mekanları" konu alan Sınırda Şehirler programının merkezi unsurlarıdır. Her ne kadar proje Liverpool Kültür Şirketi tarafından görevlendirilmiş olsa da gelişimini uluslararası üne sahip fotoğrafçı John Davies'e borçludur. John özellikle kırsal ve kentsel peyzajlarıyla ünlü olup dünyanın dört bir tarafında çalışmalarda bulunmuştur. Projenin şekillendirilmesinde son derece etkili olmuş ve hem bu kitabın hem de serginin küratörlüğünü yapma davetini kabul etmiştir.

"Sınırda Şehirler", Liverpool'un Avrupa Kültür Başkenti yılında meydana gelecek kültürel kutlamalar zincirinin önemli bir halkası ve bizim de başlıca uluslaraşırı projemizdir. Liverpool'a bir veya birçok yönden (çoğunlukla da pek çok yönden) benzeyen bir grup Avrupa liman şehri bulmayı tasarlayarak yola çıktık. Ana kriter, liman şehirlerinin hiçbirinin bir başkent olmaması şartıydı. Seçtiğimiz şehirler dünya çapında ünlü, tümü tarihi, kültürel çeşitliliğe sahip ve tutku dolu bir altılıydı; ama bir yandan da sanayi kaybına uğramış, yoksulluk, işsizlik ve bunları takip eden bir dizi sosyal sorunla yüzleşen şehirlerdi. Kısacası bunlar "sınırda" ve sinirli şehirlerdi.

Yarattığımız şebeke Liverpool, Napoli, Marsilya, Bremen, Gdańsk ve Istanbul'dan oluşmaktadır. Bu şehirler gerçekten hem gergin, huzursuz, hem de dünyaca ünlü. Her biri kendi bulundukları ülkelerde özel bir kimliğe sahip ve ekseriya ülkelerinde bir şehir-devleti, bir ada olarak görülen şehirler. Her birinde olağanüstü mimari eserlerin yanı sıra ciddi bir yoksunluk da mevcut. Her birine neşeli bir ruh hali hakim. Her biri yaratıcı şehirler, ve tabii ki hepsi futbola karşı duydukları derin tutkuyu paylaşıyorlar.

2008 programımız boyunca ortak şehirlerimizle kültürel faaliyetler paylaşıyor olacağız. Hem tanınmış hem de gelecek vaat eden sanatçıları çağıracağımız gibi, Liverpool'dan, daha geniş olan Kuzey-Batı'dan ve ortak şehirlerimizin dahil olduğu ülkelerde faaliyet gösteren sanat kuruluşlarıyla da çalışmalar yürüteceğiz. Gerçekten de altı ortak şehrimizin içinde ya da yakınlarında faaliyet gösteren altı fotoğrafçıyla çalışma şansına erişmemiz elinizdeki yayının çekirdeğini oluşturmuştur.

Önümüzdeki yıl boyunca kilit hedeflerimiz bu olağanüstü şehirlerdeki kültürel çeşitliliğin altını çizmek, aynı zamanda da sanatseverler ve genel halkta bir farkındalık yaratmaktır. Bu hedefe ulaşmak için genç insanlarla tiyatro ve müzik hakkında fikir alışverişinde bulunuyor, konferanslar düzenliyor, sergi ve kitaplar hazırlatıyor, "asi" forumlara ve canlı müzik etkinliklerine ev sahipliği yapıyor, film projeleriyle işbirliği içine giriyor ve daha pek çok çalışmalarda bulunuyoruz. Umudumuz ortak şehirlerimizin coşku ve enerjisinin şebekeyi 2008 yılından öteye taşıyarak bu sinirli şehirlerin her birinde Liverpool'dakine benzer bir etkinlikler programı düzenlemede öncü vazifesi görmeleridir.

Phil Redmond
Kreatif Yönetici ve Temsilci Başkan
Liverpool Culture Company

Avant Propos

Le projet photographique qui a engendré ce livre ainsi qu'une exposition photographique importante qui ouvrira ses portes en automne 2008 est l'un des éléments clés du programme «Cities on the Edge» («Villes en marge»), dont l'orientation principale, «les gens et les lieux», se trouve au cœur de l'histoire de toute ville portuaire. Bien qu'il fût commandé par la Liverpool Culture Company, son évolution doit beaucoup à John Davies, photographe mondialement connu. La réputation de ce dernier est basée surtout sur ses paysages ruraux et urbains et il a travaillé dans plusieurs pays du monde. Il s'est beaucoup investi dans la formulation du projet, et il a consenti à entreprendre la tâche considérable de gérer l'édition de ce livre et l'organisation de l'exposition.

L'un des fils conducteurs de nos célébrations culturelles durant cette année où Liverpool bénéficie du statut de Capitale Européenne de la Culture, «Cities on the Edge» est notre projet transnational principal. Nous sommes partis à la recherche d'un groupe de villes européennes portuaires dont certaines (ou bien plusieurs) caractéristiques rimeraient avec celles de Liverpool. Le critère fondamental fut qu'aucune ne soit la capitale de son pays. Les villes choisies forment un sextuor de métropoles mondialement connues, dotées d'un patrimoine riche, de cultures multiples, et d'une âme passionnée, mais qui ont aussi leurs problèmes: la désindustrialisation, l'indigence, le chômage, et toute la gamme de problèmes sociaux qui s'y allient. Bref, ce sont des «villes en marge» – en raison non seulement de leurs situations géographique et sociale, mais aussi de leur côté novateur, provocateur.

Le réseau que nous avons créé comprend les villes de Liverpool, Marseille, Naples, Brême, Gdańsk et Istanbul. En effet, à la fois des villes mondialement connues et des «villes en marge». Chacune a une identité très forte dans son propre pays, qui la considère pour la plupart comme un État dans l'État, une ville à part. Chacune jouit d'une architecture magnifique juxtaposée à des quartiers très défavorisés. Chacune a son propre sens de l'humour. Chacune est créatrice. Et elles partagent toutes, bien sûr, une passion pour le football.

Tout au long du programme de 2008 nous partageons des manifestations culturelles avec nos villes partenaires. Nous sollicitons la collaboration des artistes connus et prometteurs, ainsi que des organisations artistiques de Liverpool, du Nord Ouest, et des pays du partenariat. Or, cette collaboration a joué un rôle essentiel dans la réalisation de ce livre, fait dont nous réjouissons, car il nous permet de travailler avec six photographes originaires de nos villes partenaires ou de leurs environs.

Au cours de l'année, nous avons pour mission de souligner la diversité et les richesses culturelles de ces villes remarquables, et de sensibiliser en même temps la conscience des artistes et du grand public. Des échanges d'idées sur le théâtre et la musique auprès des jeunes, des congrès, des expositions, des livres, des conférences «rebelles», des événements musicaux en direct, des collaborations de projets de films, sont autant de manifestations qui servent, parmi bien d'autres, à atteindre ces objectifs. Nous espérons que l'enthousiasme et l'entrain des villes partenaires assureront que ce réseau continuera à exister bien au-delà de 2008, lorsque chacune d'elles à son tour prendra l'initiative et organisera un programme d'événements dans le même esprit que celui de Liverpool.

Phil Redmond
Directeur Artistique et Vice-Président
Liverpool Culture Company

Fotograficzne przedsięwzięcie, którego punktem kulminacyjnym jest zarówno niniejsza publikacja, jak i duża wystawa fotograficzna zaplanowana na jesień 2008 r., jest głównym elementem programu „Miasta na Brzegu" (Cities on the Edge). Jego tematem wiodącym są „ludzie i miejsca" nierozerwalnie związane z historią każdego miasta portowego. I chociaż projekt powstał na zamówienie Liverpool Culture Company, bardzo wiele zawdzięcza on Johnowi Daviesowi – cieszącemu się międzynarodowym uznaniem fotografowi, szczególnie znanemu ze swych pejzaży, zarówno miejskich, jak i wiejskich. John, który ma za sobą pracę w różnych zakątkach globu, odegrał zasadniczą rolę w kształtowaniu całego przedsięwzięcia; zgodził się również podjąć wyzwanie i objął stanowisko kuratora zarówno niniejszego albumu, jak i wystawy.

„Miasta na Brzegu" to ważny element całorocznego ciągu imprez towarzyszących nadaniu miastu Liverpool tytułu Europejskiej Stolicy Kultury; to również nasze główne przedsięwzięcie międzynarodowe. Postanowiliśmy znaleźć grupę europejskich miast portowych, które w jakiś sposób (częstokroć więcej niż jeden) przypominałyby Liverpool. Głównym kryterium było założenie, że żaden z portów nie może być stolicą swego kraju. Wyłoniona w ten sposób szóstka to miasta znane na całym świecie, posiadające bogatą historię, różnorodne kulturowo, pełne sił witalnych; nie są im również obce bolączki, takie jak regres ekonomiczny, bieda, bezrobocie i pełna gama problemów społecznych, jakie towarzyszą takim zjawiskom. Krótko mówiąc, są to miasta wyjątkowe, miasta „na brzegu".

W skład grupy wchodzą Liverpool, Marsylia, Neapol, Brema, Gdańsk oraz Stambuł – miasta bez wątpienia znane na całym świecie, a jednocześnie leżące „na skraju". Każde z nich zajmuje we własnym kraju szczególną pozycję; każde też powszechnie uznawane jest za enklawę, swoistą wyspę na morzu swego kraju. We wszystkich znajdziemy perły architektury sąsiadujące z obszarami bardzo zaniedbanymi. Wszystkie cechują się poczuciem humoru, kreatywnością oraz – jakżeby inaczej – namiętnością do piłki nożnej.

Program imprez na 2008 rok obejmuje wydarzenia kulturalne przygotowywane wspólnie z naszymi miastami partnerskimi. Do współpracy zapraszamy zarówno uznanych, jak i dopiero zdobywających uznanie artystów i organizacje artystyczne z Liverpoolu, całej północno-zachodniej Anglii oraz z krajów miast partnerskich; taki też cel przyświeca niniejszej publikacji. To, z kolei, oznacza przyjemność współpracy z sześcioma fotografami pochodzącymi z sześciu partnerskich miast bądź ich okolic.

Główne zadania, jakie wyznaczyliśmy sobie na ten rok, to uwypuklenie kulturowej różnorodności i bogactwa tych niezwykłych miast, a równocześnie ich przybliżenie zarówno kręgom artystycznym, jak i szerszym grupom społeczeństwa. Z myślą o tym, w ramach prowadzonych przez nas projektów, młodzi ludzie wymieniają się doświadczeniami z dziedziny muzyki i teatru, organizowane są konferencje i wystawy, zamawiamy publikacje, gościmy „niepokorne" wykłady, prezentujemy na żywo wydarzenia muzyczne, współpracujemy nad filmami i współuczestniczymy w wielu innych przedsięwzięciach. Mamy nadzieję, że entuzjazm i zapał miast partnerskich będzie gwarancją, iż ich współpraca rozciągnie się poza rok 2008, a każde z tej wyjątkowej szóstki przejmować będzie

organizację programu imprez w duchu podobnym do Liverpoolu.

Phil Redmond
Wiceprezes i Dyrektor ds. Kreacji
Liverpool Culture Company

Unser Fotografie-Projekt – gipfelnd in dieser Publikation und einer großen Fotoausstellung während des Herbstes 2008 – ist ein zentrales Element des 'Cities on the Edge'-Programms. Das Thema des Projektes ist "Menschen und Orte", Wesenhaftes in der Geschichte einer Hafenstadt.

Obwohl das Projekt von der Liverpool Culture Company in Auftrag gegeben wurde, ist sein Zustandekommen im Wesentlichen dem international renommierten Fotografen John Davies zu verdanken. Davies ist bekannt für seine ländlichen und städtischen Landschaften und arbeitete bereits an vielen Orten weltweit. Er hat das Projekt mitgeformt und die Herausforderung angenommen, sowohl das Buch als auch die Ausstellung zu kuratieren.

'Cities on the Edge' ist ein bedeutender Teil innerhalb unserer kulturellen Feierlichkeiten während Liverpools Jahr als europäische Kulturhauptstadt und es ist unser wichtigstes transnationales Projekt. Dazu wählten wir eine Gruppe von europäischen Hafenstädten aus, die Liverpool auf die eine oder andere Weise (und meist in vieler Weise) gleichen. Unser Hauptkriterium war, dass keine der Hafenstädte eine Hauptstadt sein sollte. Die Teilnehmer sind nun ein Sechstett weltberühmter Städte; alle geschichtsträchtig, kulturell vielfältig, leidenschaftlich. Aber es sind auch Städte mit Problemen wie der Abwanderung oder dem Verlust von Industrien, Armut, Arbeitslosigkeit und der ganzen Palette sozialer Folgeerscheinungen. Kurzum, es sind Städte "am Rand" – kantige Städte.

Das Netzwerk, das wir geschaffen haben, besteht aus Liverpool, Marseilles, Neapel, Bremen, Danzig und Istanbul. Dies sind in der Tat weltberühmte und gleichzeitig kantige Städte. Jede von ihnen besitzt eine besondere Identität im jeweils eigenen Land und sie sind bekannt als Stadtstaaten – Inseln in der eigenen Nation. Sie alle besitzen Viertel mit großartiger Architektur direkt neben Gegenden städtischer Verwahrlosung. In diesen Städten hat man Humor. Man ist kreativ und teilt natürlich die Leidenschaft für den Fußball.

Über das gesamte Programm hinweg finden gemeinsame kulturelle Veranstaltungen mit unseren Partnerstädten statt. Wir laden sowohl etablierte als auch junge Künstler ein, sowie Künstlervereinigungen aus Liverpool, dem gesamten Nord-Westen Englands und den Ländern unserer Partnerstädte, um mit uns zu arbeiten. Das war der zentrale Gedanke auch für diese Publikation und es bedeutete ein großes Glück, mit sechs Fotografen zu arbeiten, die alle aus oder aus der Nähe einer unserer Partnerstädte stammen.

Während eines Jahres waren unsere zentralen Absichten, kulturellen Reichtum und Vielfalt hervorzuheben, die man in diesen bemerkenswerten Städten findet und gleichzeitig Aufmerksamkeit zu erzeugen, sowohl innerhalb der Kunst als auch in der Öffentlichkeit. Zu diesem Zweck tauschen wir Ideen aus mit jungen Menschen über das Theater und die Musik, wir veranstalten Konferenzen, geben Ausstellungen und Publikationen in Auftrag, laden ein zu "unbequemen" Lesungen, zu Live-Konzerten, arbeiten mit an Filmprojekten und noch vieles mehr. Wir hoffen, dass der Enthusiasmus und der Drive unsere Partnerstädte dazu ermuntern, dieses Netzwerk über das Jahr 2008 hinaus lebendig zu

erhalten. Denn jede dieser 'kantigen' Städte wird später, genau wie Liverpool, einmal eine solche Veranstaltungsreihe übernehmen.

Phil Redmond
Creative Director und stellvertretender Vorsitzender der Liverpool Culture Company

Il progetto fotografico, che raggiunge la massima espressione con la presente pubblicazione e con un'importante mostra fotografica nell'autunno 2008, è uno degli elementi centrali del programma "Cities on the Edge, Città di Frontiera". I temi dominanti del programma sono "gli individui e i luoghi", caratteristiche intrinseche della storia di ogni città portuale. Il progetto, sebbene commissionato dalla Liverpool Culture Company, deve molto, per quanto ne concerne lo sviluppo, al fotografo di fama internazionale, John Davies. John, che ha lavorato in tutto il mondo, è particolarmente noto per i paesaggi rurali e urbani. Il suo impegno è stato fondamentale per la costruzione del progetto ed egli ha accettato la sfida prendendosi cura di questo libro e della relativa mostra fotografica.

"Cities on the Edge" è parte fondamentale delle celebrazioni culturali che si svolgono durante l'anno in cui Liverpool viene eletta Capitale Europea della Cultura ed è il progetto transnazionale più importante. Abbiamo intenzionalmente ricercato un gruppo di città portuali europee che, per un motivo o per un altro (e spesso anche per più motivi insieme), assomigliassero a Liverpool. Il criterio di base è stato scegliere dei porti che non fossero anche città capitali. La scelta è caduta su un sestetto di città, famose in tutto il mondo; città storiche, vibranti, culturalmente diverse eppure, allo stesso tempo, accomunate da difficoltà simili, quali la crisi delle industrie, la povertà, la disoccupazione e tutta la serie di problematiche sociali che ne derivano. In breve sono città "di frontiera", città inquiete.

Abbiamo intessuto una rete di contatti tra Liverpool, Marsiglia, Napoli, Brema, Danzica e Istanbul, che sono appunto un gruppo di città famose, ma allo stesso tempo inquiete. Ciascuna possiede una speciale identità rispetto al paese ove è geograficamente collocata e tutte sono comunemente considerate delle città-stato, ovvero delle isole all'interno della propria nazione. Tutte vantano strutture architettoniche superbe che si erigono affiancate da aree in serio stato di povertà. Tutte hanno un proprio senso dell'umorismo, sono creative e, naturalmente, tutte hanno in comune la passione per il calcio.

Nell'ambito del programma, che si svolge nel 2008, condividiamo eventi culturali con queste città-partner. Invitiamo a collaborare artisti noti, emergenti e associazioni artistiche di Liverpool, di tutto il nord-ovest e delle nazioni di provenienza delle città-partner. E questa certamente è stata l'idea portante della presente pubblicazione che ha dato a tutti noi l'opportunità di lavorare con sei fotografi, ciascuno proveniente da una delle sei città-partner o dai dintorni delle stesse.

Gli obiettivi che intendiamo raggiungere durante l'anno sono: evidenziare la diversità culturale e la ricchezza propria di queste città degne di nota e insieme risvegliare la consapevolezza sia del mondo artistico sia di un pubblico più vasto. A questo scopo proponiamo uno scambio di idee su teatro e musica con i giovani, organizzando conferenze, commissionando mostre e libri, ospitando comizi "rivoluzionari" ed eventi di musica dal vivo, collaborando a progetti di film e a molto altro. Il nostro augurio è che l'entusiasmo e la grinta delle città-partner assicurino lunga vita, ben oltre il 2008, a questa rete di contatti, quando ciascuna delle città inquiete si

impegnerà nell'organizzazione di un programma di manifestazioni culturali, adottando lo stesso stile di Liverpool.

Phil Redmond
Direttore Creativo e Vicepresidente
Liverpool Culture Company

Ali Taptik

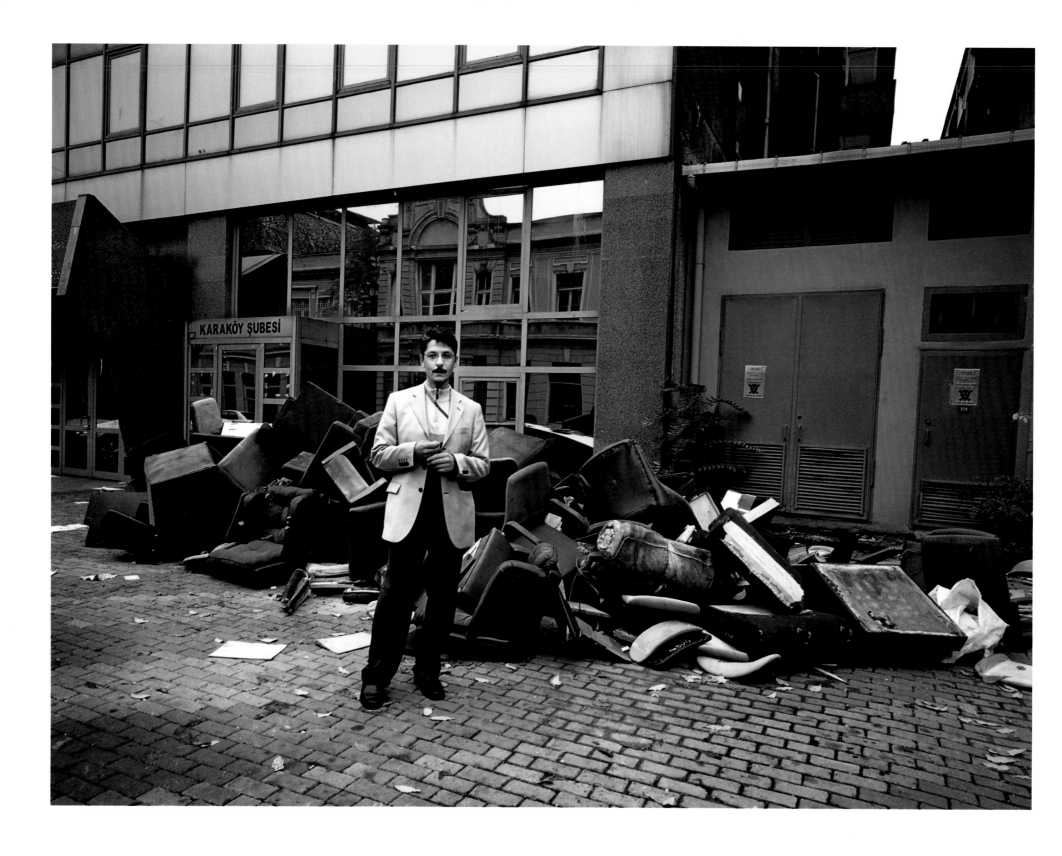

Karaköy, Istanbul

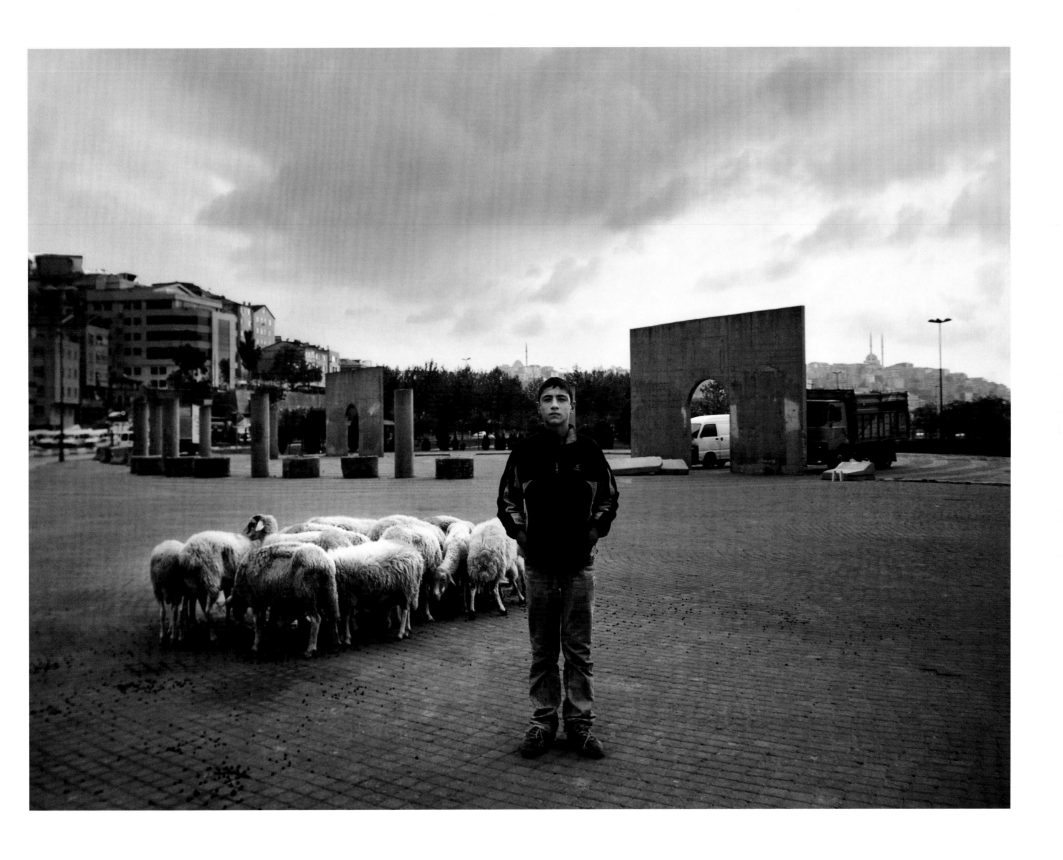

Sütlüce, Istanbul

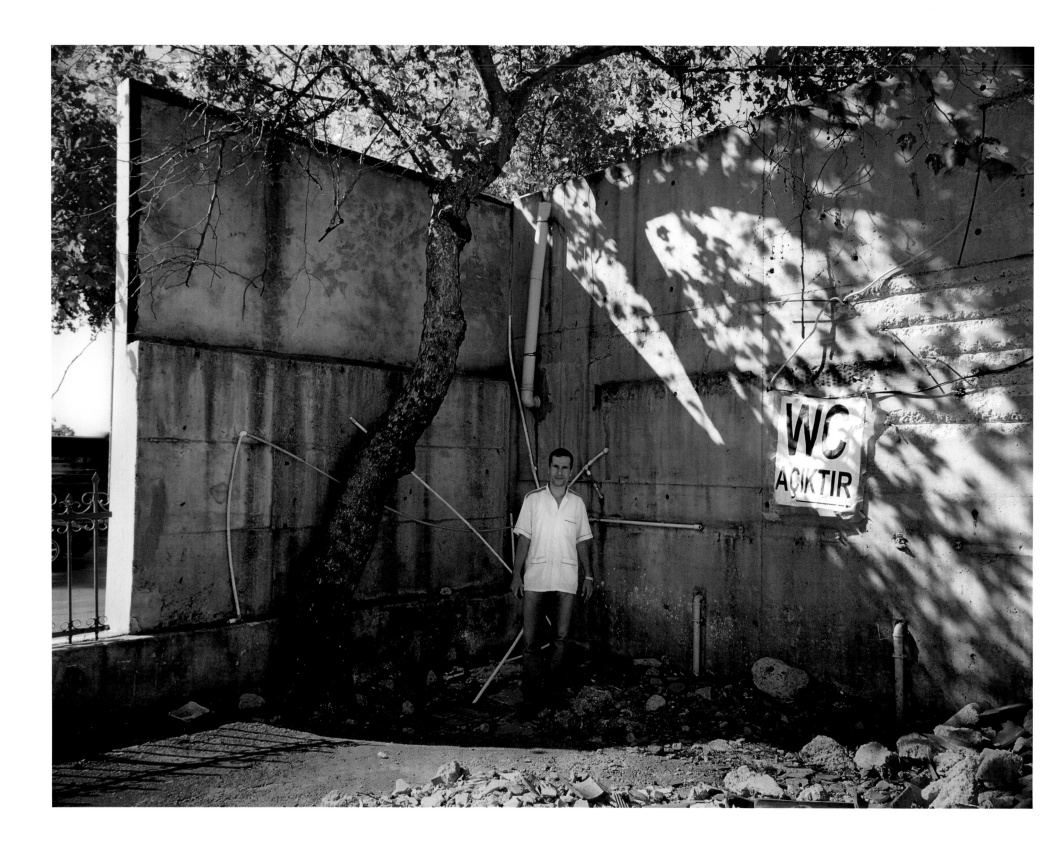

Besiktas, Istanbul

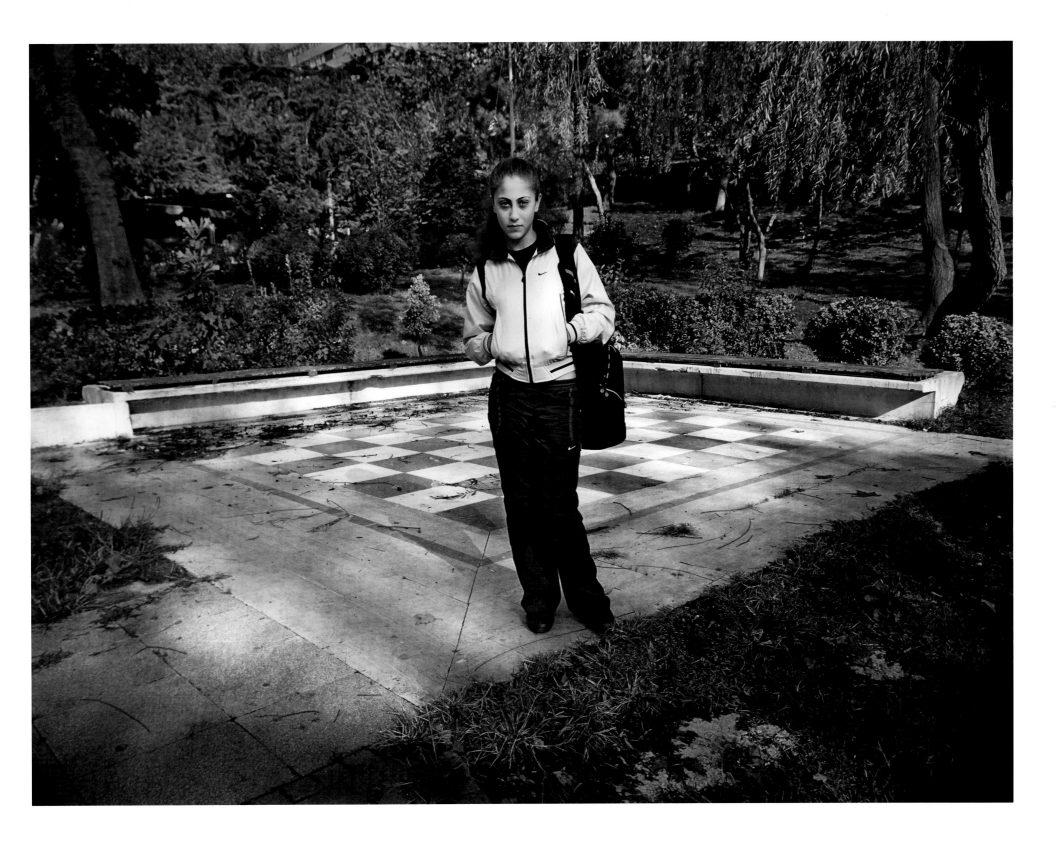

Maçka, Istanbul

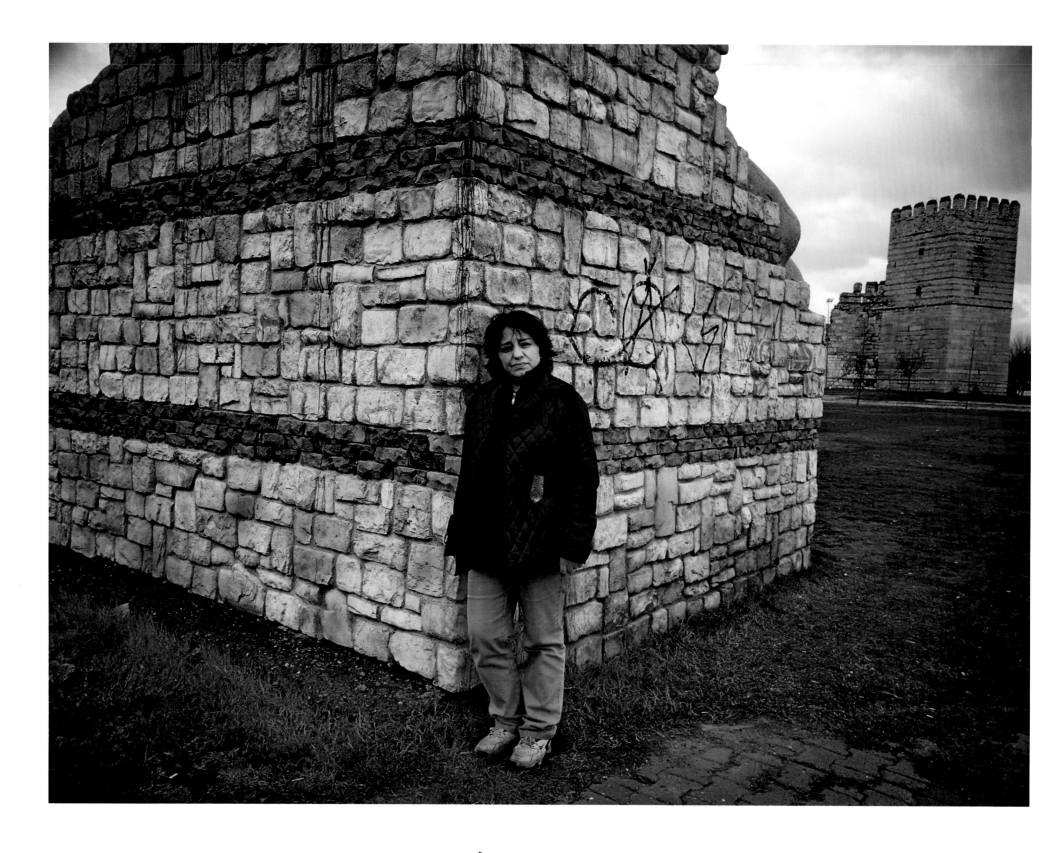

Yedikule, Istanbul

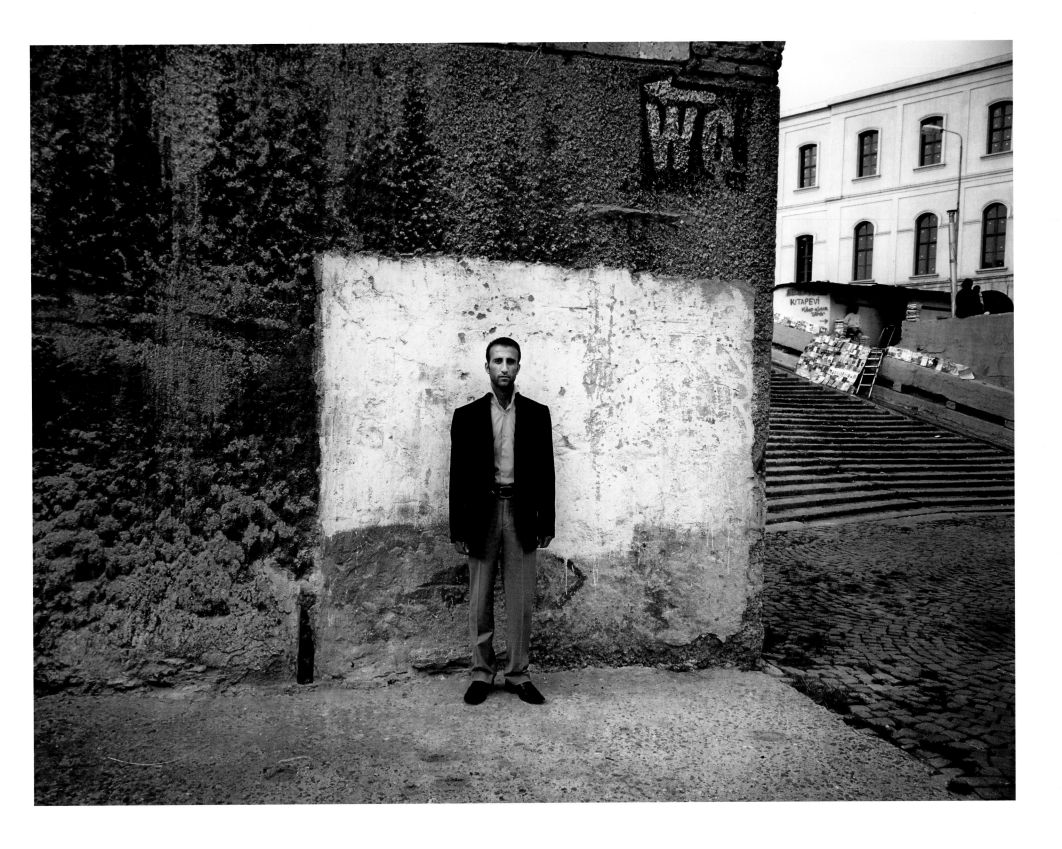

Beyazit, Istanbul

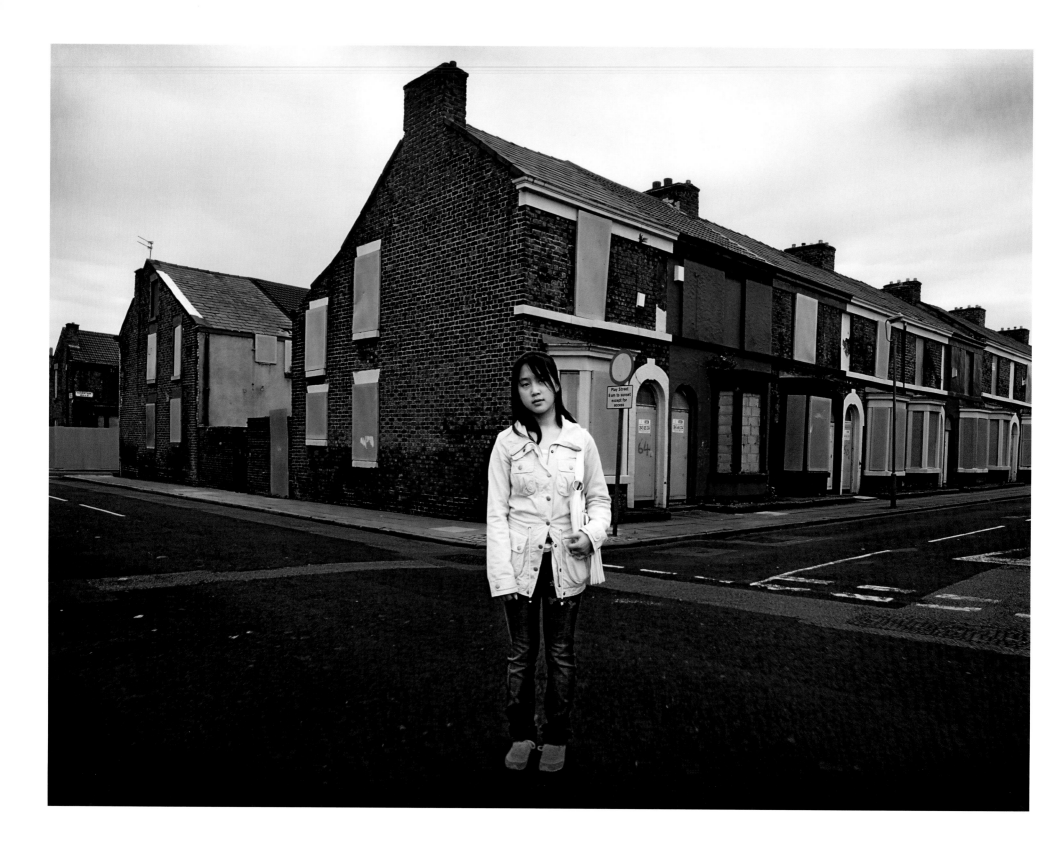

Edge Hill, Liverpool

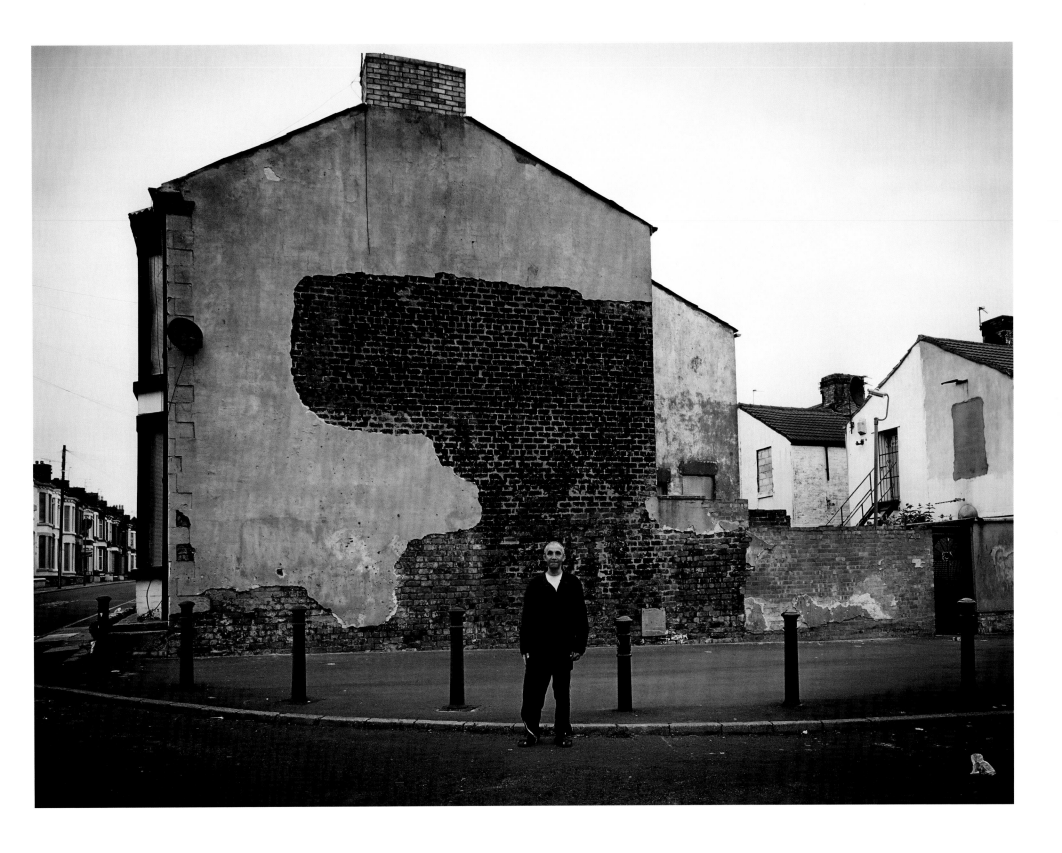

Kensington, Liverpool

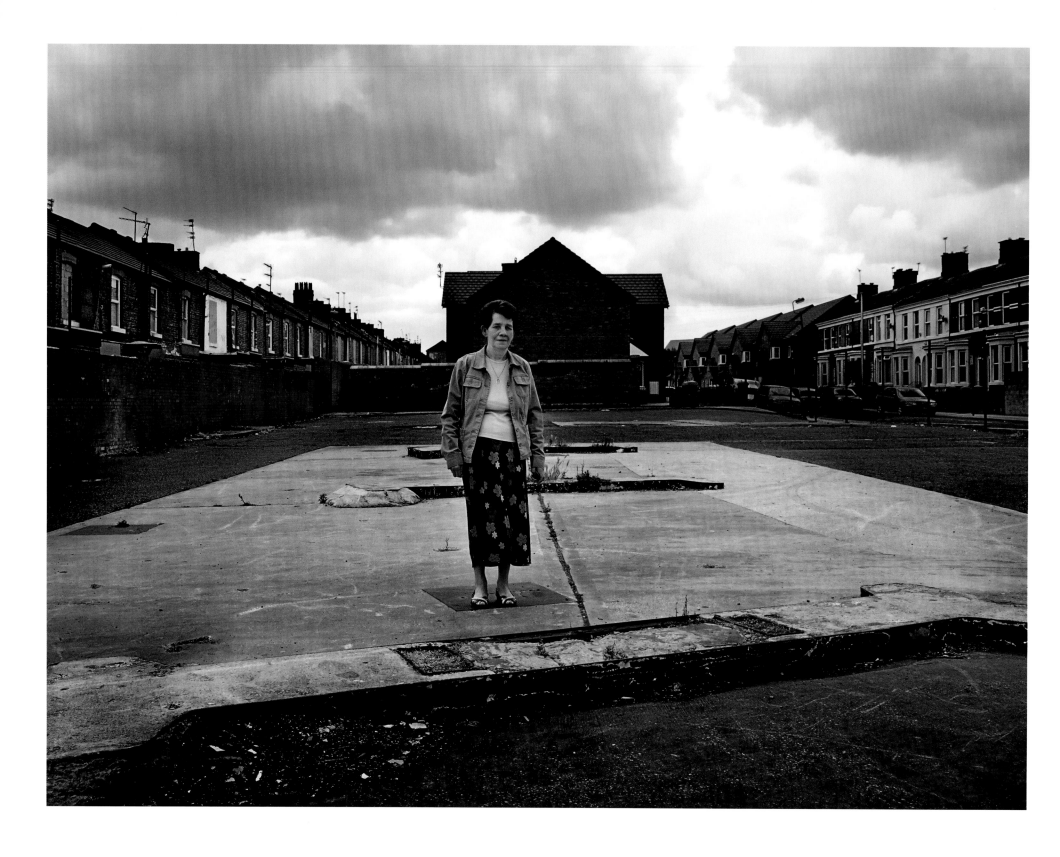

Anfield, Liverpool

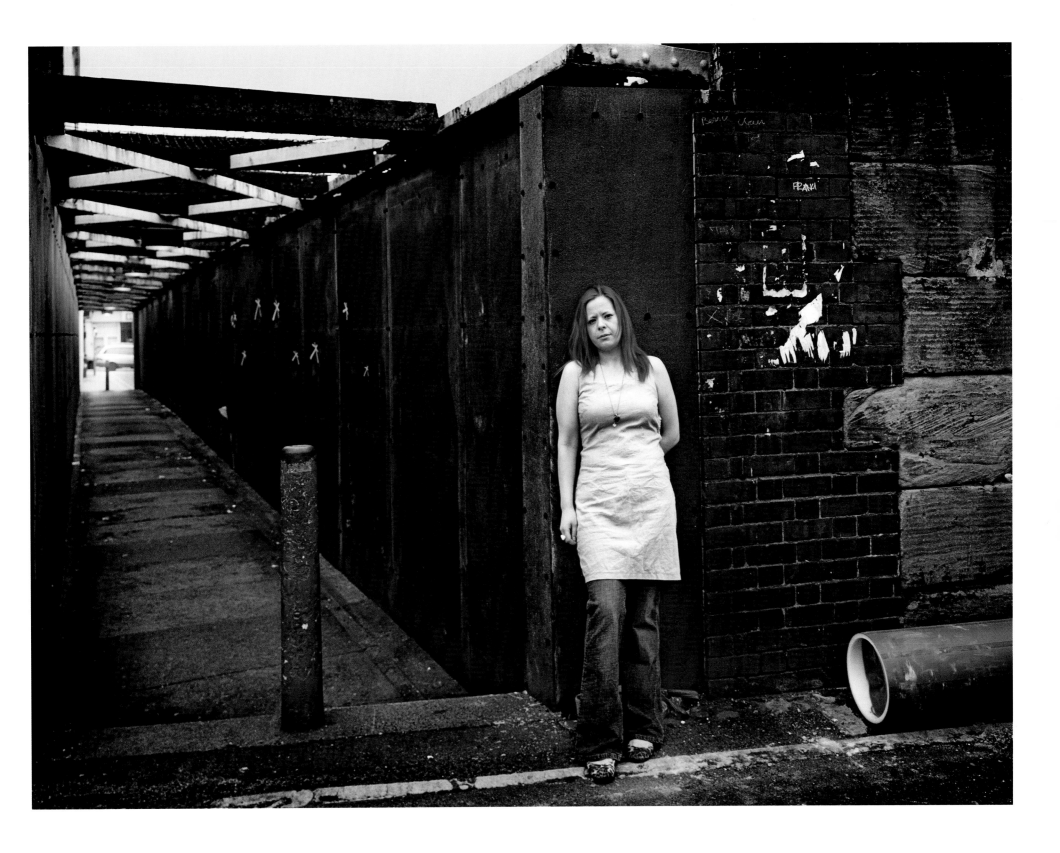

Ropewalks, Liverpool

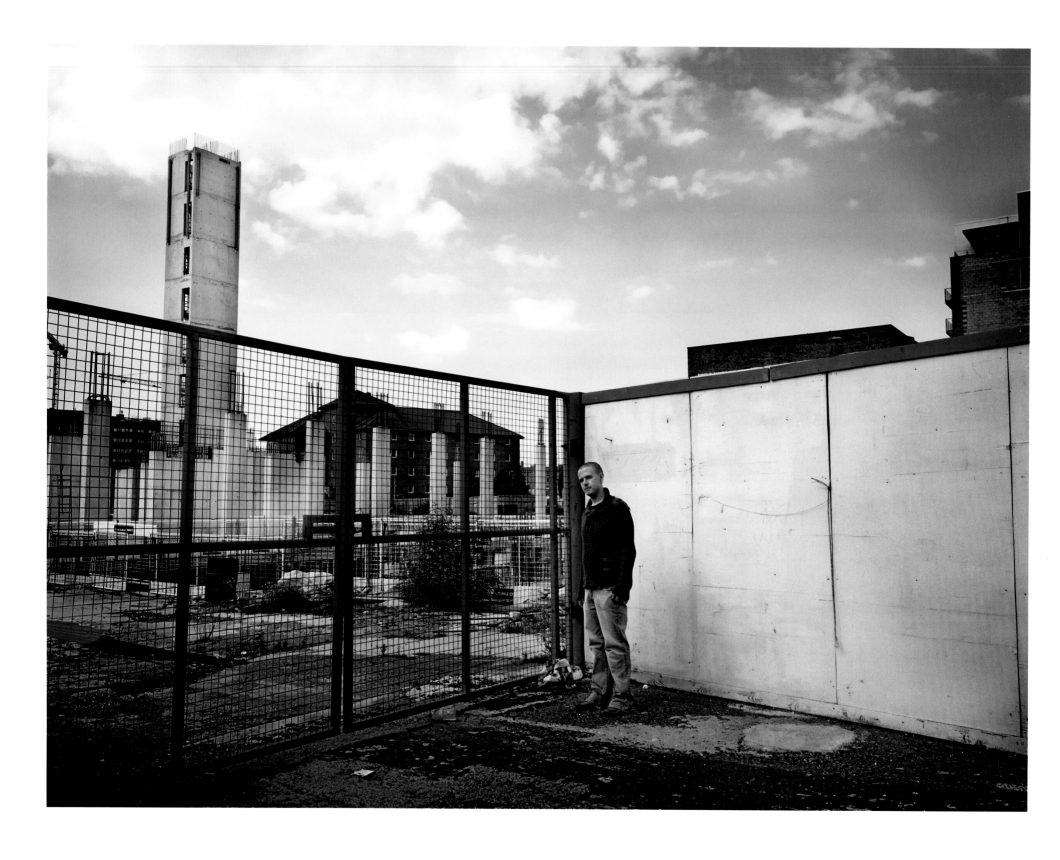

Wapping, Liverpool

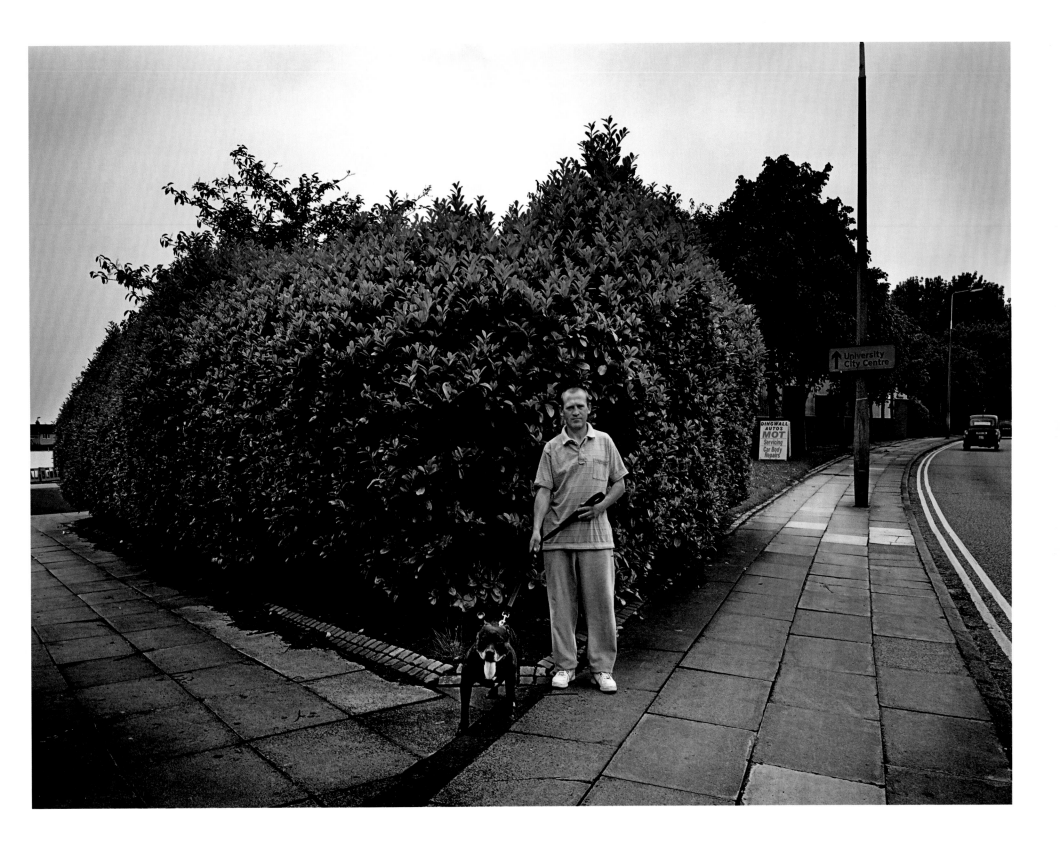

Edge Hill, Liverpool

Philippe Conti

Marseilles + Liverpool

Les terrasses du Verduron, Plan d'Aou, Marseilles

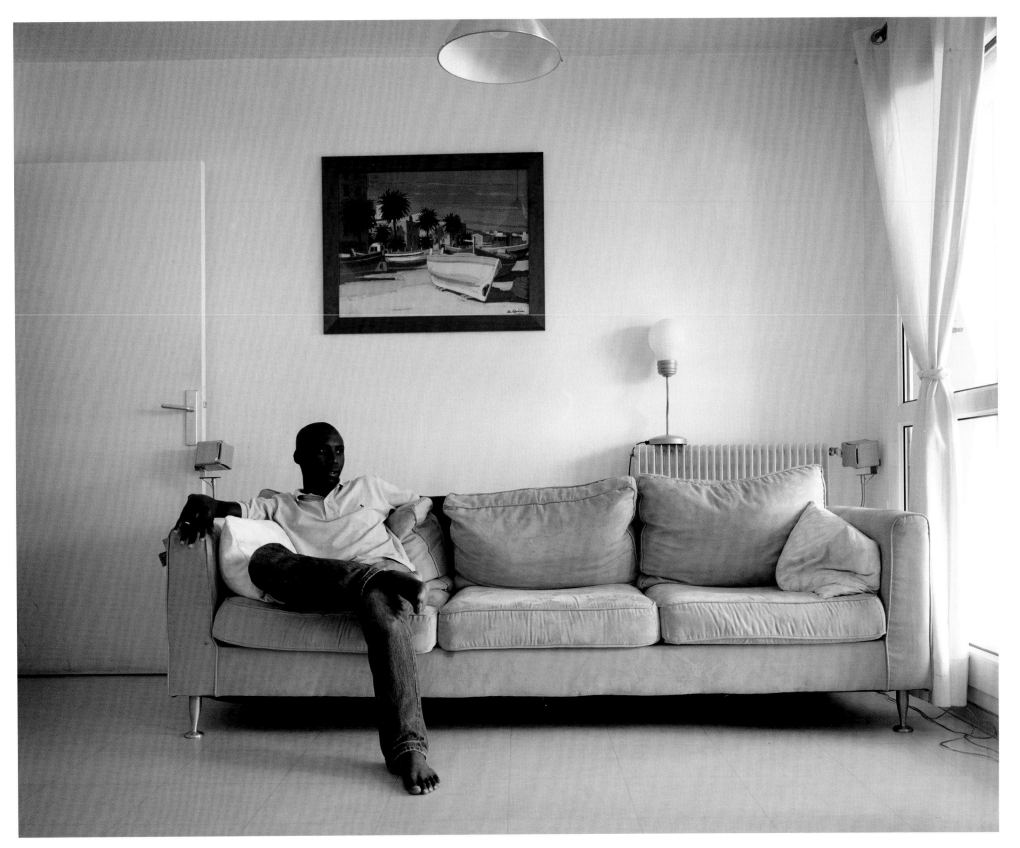

Les hauts de St Antoine, Plan d'Aou, Marseilles

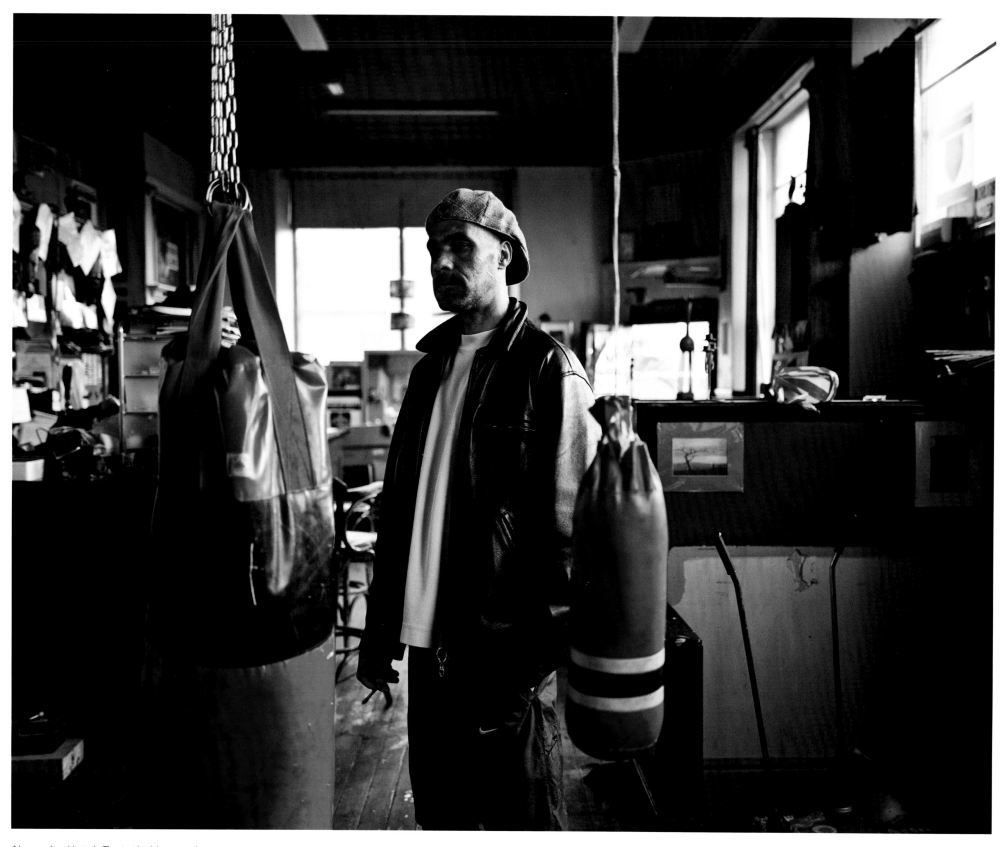

Alexandra Hotel, Toxteth, Liverpool

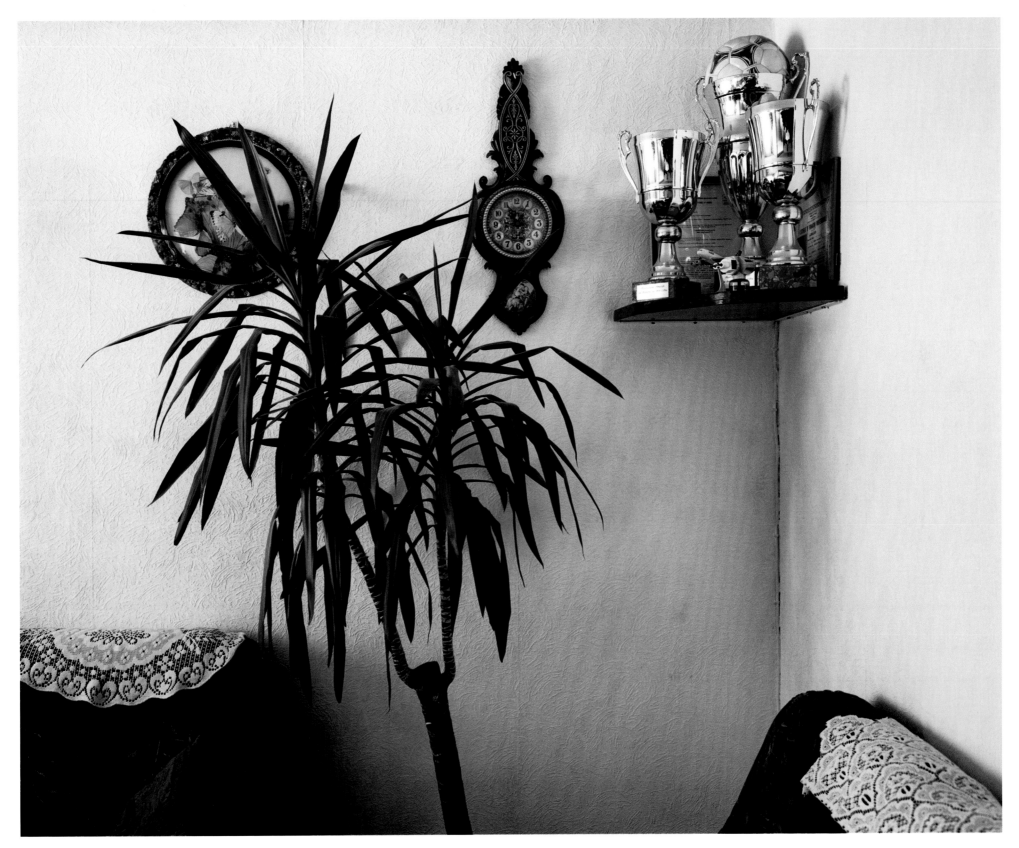

Les Gallions no 2, Plan d'Aou, Marseilles

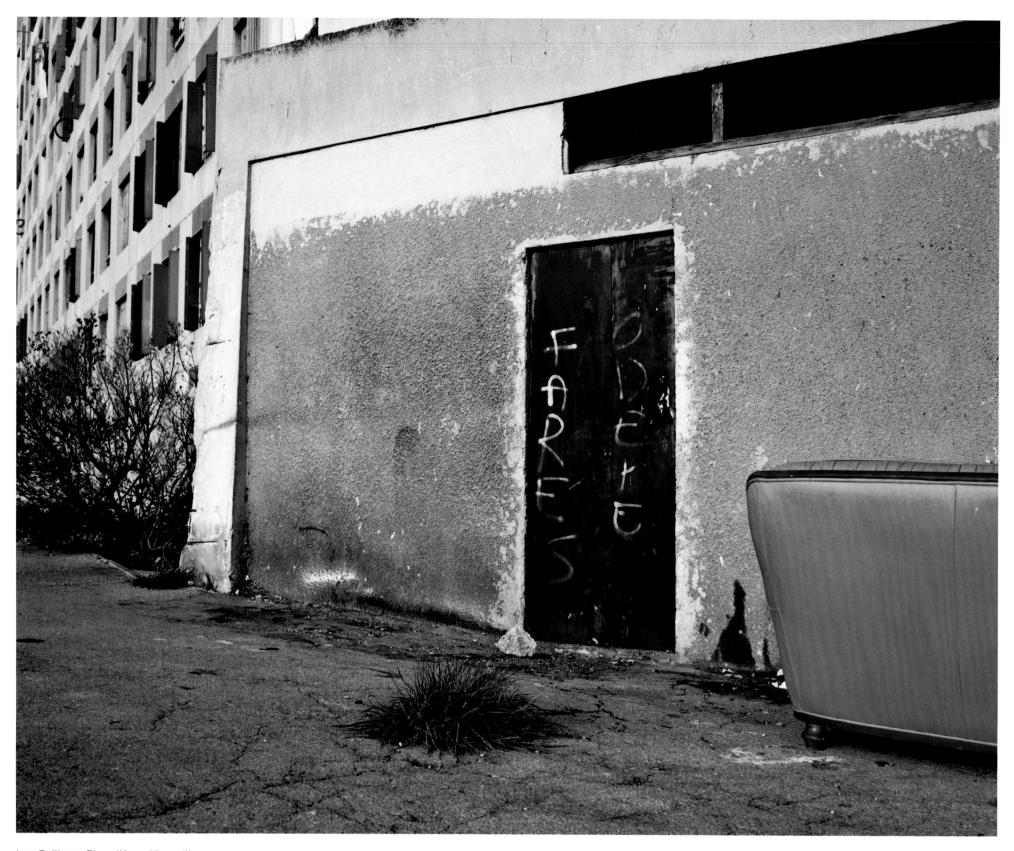

Les Gallions, Plan d'Aou, Marseilles

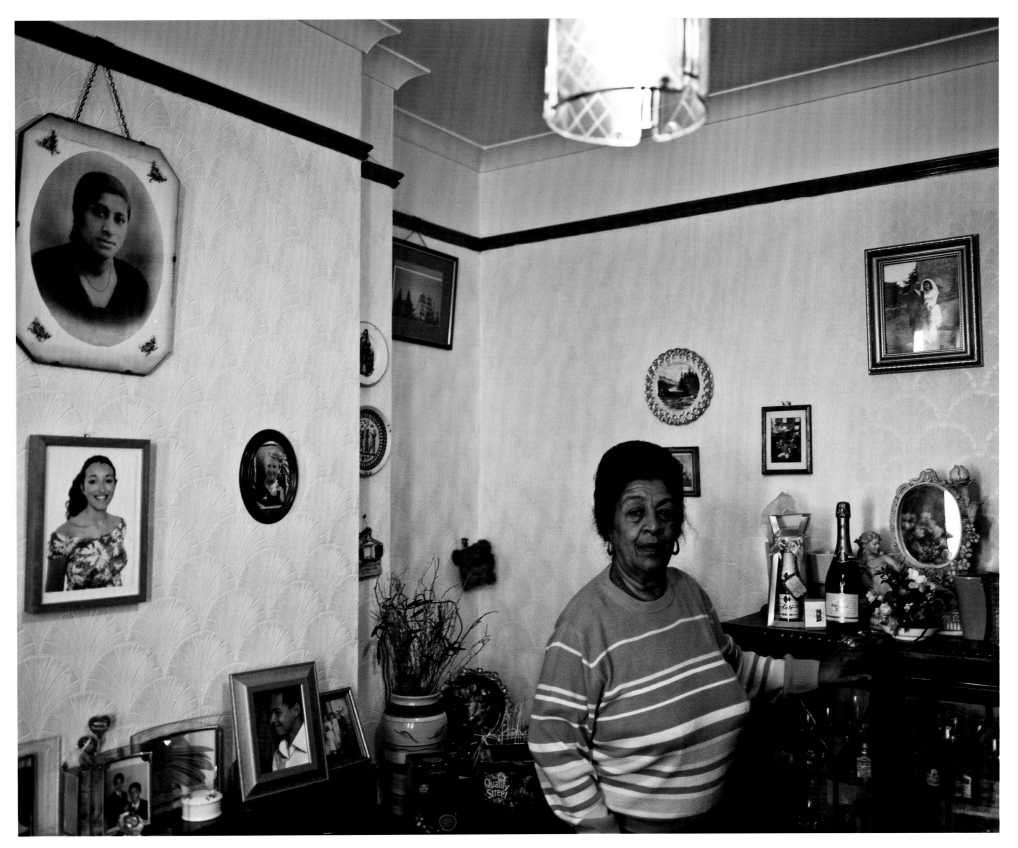

Cairn Street, Toxteth, Liverpool

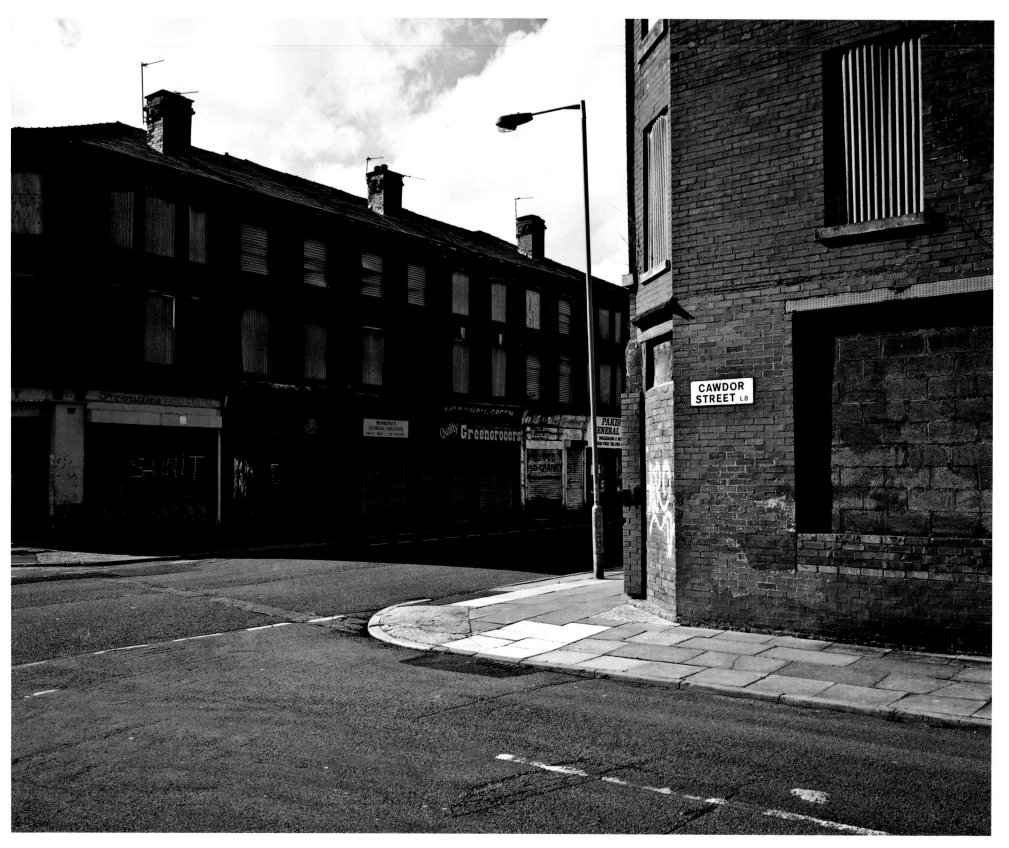

Cawdor Street and Granby Street, Toxteth, Liverpool

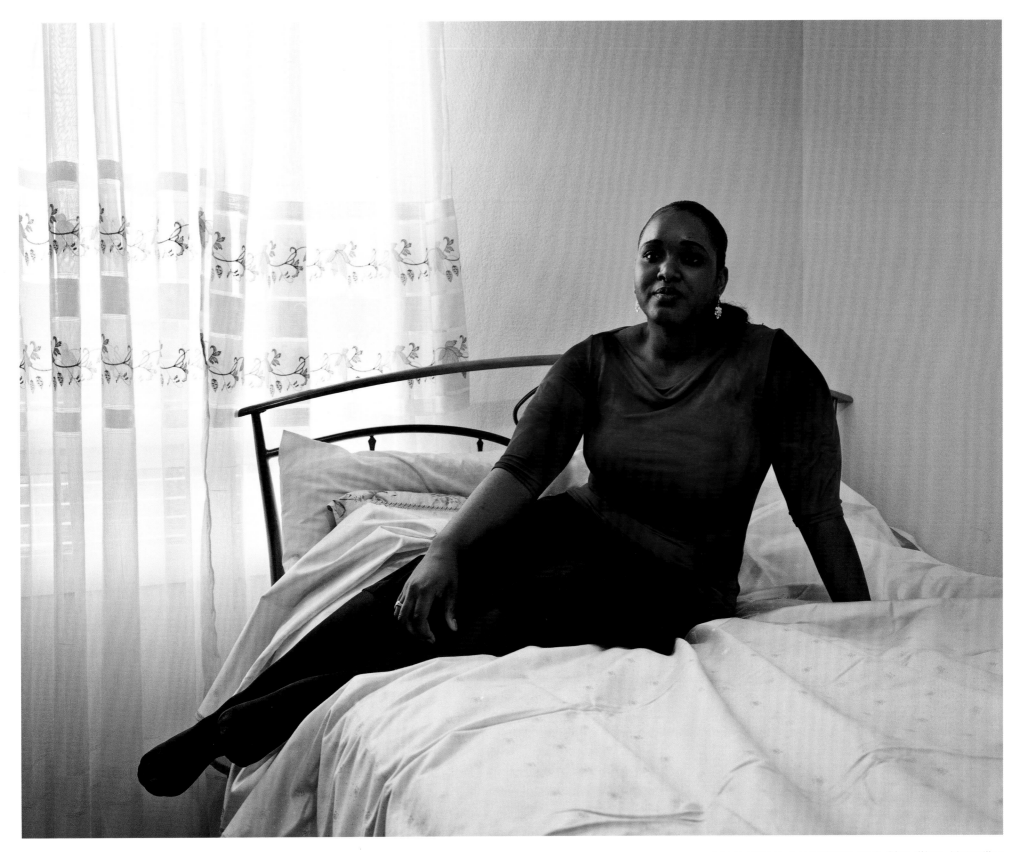

Les terrasses du Verduron no 5, Plan d'Aou, Marseilles

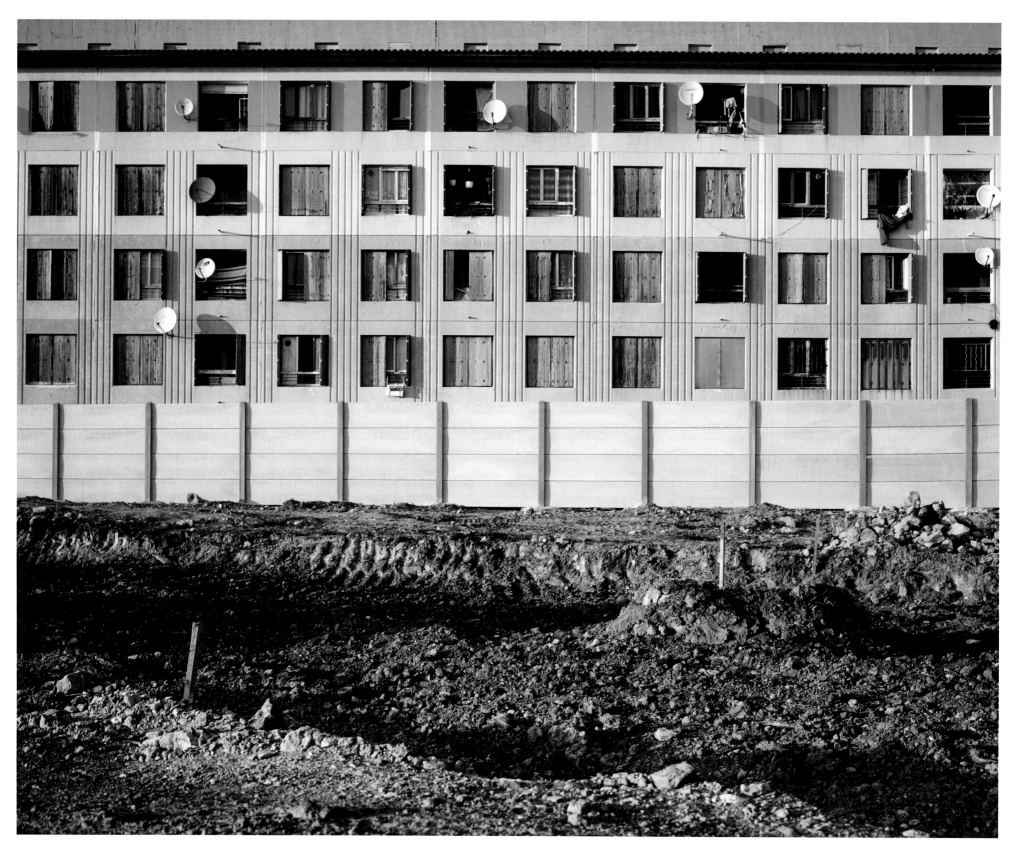

Avenue du Plan d'Aou, Belvédère, Plan d'Aou, Marseilles

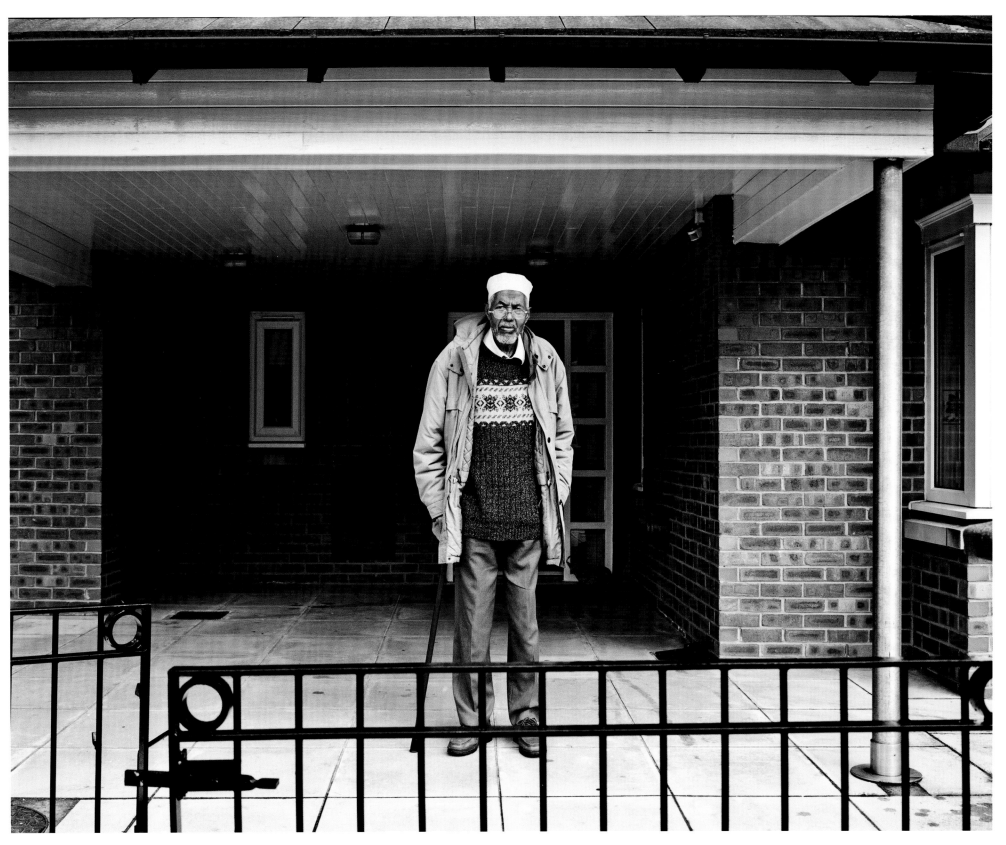

Millennium Road, Toxteth, Liverpool

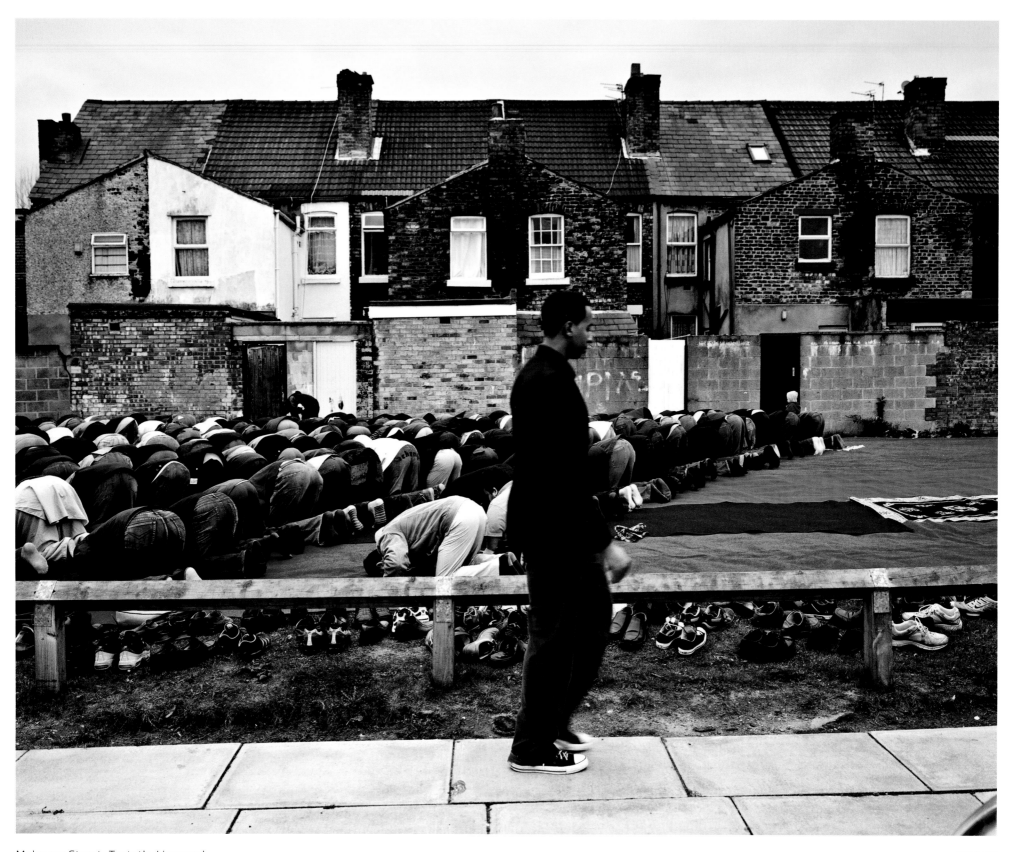

Mulgrave Street, Toxteth, Liverpool

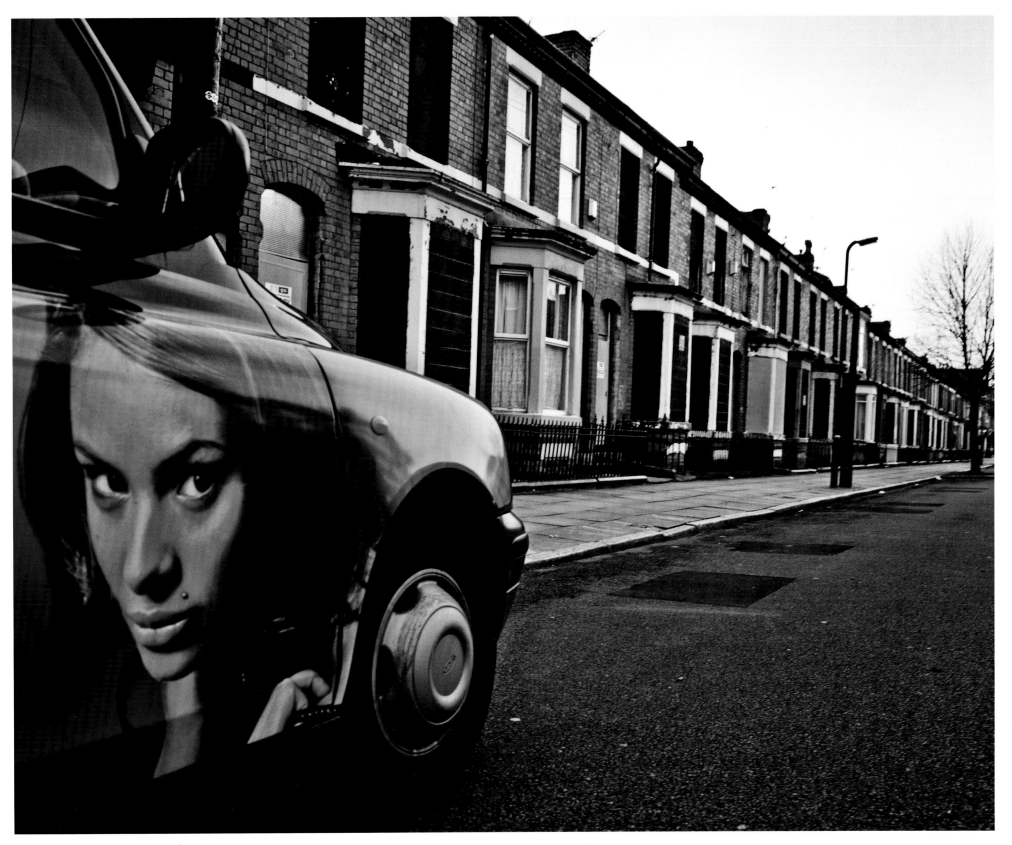

Beaconsfield Street, Toxteth, Liverpool

Wojtek Wilczyk

Gdańsk + Liverpool

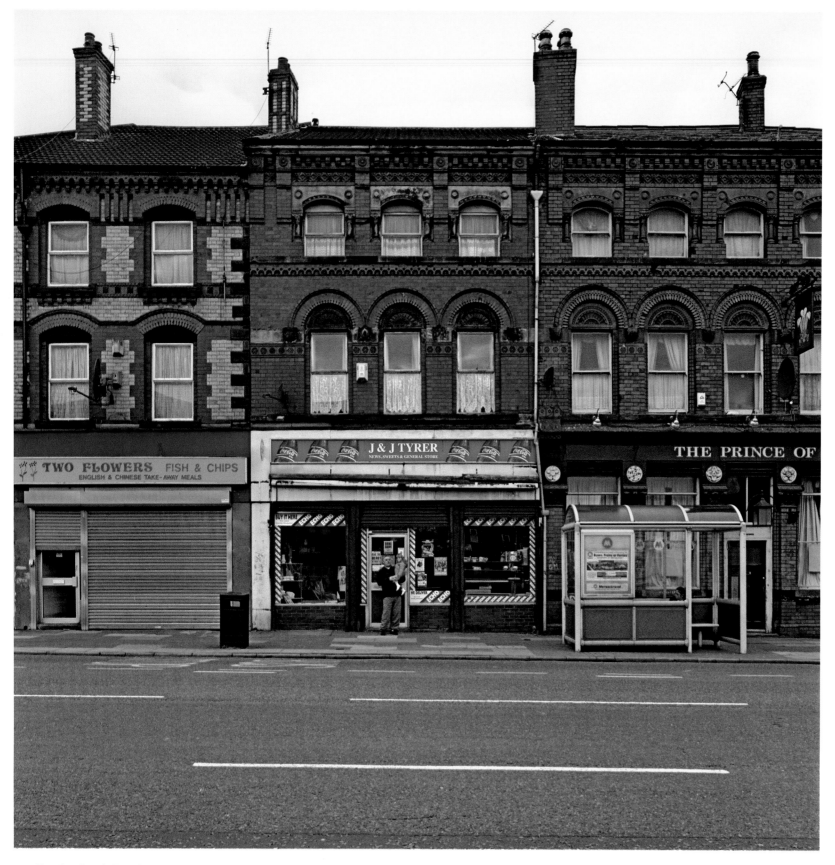

Stanley Road, Bootle, Liverpool

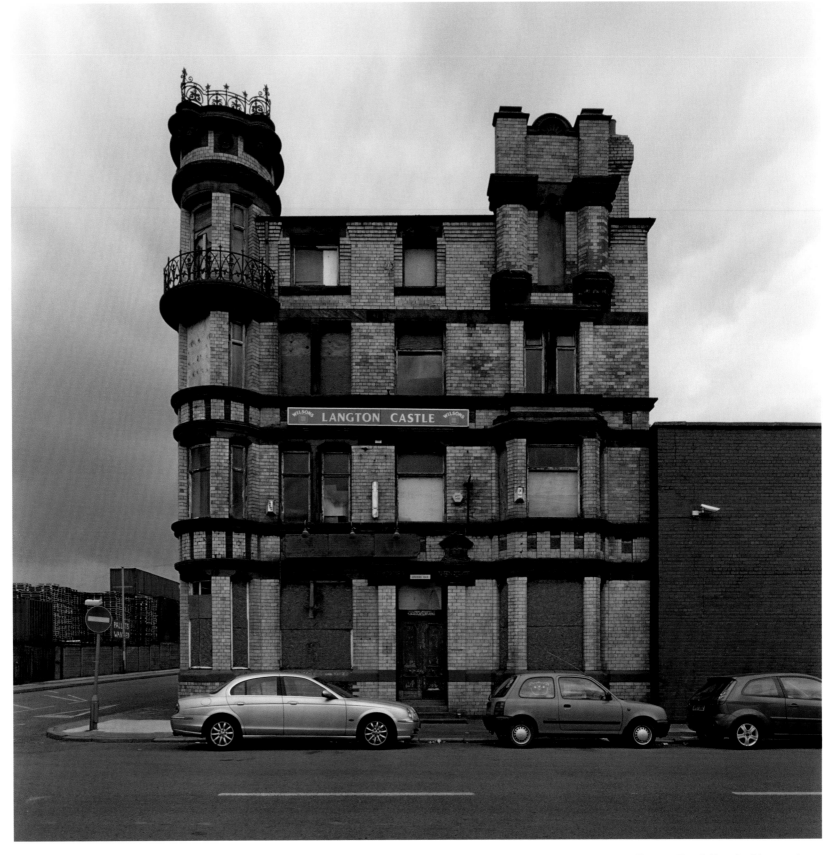

Regent Road, Bootle, Liverpool

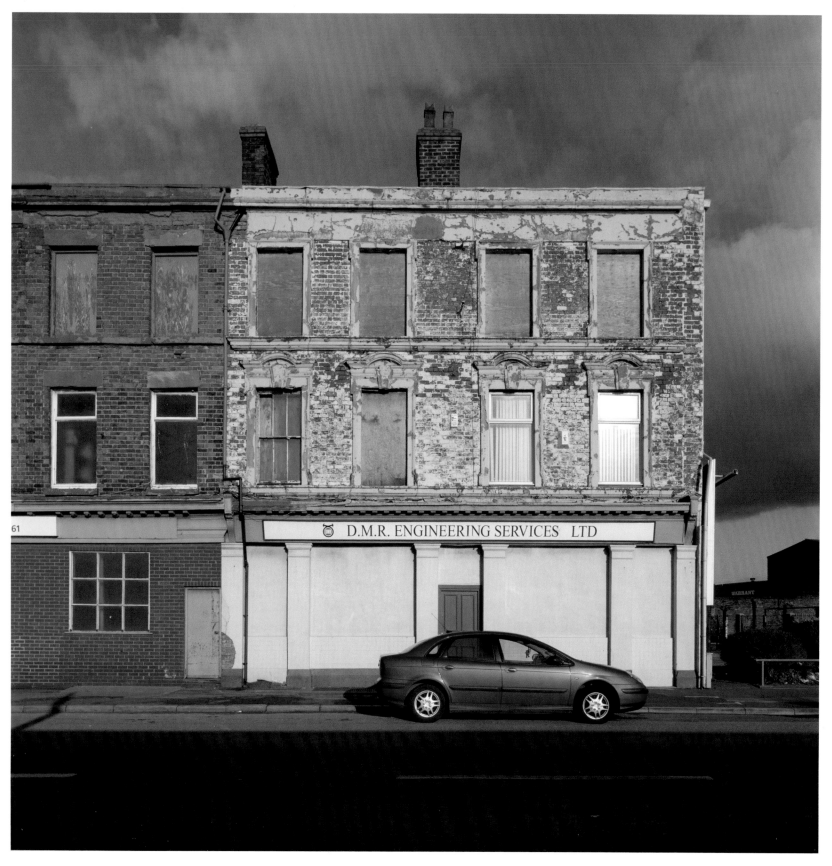

Regent Road, Bootle, Liverpool

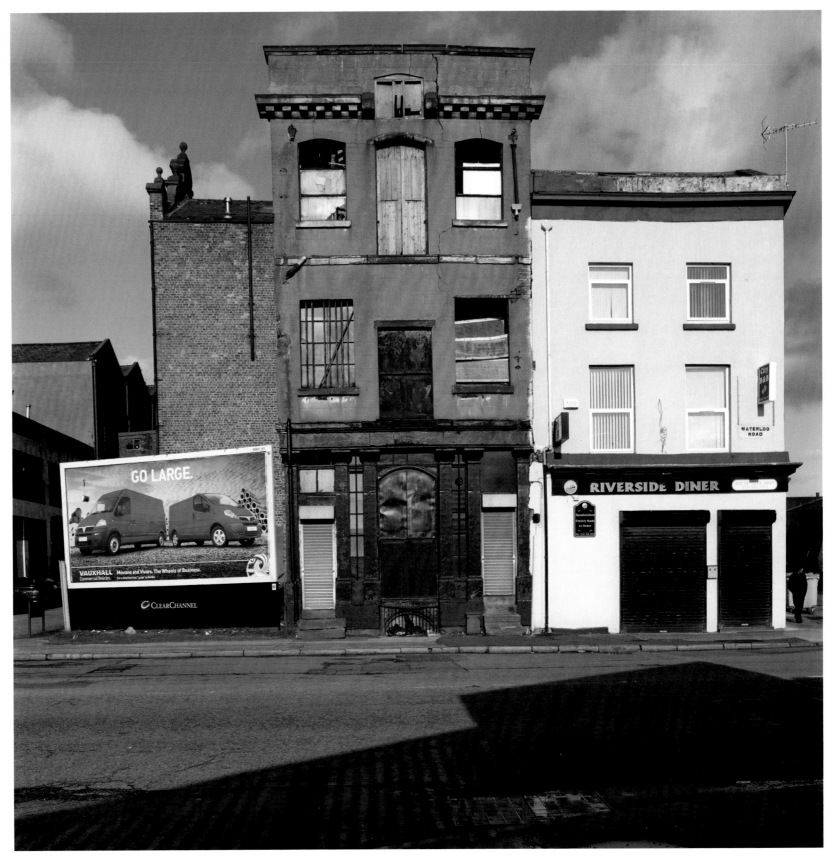

Waterloo Road, Liverpool

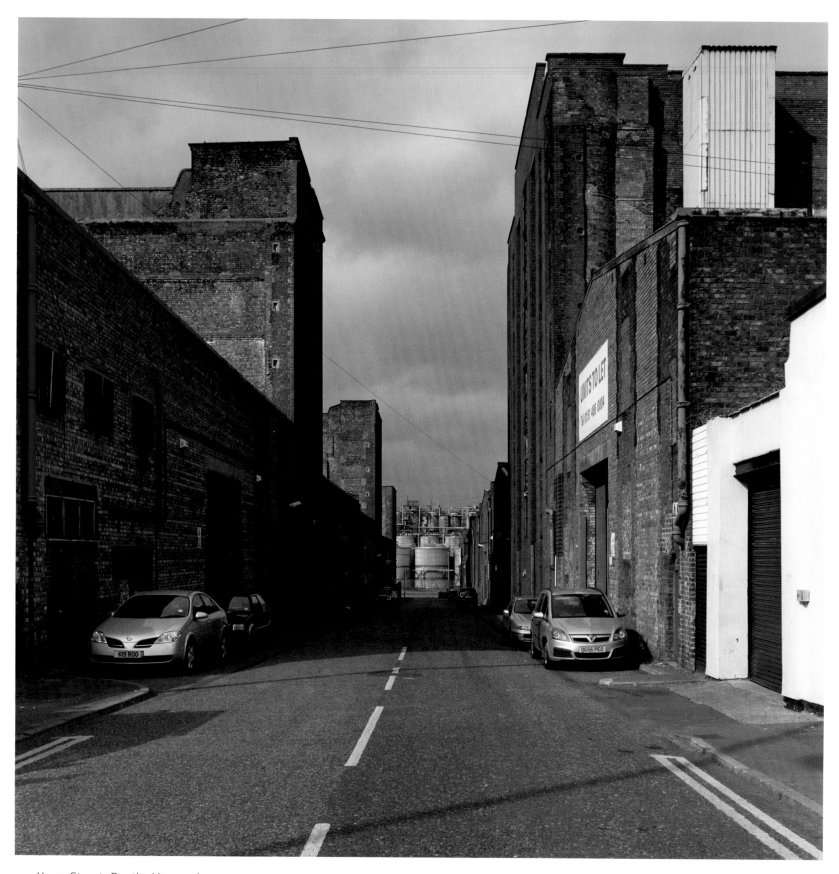

Howe Street, Bootle, Liverpool

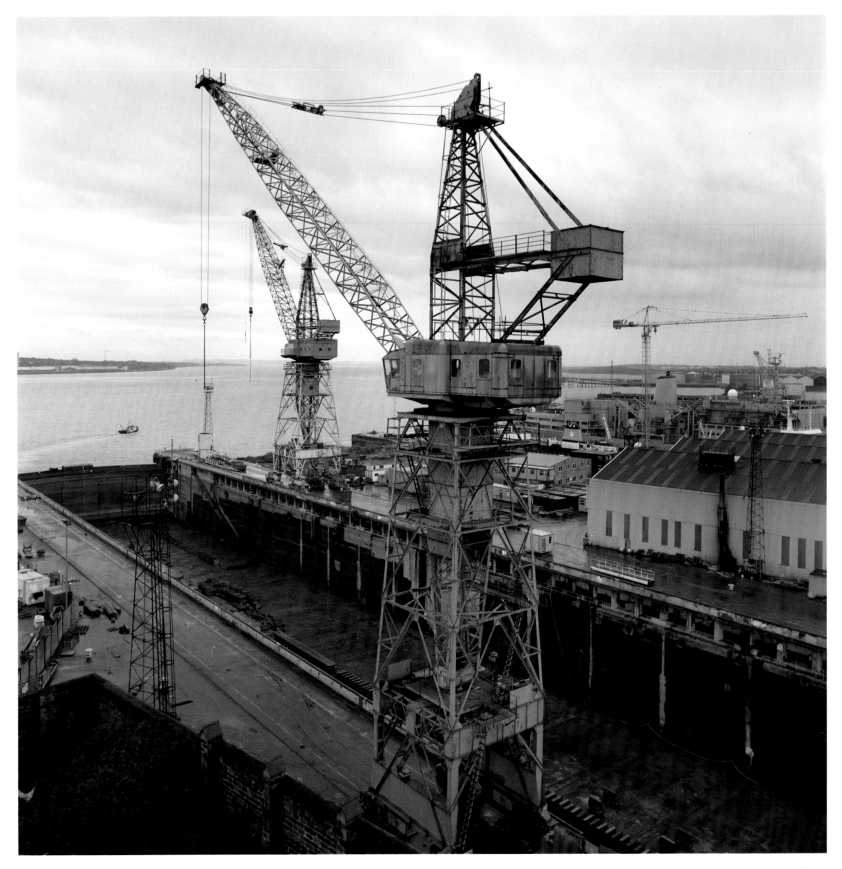

View from St Mary's Tower, Church Street, Birkenhead, Liverpool

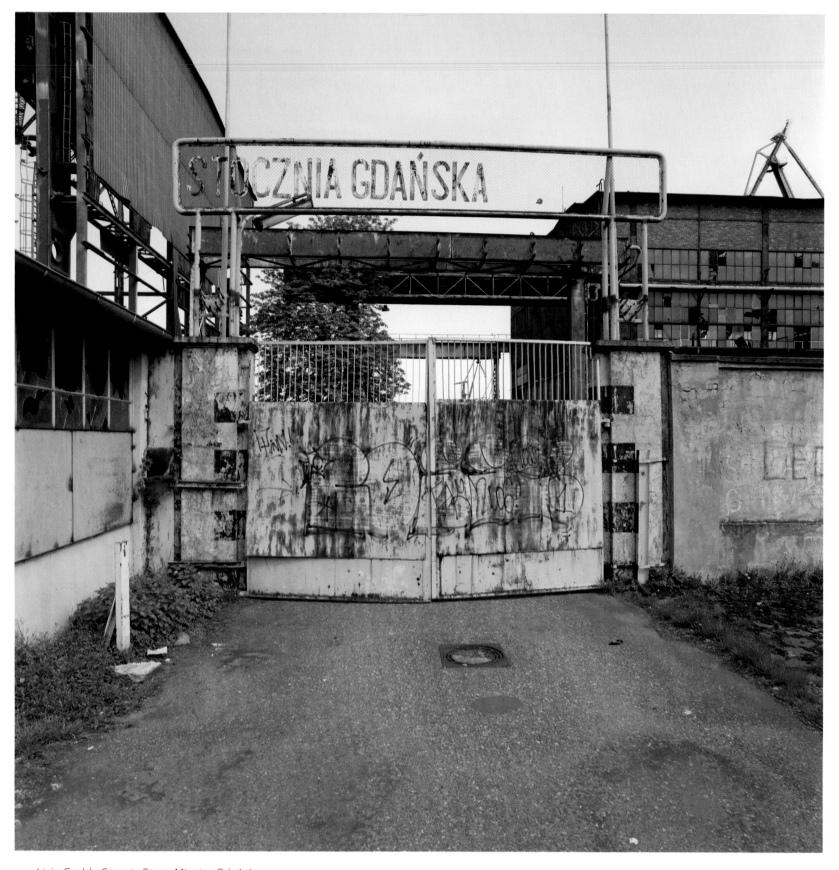

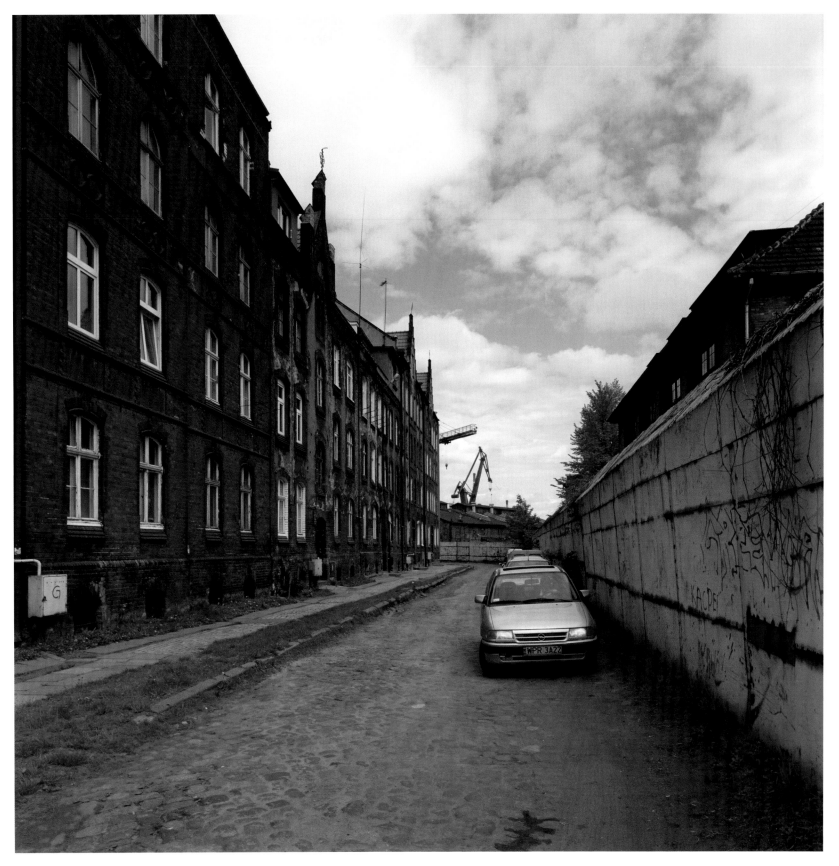

Stefana Jaracza Street, Stare Miasto, Gdańsk

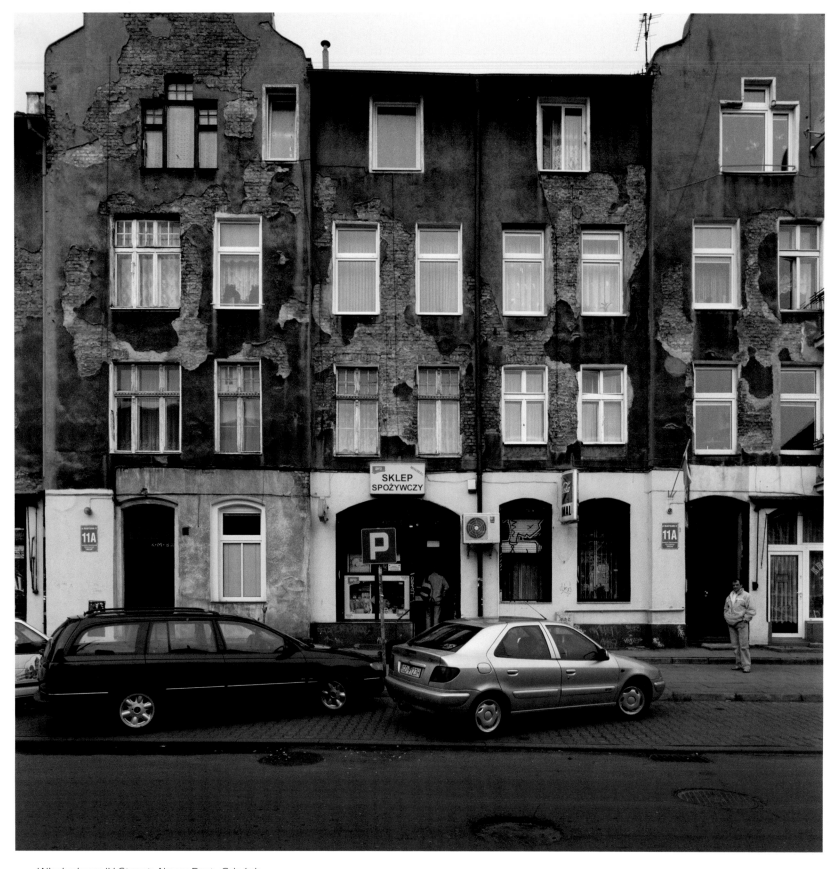

Władysława IV Street, Nowy Port, Gdańsk

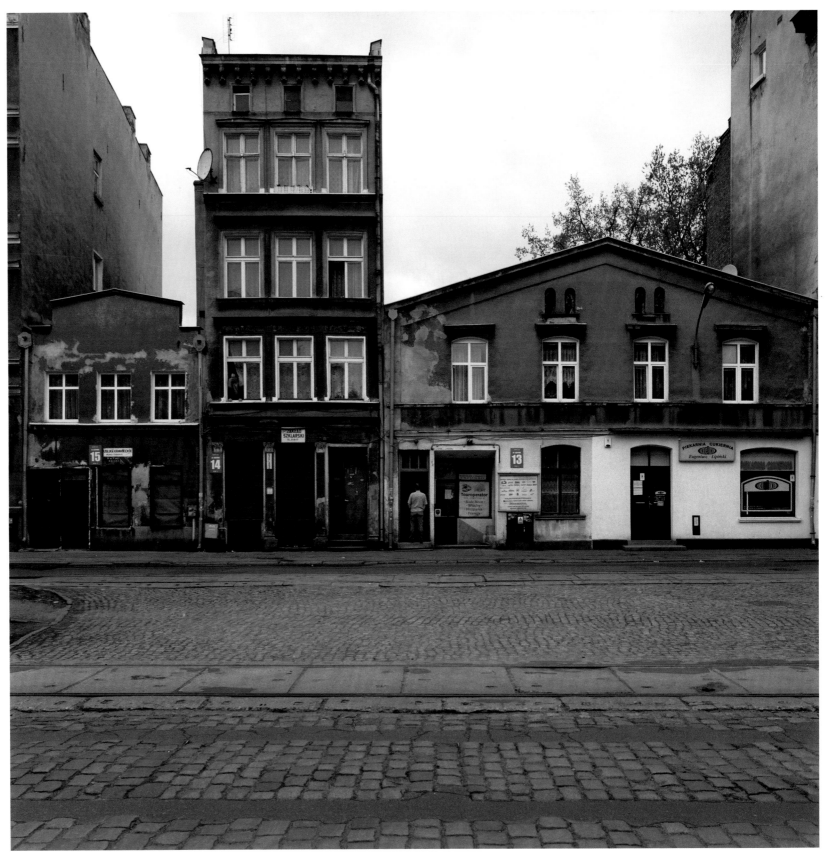

Łąkowa Street, Dolne Miasto, Gdańsk

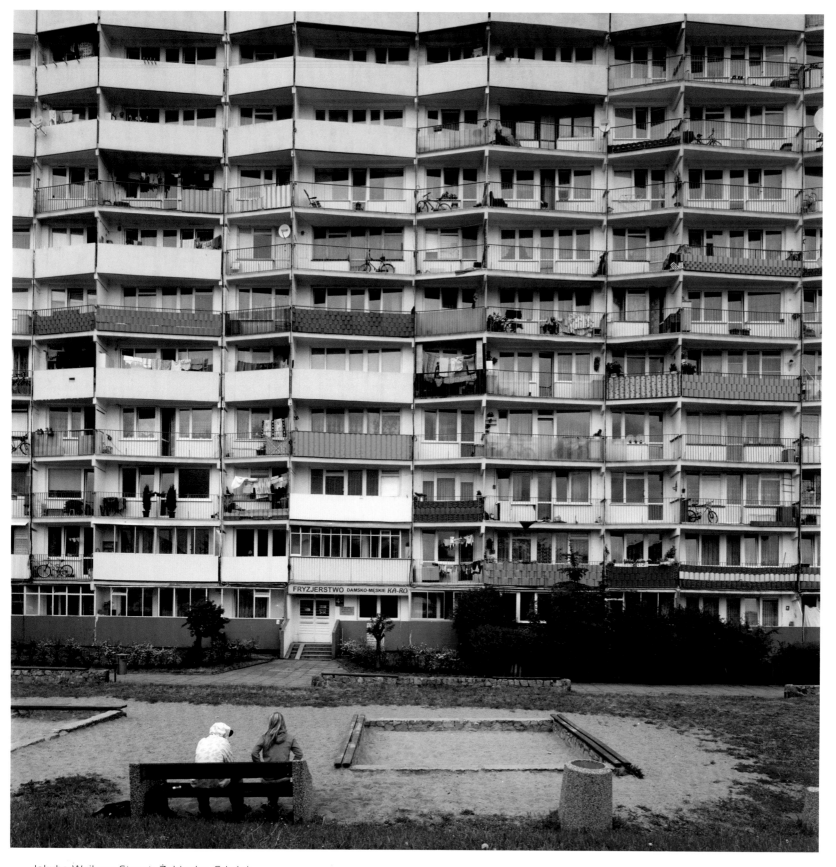

Jakuba Wejhera Street, Żabianka, Gdańsk

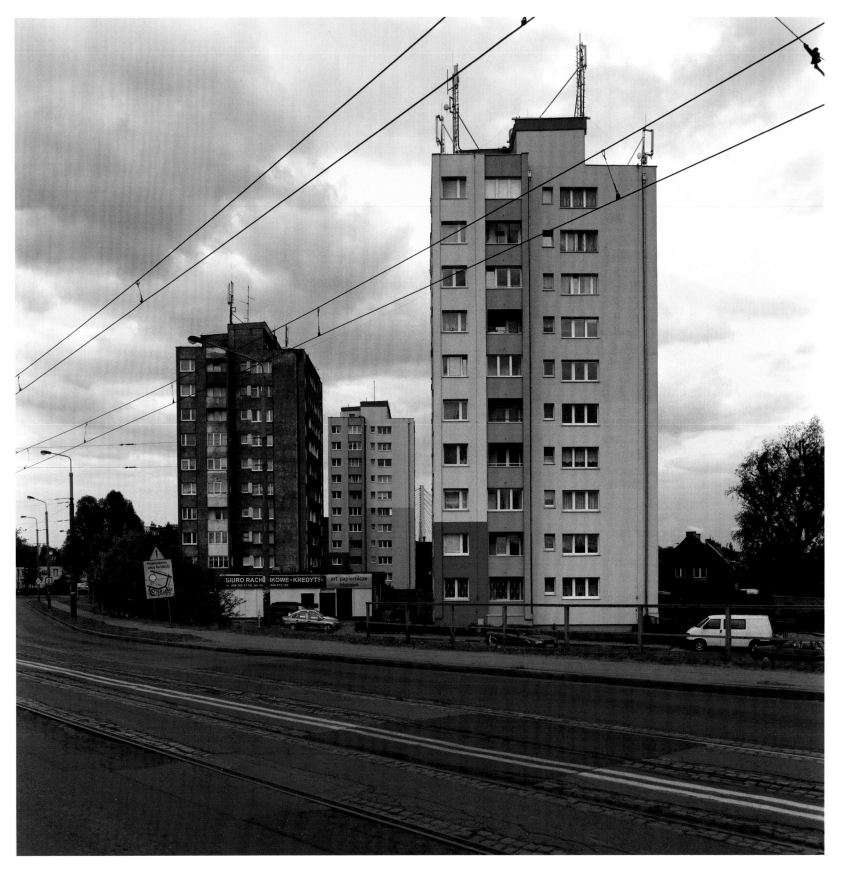

Siennicka Street, Przeróbka, Gdańsk

Sandy Volz

Bremen + Liverpool

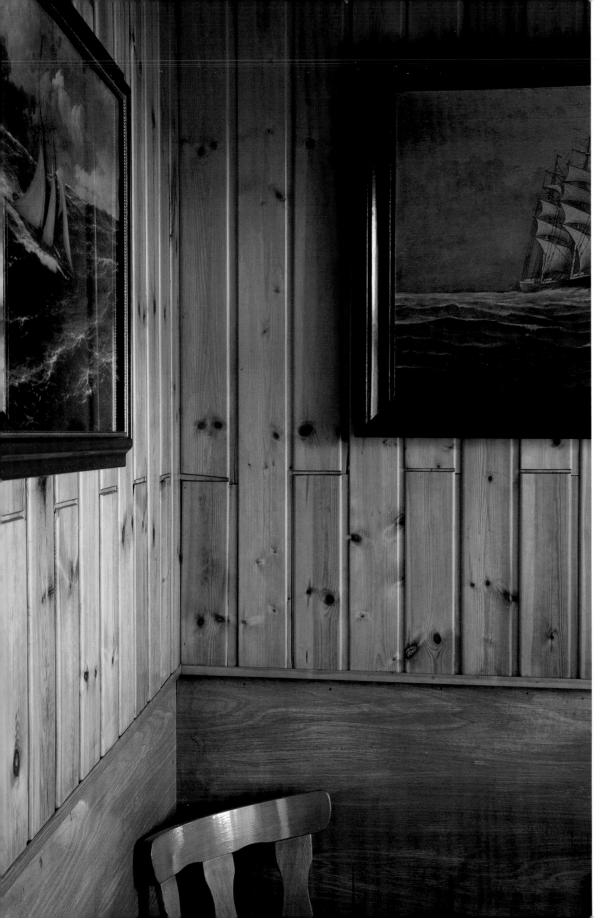

Zur Reede, Bremen

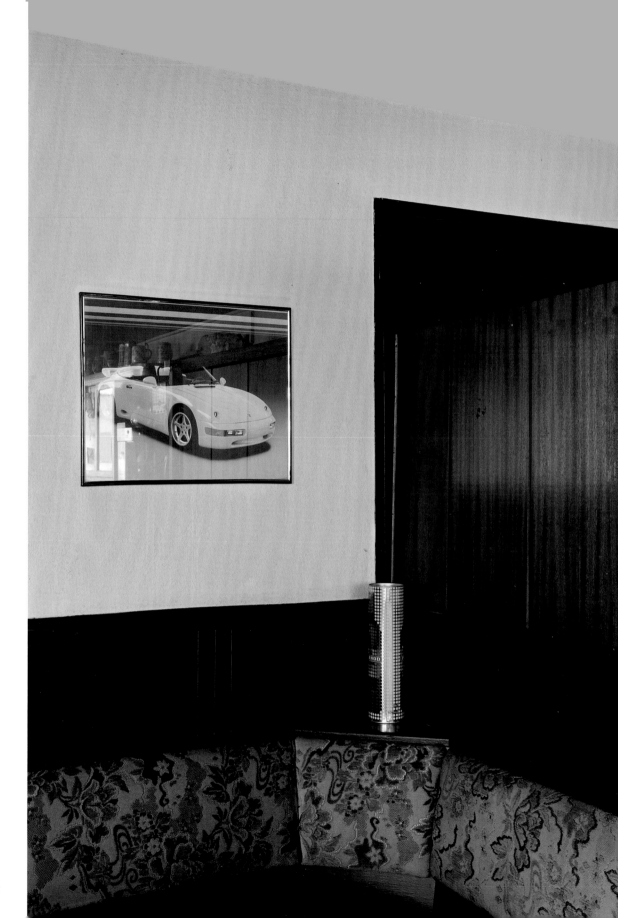

Bei Hanni, Bremen

Richy's, Bremen

Elke's Stübchen, Bremen

Jeden Mittwoch
haben wir erst
ab 16⁰⁰ Uhr
geöffnet.

Klause 38, Bremen

Cumberland Arms 'The Flower House', Liverpool

The Anglesea, Liverpool

The Phoenix, Liverpool

Rob Roy, Liverpool

Gabriele Basilico

Naples + Liverpool

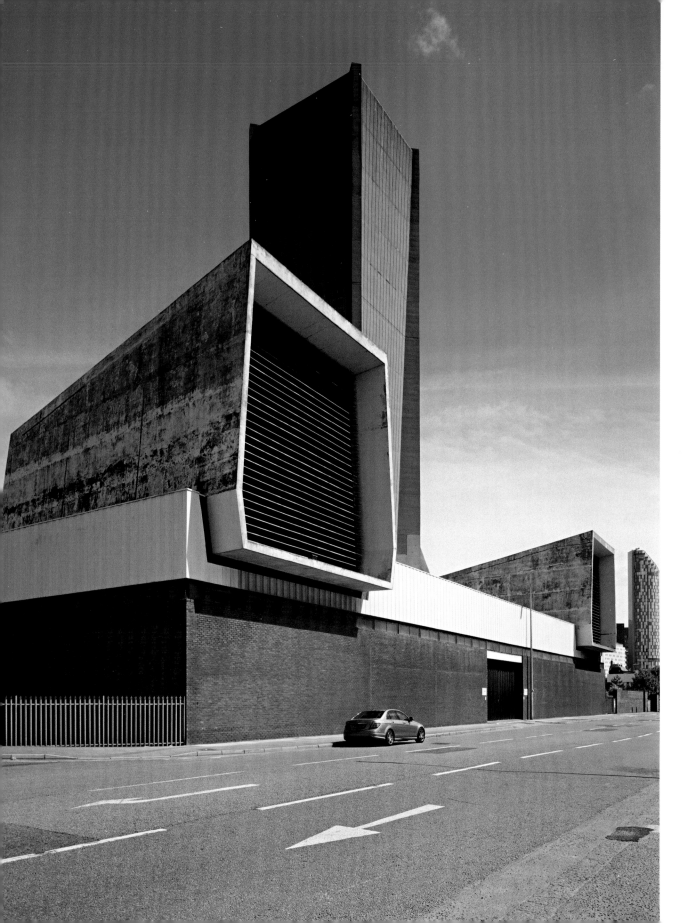

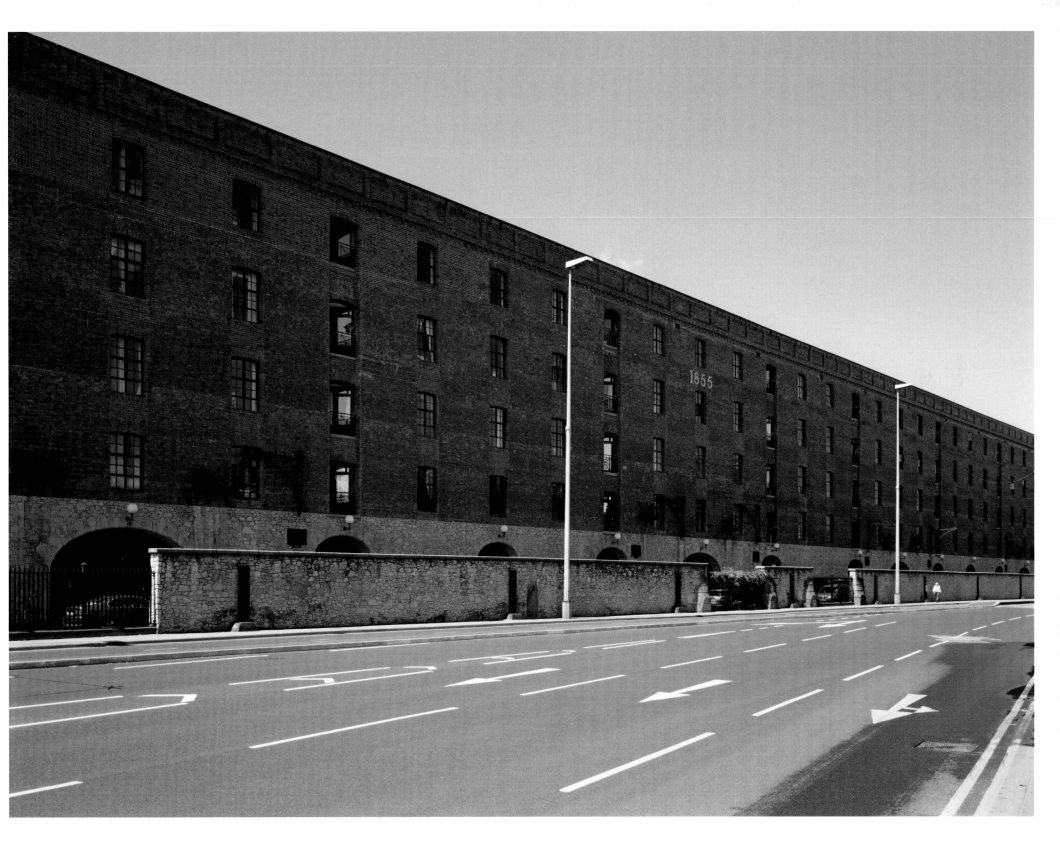

Apartments, Wapping, Liverpool

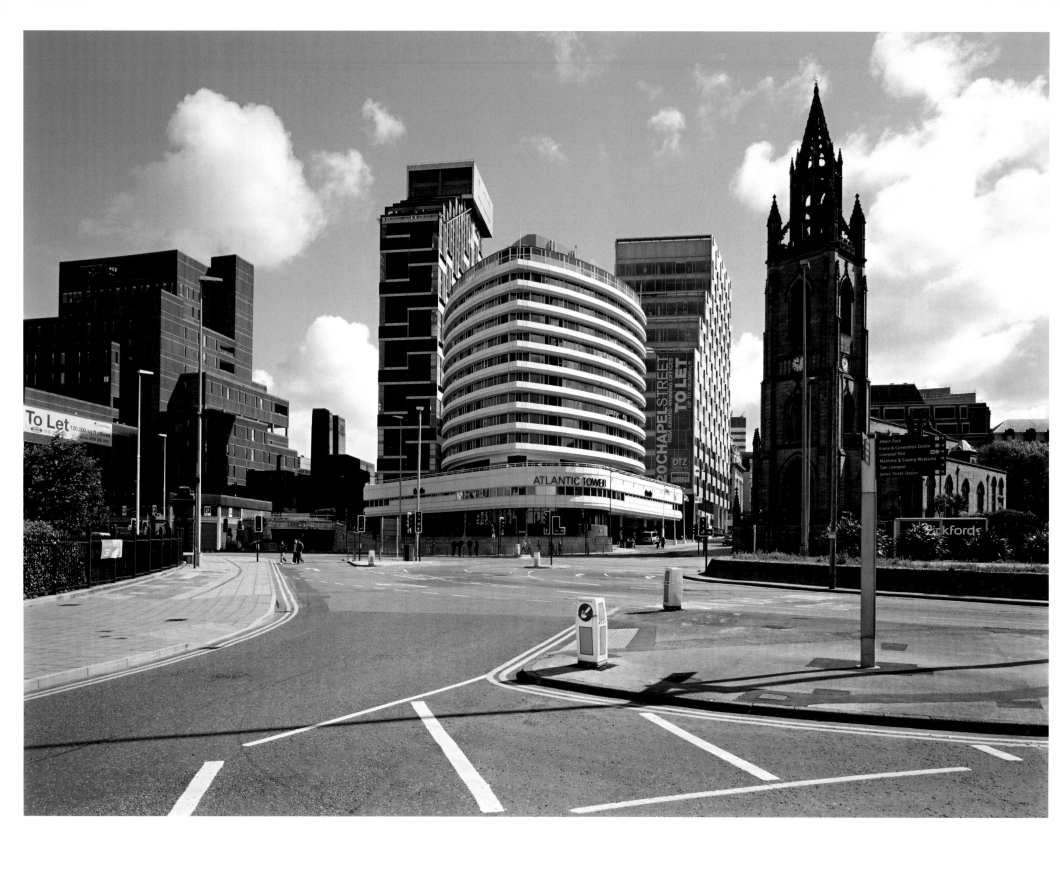

Saint Nicholas Place, Liverpool

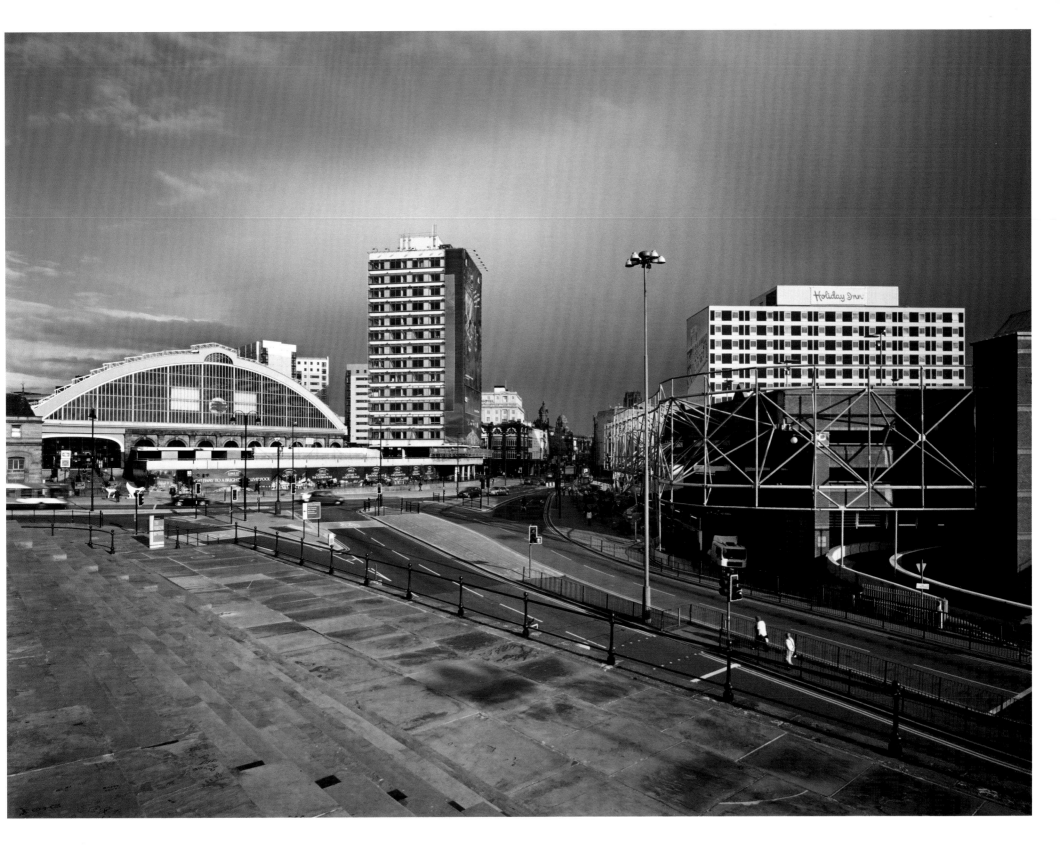

Lime Street, Liverpool

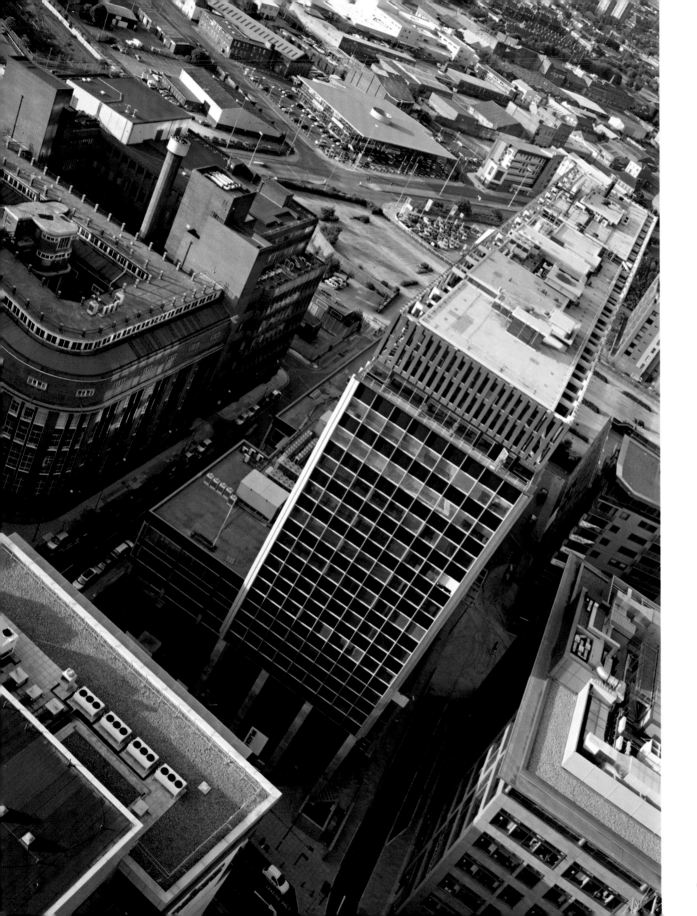

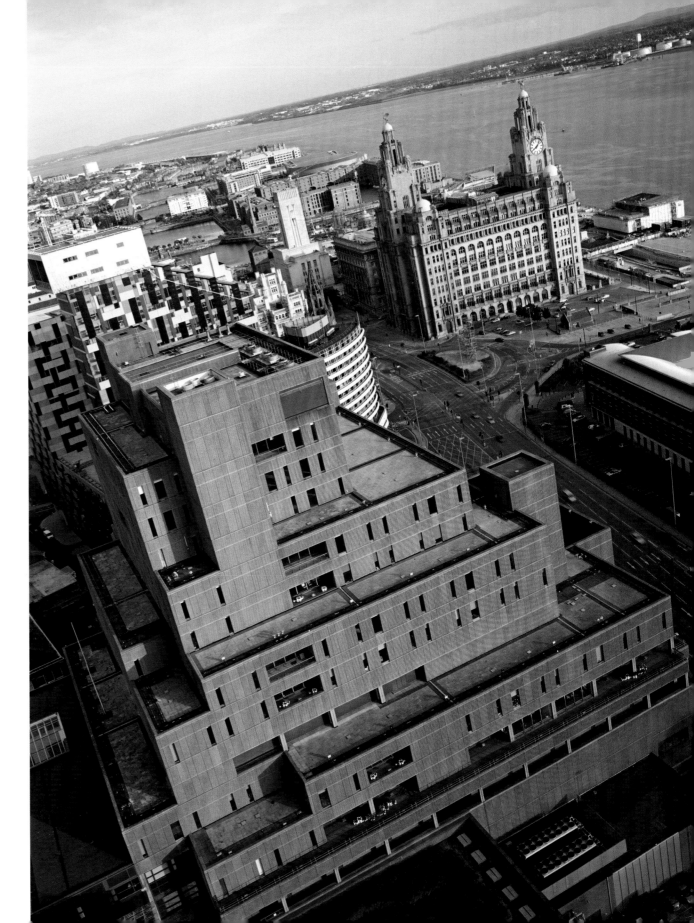

Capital Building, Liverpool

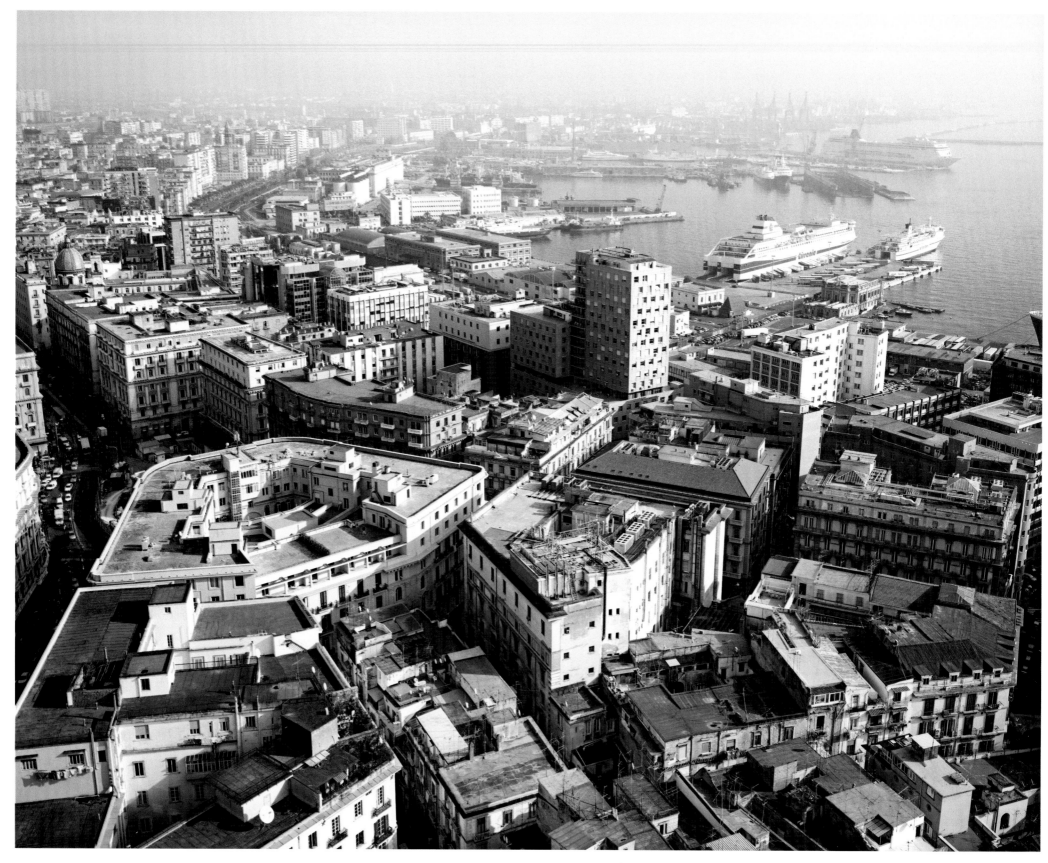

Panoramic view from the Jolly Hotel, Naples

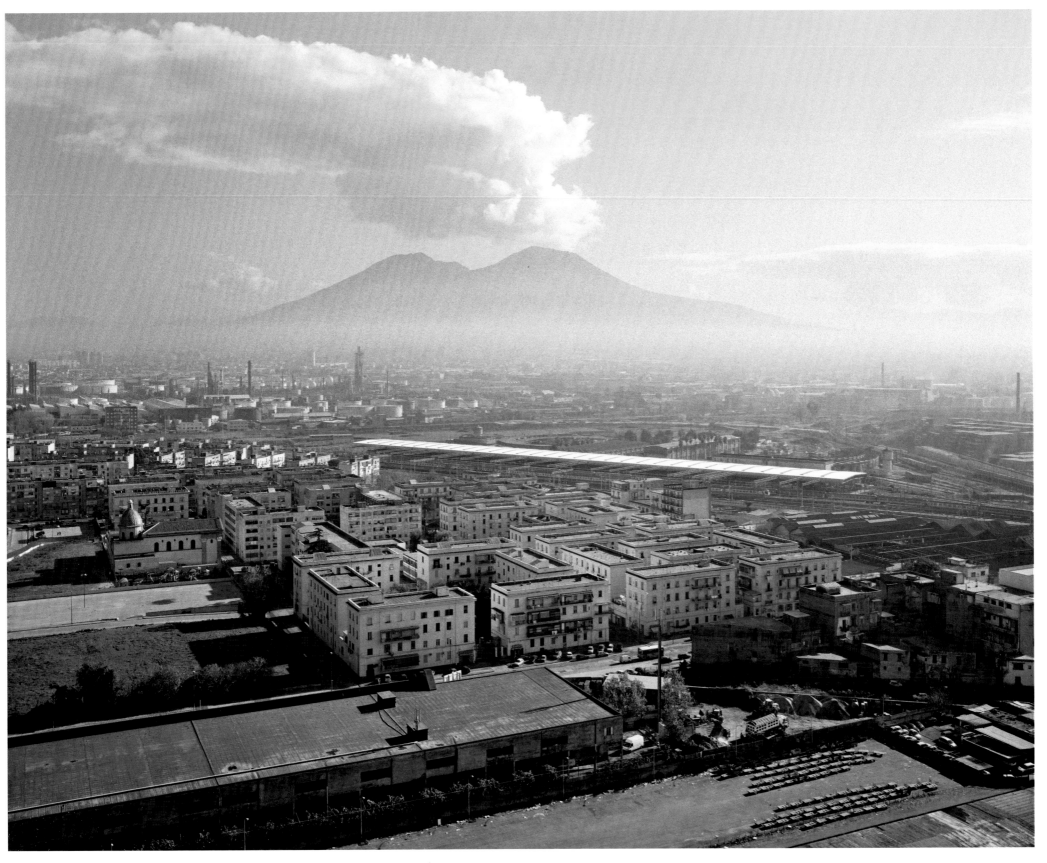

Vesuvius seen from the Centro Direzionale, Naples

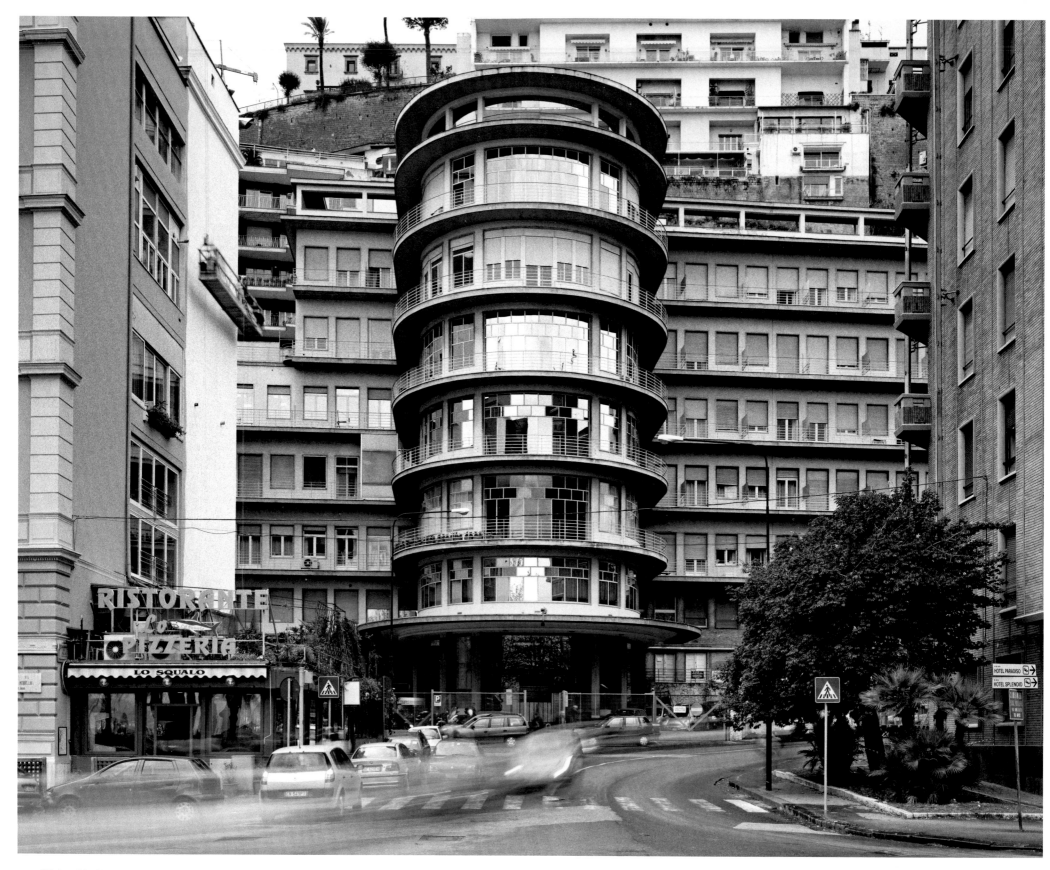

Clinica Mediterranea, via Caracciolo, Naples

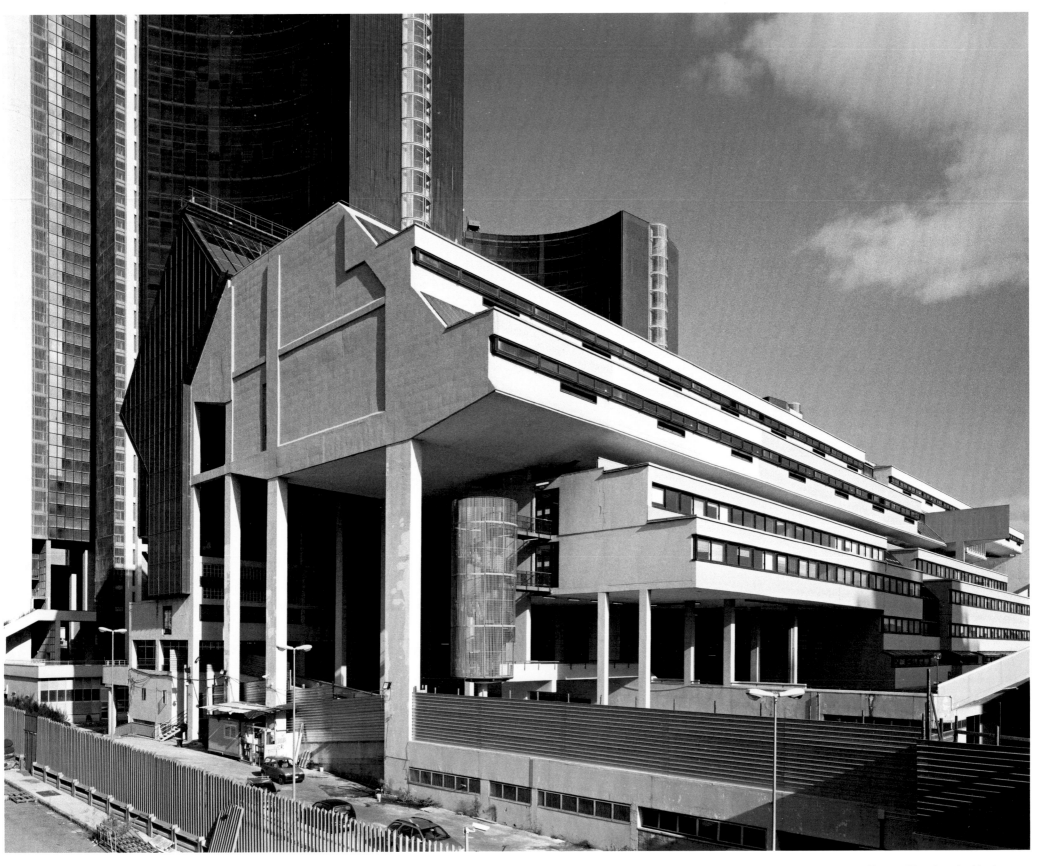

Centro Direzionale, Naples

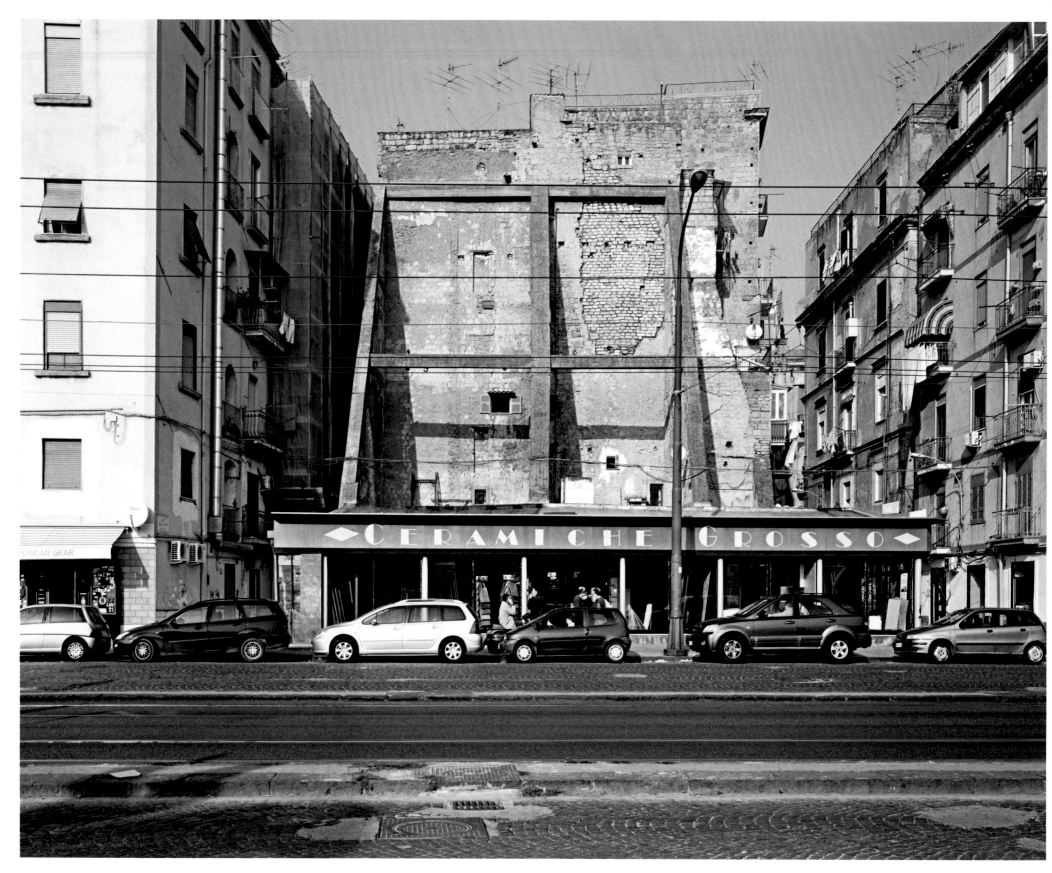

Ceramiche Grosso, via Colombo, Naples

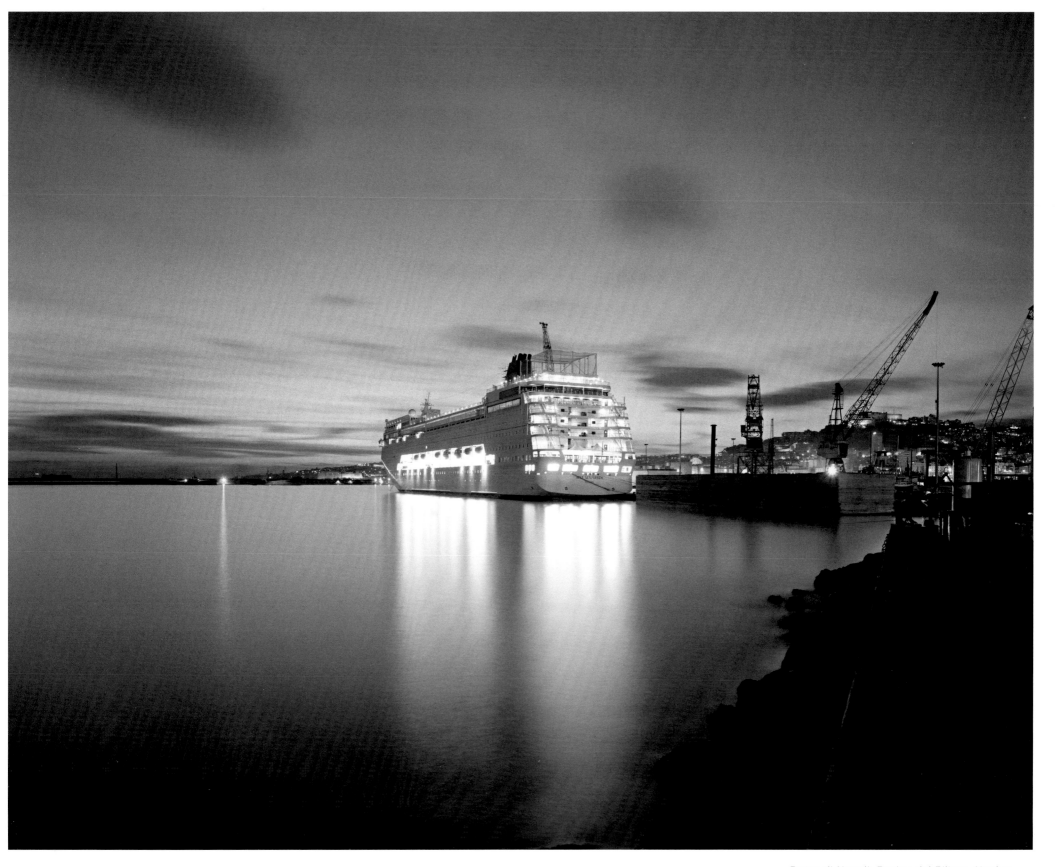

Porto di Napoli, Bacino del Piliero, Naples

John Davies

Liverpool

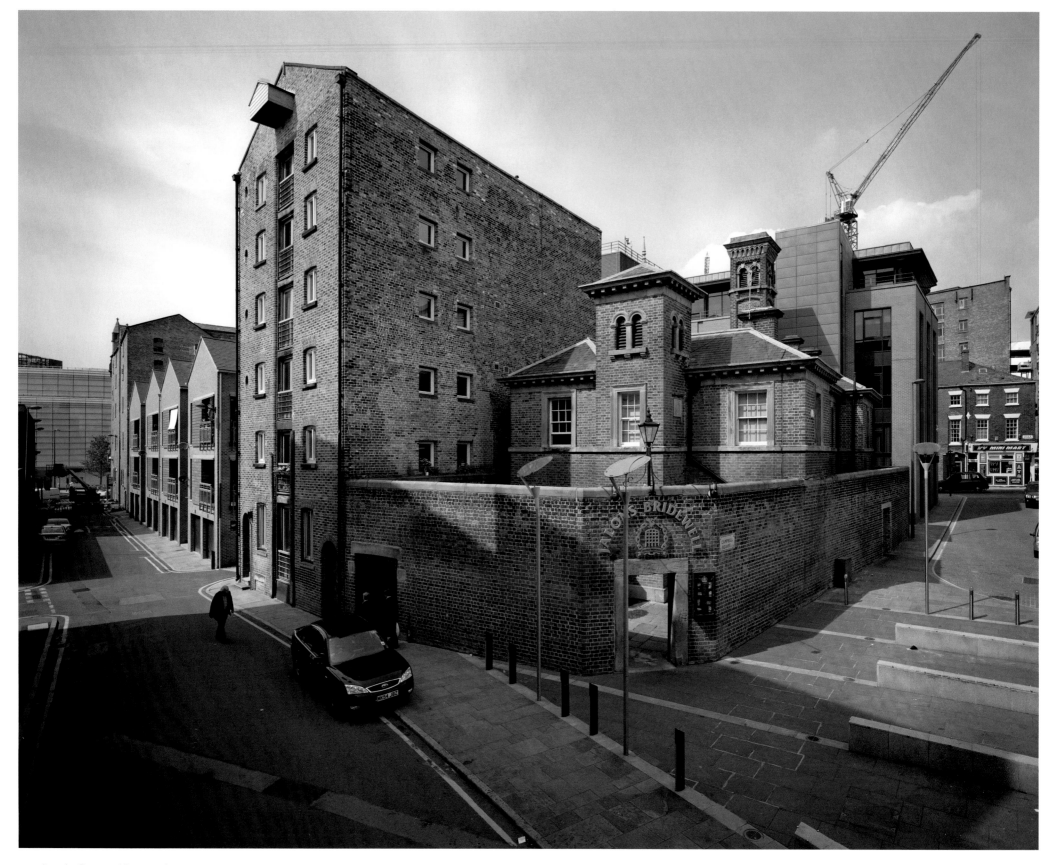

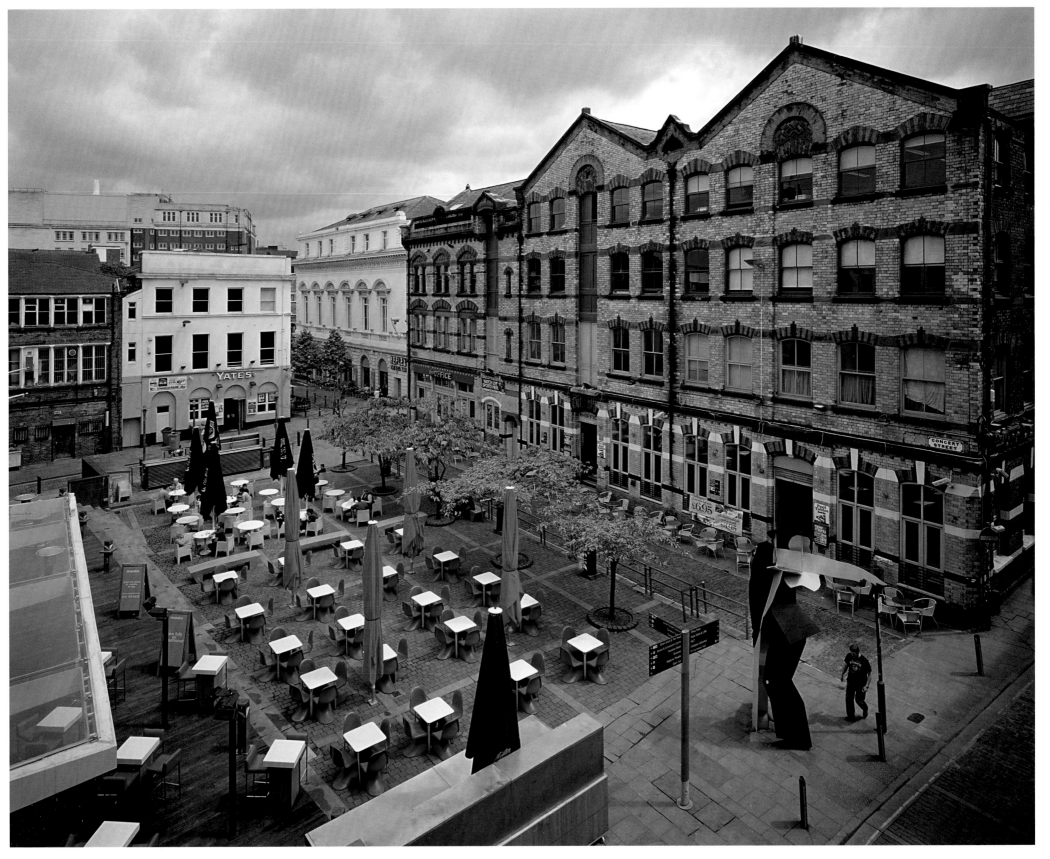

Concert Street, Liverpool

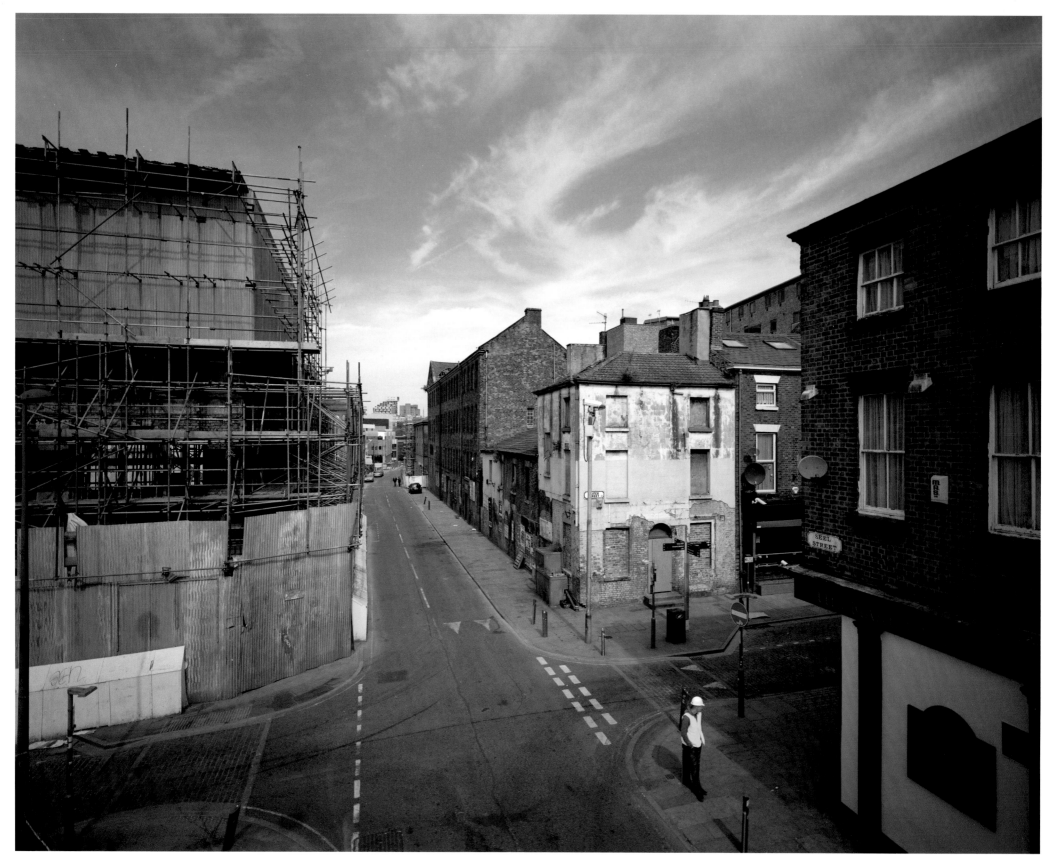

Seel Street, Liverpool

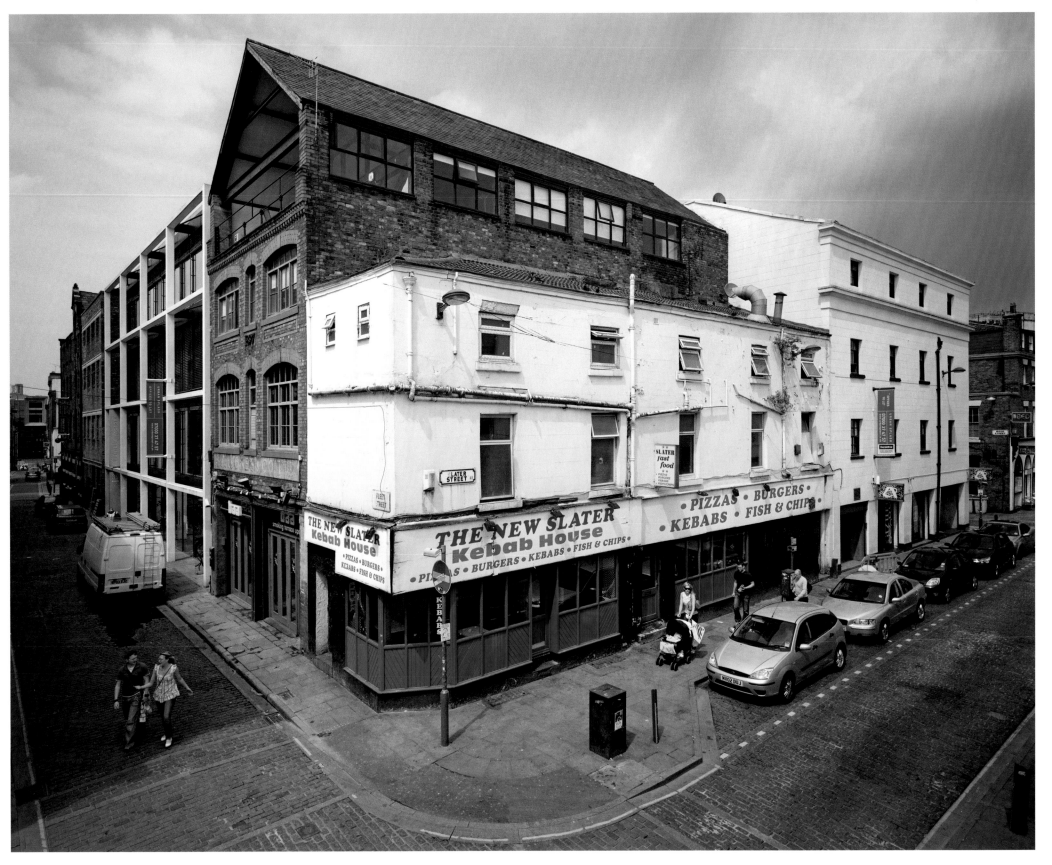

Slater Street, Liverpool

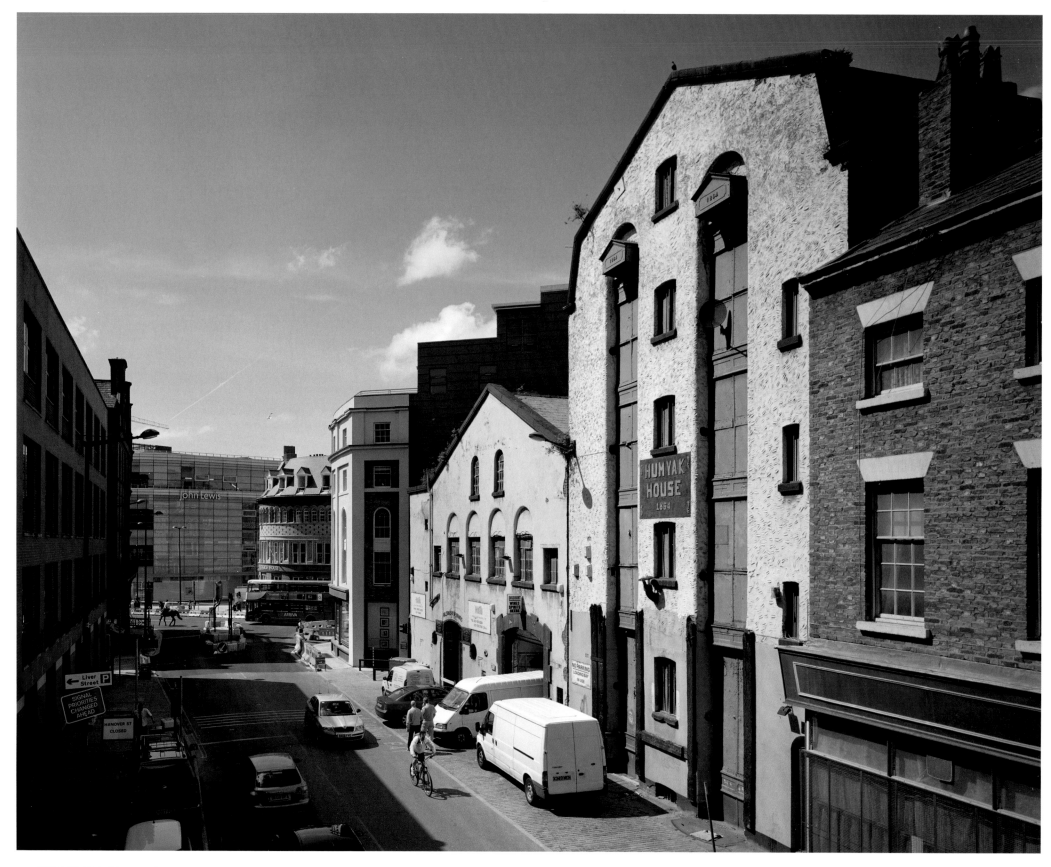

Duke Street, Liverpool

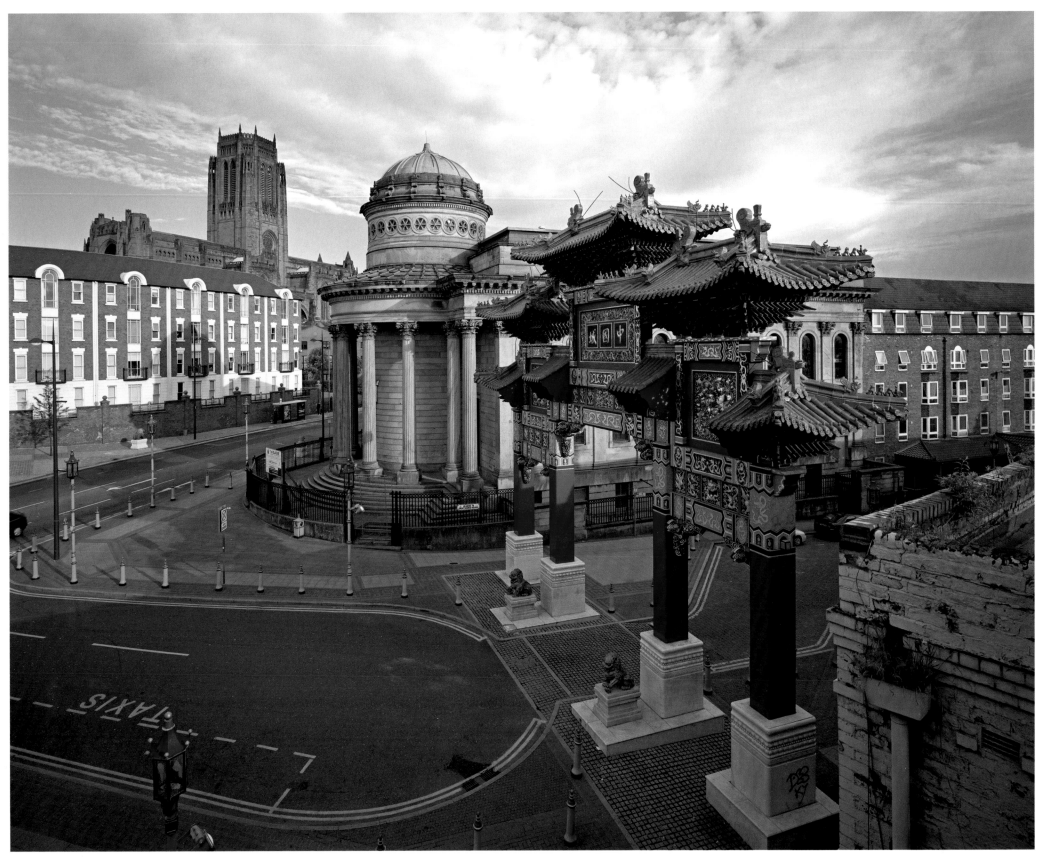

Nelson Street, Liverpool

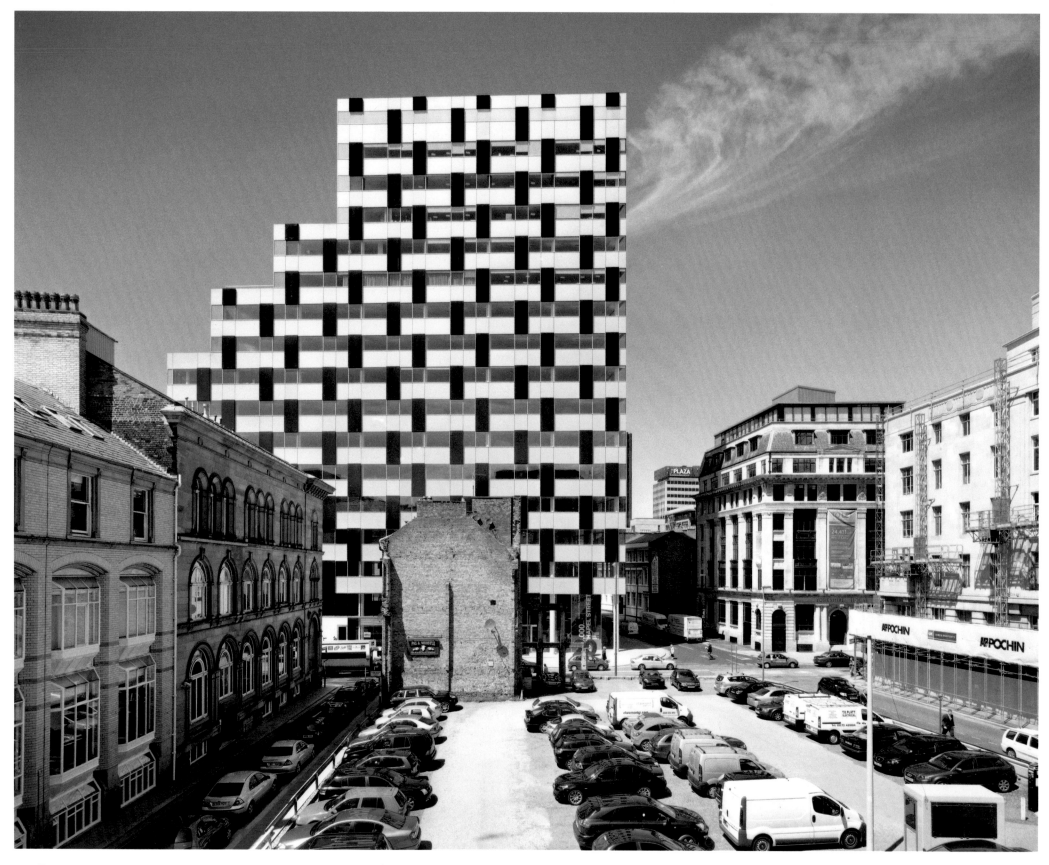

Chapel Street, Liverpool

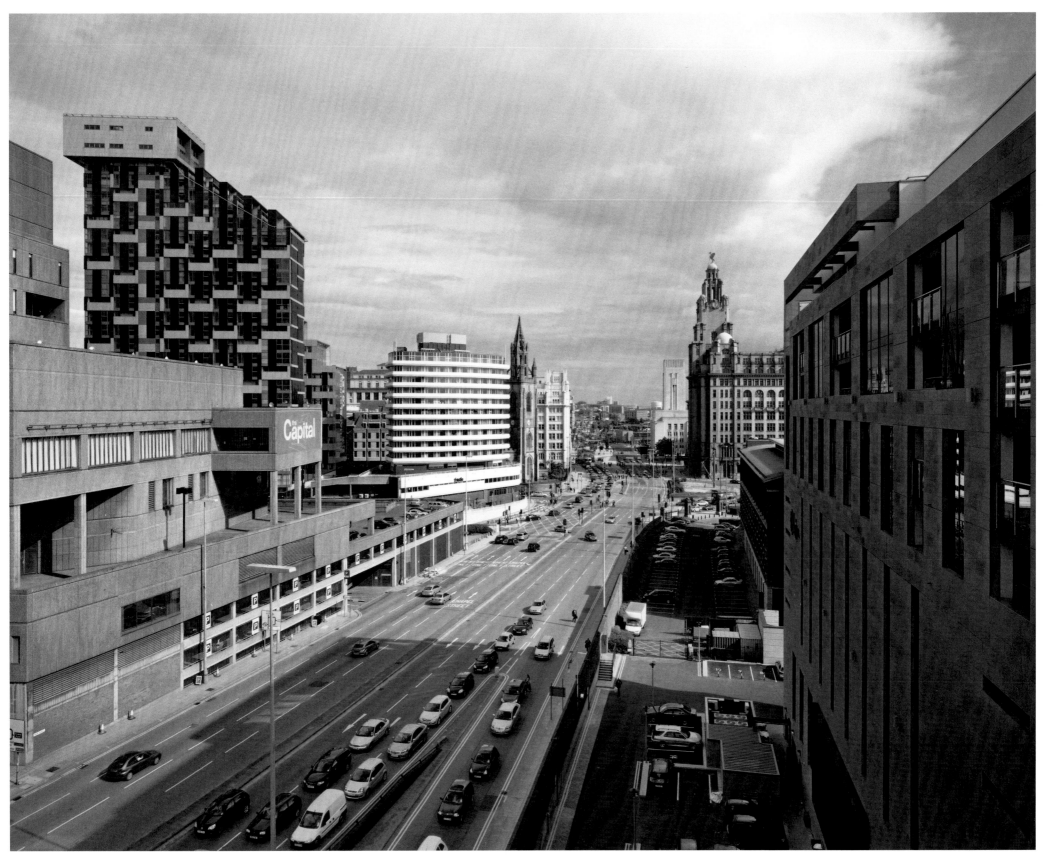

Strand Street, Liverpool

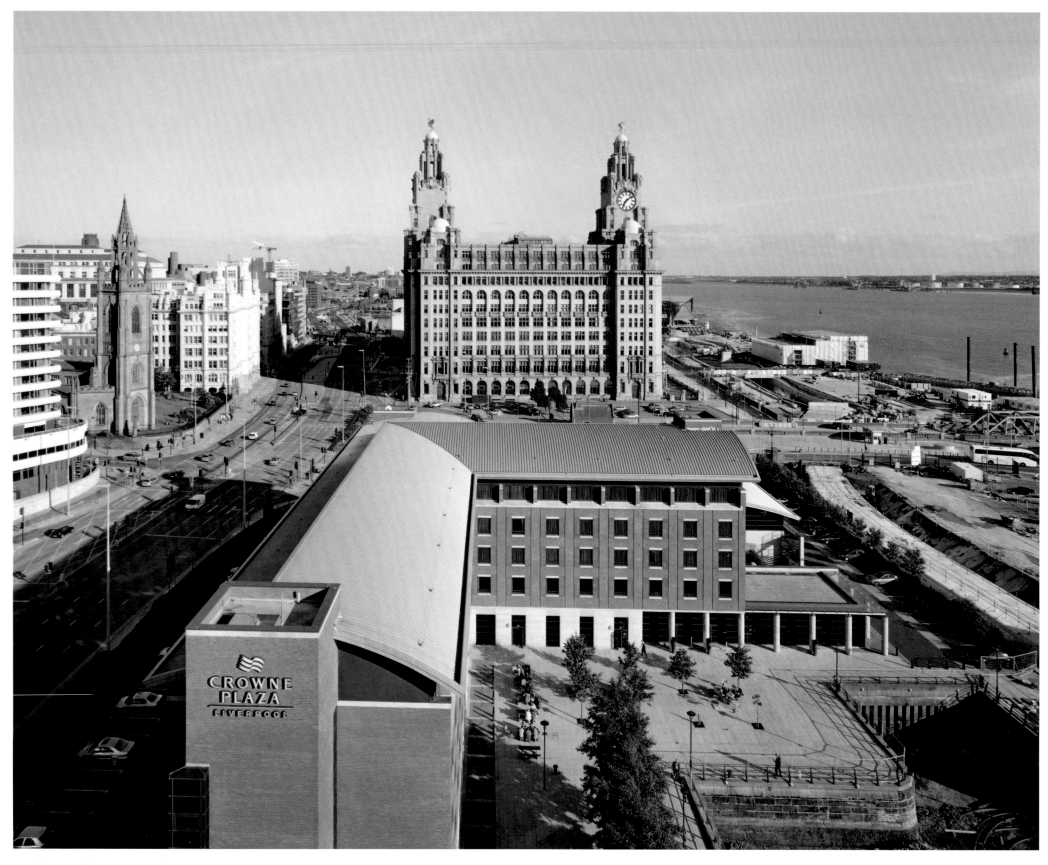

Crowne Plaza, Liverpool

Mann Island, Liverpool

New Hotel, Liverpool One, Liverpool

Chavasse Park, Liverpool One, Liverpool

Photography on the Edge
Franco Bianchini

Artists' biographies

Photography on the Edge

The photographs in this book touch on several of the themes at the centre of 'Cities on the Edge', a cultural co-operation partnership involving local authorities and other urban cultural policy-making organisations in Bremen, Gdańsk Istanbul, Liverpool, Marseilles and Naples. The photographers portray many different aspects of the six cities. These include ethnic and cultural diversity; economic decline, de-industrialisation and regeneration; the privatisation of public space brought about by new shopping malls; the special atmospheres of pubs and bars; the complexity and theatricality of old and new townscapes; the multiple and imaginative ways in which people use and adapt even the most inhospitable urban spaces.

There are important differences between the six Cities on the Edge, in terms of size, age, economic functions and forms of governance, and in many other areas, but they also have several shared characteristics. They are all ports, orientated towards the sea rather than their hinterlands. They often have tense relationships with the centres of political, economic and media power in the capitals of their respective countries. They are famous for an irreverent sense of humour, for their rebelliousness and independence of thought. They have serious problems of crime, litter, unemployment, conflict, and sometimes a tendency to paranoia and victimisation. These issues are in some cases regarded by economic and political elites in their countries as being almost intractable – for example, the protracted rubbish collection and disposal crisis in Naples in 2007 and 2008. However, all six cities also have a strong ability to adapt to adverse circumstances, and to be inventive and resilient.

The six cities are at the edge of their countries and with an edge to their attitude. They share an exceptionally strong sense of their own cultural identity, shaped by influences such as immigration and emigration, and by distinctive religions and political traditions. They are in fact essential to the definition of the cultural identity of their respective countries – through symbols such as the Beatles, Liverpool Football Club, *O Sole Mio* and other Neapolitan songs, the *Marseillaise*, or the Solidarity movement in Gdańsk, led by Lech Walesa.

Because of their importance as ports, all six cities have a cosmopolitan character and histories of intercultural exchange and religious pluralism, with the well-established presence of many foreign origin communities. For example, there are large Turkish communities in Bremen, and Chinese, Ukrainians, Tunisians, Moroccans, Nigerians, Somalis, Sri Lankans and many other ethnic groups in Naples. Multi-ethnicity coexists with problems of racism, and of spatial segregation of minority groups, which in many cases continue to suffer from exclusion from civic life. Specific neighbourhoods – such as the housing estate of Osterholz-Tenever in Bremen, or Toxteth in Liverpool, or the area around Piazza Garibaldi in Naples – have strong concentrations of ethnic minority populations, but their presence in many cases does not visibly shape and influence civic symbols such as public art, museums or the design of the public realm. For example, some critics have argued that the 'Arabic' character of Marseilles – an important component of the city's contemporary identity – is not visible enough in the public realm, in the city's built environment, and in its cultural programming.

There is also an awareness in the six cities of the divergence between buzzing, cleaned up and revitalised city centres and continuing (and in some cases growing) deprivation around the city core. Social polarisation is clearly visible in all six cities. In Bremen, for example, the re-orientation of the local economy towards high technology has not – despite the local authority's efforts – sufficiently benefited the long-term unemployed, immigrants, and the lower skilled among the workforce. In other cases, as in Liverpool, recent growth in employment in the relatively lower skilled and lower paid distribution, hotel and restaurant sectors has not fully addressed problems of economic inequality.

Social divisions are often exacerbated by processes of gentrification in city centres, with the displacement of lower-income residents to more peripheral areas (as in the cases of parts of central Istanbul and Naples, and of the multi-ethnic Belsunce district in Marseilles). There are high levels of multiple (economic, social, cultural and environmental) deprivation in, for example, large areas of north Liverpool, including Anfield, the home of Liverpool FC, one of Europe's wealthiest and most successful football clubs. Similar patterns of deprivation are found in Marseilles' northern quarters (inhabited mainly by people of immigrant origin, principally from Algeria and other North African countries), or in high-rise peripheral housing estates in Naples such as Scampia, where much of the local economy is controlled by the murderous local mafia, the Camorra, which uses part of the estate as a drug dealing market. The renaissance of city centres in the six cities is not systematically accompanied by the provision of good schools, cultural centres and places for

socialisation in low-income inner city and peripheral areas. These places represent edges of deeper social exclusion within the Cities on the Edge.

It is common for travellers – for example Walter Benjamin in Naples in the 1920s – to experience cities such as these as a revelation of the unevenness and interconnectedness of urban problems: a revelation of truths about other places. Naples was defined by Benjamin as 'porous', in an article in the *Frankfurter Zeitung* on 19 August 1925. The description of Naples' 'sponge-like' qualities perhaps applies to aspects of the other Cities on the Edge: it is centred on the idea of a place open to old and new ideas, which is able to absorb and metabolise contradictory elements, a virtual bridge between cultures, a place of intense experiences where boundaries are constantly undermined. There is cruelty, crime and callousness in these cities, but also humanity. There would probably be a lot of potential for other cities to learn from the experiences of the six Cities on the Edge.

In these 'sleepwalking' times – under pressures of conformism and fatalism resulting from a widespread sense of powerlessness (and increasing disaffection with traditional political ideologies and forms of party politics) – the bloody-mindedness and irreverence of these cities can perhaps offer an alternative to the production of ever more dehumanised, bureaucratised, cloned and controlled cities, characterised by the growing privatisation and erosion of public space and of the public sphere. All six cities are, however, under considerable pressure to conform to the imperatives of policies to enhance their international urban competitiveness. Property developers are building new standardised shopping malls, 'high-quality' office blocks and corporate plazas, 'international' hotels, bars and restaurants, and luxury flats in converted warehouses in waterfront locations. These facilities tend to resemble each other – in terms of design and feel – in regenerating cities all over the world, from Brisbane to Barcelona, or from Baltimore to Bilbao. This is, of course, not to deny that urban regeneration strategies are making in many ways a positive contribution to local economies.

The cities in this book still possess some distinctive values and world-views, elements of which can perhaps be discerned in some of the images in this book. Steve Higginson and Tony Wailey, in their *Edgy Cities* pamphlet, rightly observe that port cities are characterised by 'highly erratic and irregular' working patterns, and by a resistance to the rigidities of clock time, which is the dominant organising force of manufacturing cities in the hinterland.[1] Port cities tend to have a fluid, more lunar sense of time, rhythm and movement. This, as Higginson and Wailey point out, is especially true for tidal ports such as Liverpool. These attitudes to time are linked to the spontaneity, fierce independence and reluctance to be disciplined that characterise the people of our six cities.

The Cities on the Edge are articulate and communicative places, where conversation and interaction are important, in pubs and bars especially in Gdańsk, Bremen and Liverpool, and more on the street, in markets, pavement cafés and other outdoor places in Marseilles, Naples and Istanbul. This set of values of the six cities is linked with their hedonism and playfulness, which may in part be related to the tradition of sailors coming on shore to have a good time. There is a culture of physical expressiveness, flamboyance and sensual gratification, as witnessed by the historic importance of red-light districts as places of intense, quick and time-limited pleasure. With their teeming and densely packed streets, parts of central Istanbul or the Spanish Quarters in the historic city centre of Naples, for example, provide an antidote to the prudish fear of contamination by others who are different, visible in the growth of urban 'gated communities' for the wealthy in North America and Europe.

These local world-views could produce less globalised urban policies, which could be more appropriate to the local context but also relevant to other places. Such world-views, however, are often not even acknowledged in the public debate. The intellectual task of linking elements of the popular traditions of these cities to policy debates – to contribute to defining the destiny of these places – has not yet been fully undertaken. Is it possible to turn the 'edgy' qualities of these cities into assets for future urban strategies? Are such qualities being documented, nurtured and protected against the dangers of sanitisation and excessive 'normalisation' which commercially driven cultural tourism strategies tend to produce? One of the challenges for our six cities is indeed to become more 'normal', through improved public services – for example, in health, street cleaning and education – while retaining the irreverent humour, distinct expressiveness and other positive aspects of their 'edginess'. This would require a bold approach that recognises the value of transgressive and subversive traditions as well as the costs and difficulties of them, including of course the problem of how to communicate a strategy of this kind to the public through the media.

The historical dimension of these port cities and their awkwardness and 'unruly genius' relied on the global function of the port, which has changed. So the future of this edginess depends on creating new international linkages that will keep these cities open and ensure an influx of stimulating ideas and people. The Cities on the Edge cultural co-operation project aims precisely to offer a contribution to this new internationalism.

In the past these cities had their own international strategies for trade, which in most cases are now in crisis. All six cities are – to varying degrees – victims of the building of the nation state in their respective countries: for example, the loss of Liverpool's financial, banking, insurance, trade and legal functions to London; the loss of similar service industries in Naples in the nineteenth century after the unification of Italy; and the gradual loss of importance of Marseilles as a key point in the relationship between France and the Southern Mediterranean. In the popular

culture of the six cities the presence of this internationalism can still be felt: think of the international influences shaping their popular music, or of the international following of football clubs such as Liverpool (with a strong fan base especially in Scandinavia and Ireland), Napoli (parts of South America and the USA), Olympique Marseille (Algeria, Senegal and Mali) and the three Istanbul teams (Germany and major cities elsewhere in Europe, including London).

Two preconditions for a new internationalism are that the mindscapes of these cities are open to newcomers and new cultural influences, and that urban policies build on local traditions of hybridity and of progressive cosmopolitanism and openness. There are many examples of good practice in the Cities on the Edge. These range from the much-praised cross-departmental strategy for the integration of ethnic minorities adopted by the City of Bremen, to the opening in 2004 of the Kuumba Imani Millennium Centre in Toxteth, Liverpool (an integrated community and training facility), to the establishment in 2006 of the intercultural centre of via Speranzella, in the Spanish Quarters, in Naples, and the success (in terms of both community development and conflict prevention) of the inter-religious association Marseille Espérance. All six cities are also developing new cultural visions of internationalism, openness and intercultural dialogue. These are very much part of Liverpool's 2008 European Capital of Culture (ECoC) programme, of Istanbul's successful bid for ECoC 2010, and of the candidatures of Marseilles and Gdańsk for the title in 2013 and 2016 respectively. Similarly, Naples has chosen Euro-Mediterranean co-operation, and the dialogue with Islamic countries, as a central theme for the UNESCO-sponsored Universal Forum of Cultures, which the city will host in 2013. Lastly, the Marseille-Provence bid for the 2013 European Capital of Culture also focuses on cultural exchange with Islam, through the *Ateliers de la Méditerranée* concept, and with the following important justification:

[I]t is no longer possible for the geopolitics of development to regard culture lightly. Establishing the means of cultural dialogue and collaboration is made ever more urgent by the prevailing sense of failure concerning the creation of communal and hybridised values and by the fact that the mechanics of identity and religious regression are, more than ever, at work.[2]

Franco Bianchini
Professor of Cultural Policy and Planning, Leeds Metropolitan University
Project Advisor, Cities on the Edge

Acknowledgments

This paper is based in part on a research project on cultural policy and urban change in European port cities, funded by the UK's Arts and Humanities Research Council through an award under their Research Leave scheme (September 2005–April 2006). The information on Bremen is derived mainly from Jörg Plöger, *Bremen. City Report* (London, London School of Economics, Centre for Analysis of Social Exclusion, 2007). I would like to thank Dr Jude Bloomfield for discussing with me some of the ideas contained in this paper.

1 Steve Higginson and Tony Wailey, *Edgy Cities* (Liverpool, Northern Lights, 2006), p. 20.

2 Marseille-Provence 2013, *Marseille-Provence 2013 European Capital of Culture Application* (Marseilles, Marseille-Provence 2013, 2007).

Sınırda Fotoğraflar

Bu kitapta bulunan fotoğraflar, Liverpool, Bremen, Gdańsk, İstanbul, Marsilya ve Napoli'den yerel makamlar ve kent kültür gündemi oluşturan birçok kuruluşla ortaklaşa hazırlanan "Sınırda Şehirler" kültür projesinin odağındaki birçok temayla ilişkilidir. Buradaki fotoğraflar altı şehrin çok çeşitli çehrelerini resmetmektedir. Bunlar arasında etnik ve kültürel çeşitlilik; ekonomik çöküş, endüstriyel faaliyetlerin iptali ve yenilenme; yeni alışveriş merkezleriyle birlikte kamusal alanın özelleştirilmesi; pub ve barların kendine özgü ortamı; eski ve yeni kentten manzaraların tiyatrallik ve karmaşıklığı; en konuksevmez şehir alanına dahi uyum sağlayıp onu binbir yaratıcı şekilde kullanabilen insanoğlu sayılabilir.

Altı sınırda şehrin arasında, boyut, yaş, ekonomik işlev, yönetim şekli ve başka pek çok alanda önemli farklılıklar var, ancak bu şehirlerin paylaştığı bir çok yan da mevcut.

Her biri, hinterland yerine denize yüzünü dönmüş birer liman. Bağlı bulundukları ulusların başkentlerindeki siyasi, ekonomik ve medya merkezleriyle aralarında çoğu zaman gergin bir ilişki var. Riayetsiz espri anlayışları, asilikleri ve başına buyruklukarıyla ünlüler. Suç, çöp, işsizlik, ihtilaf gibi konularda çok ciddi sorunları, bazen de paranoya ve kurbanlaştırmaya uzanabilen bir ruh haline sahipler. Ülkelerinin ekonomik ve siyasi elitleri bu çeşit sorunları zaman zaman neredeyse çözülmesi imkansız gibi görebiliyor – Napoli'de 2007 ve 2008 yıllarında başlayıp sürüncemede kalan çöp toplama ve yok etme krizi gibi. Yine de bu altı şehir olumsuz koşullara uyum sağlama, yaratıcılık ve dayanıklılıkta son derece kabiliyetliler.

Bu altı şehir, ülkelerinde olduğu kadar tavırlarında da sınırdalar. Belirgin dini, siyasi farklılıklarla beraber iç ve dış göç sayesinde oluşmuş kültürel kimlikleri konusunda güçlü bir mefhuma sahipler. Hatta bulundukları ülkelerin kültürel kimliğinin tanımlanmasında – Beatles, Liverpool Football Club, *O Sole Mio* ve diğer Napoliten şarkıları, *Marseillaise* ya da Lech Walsea önderliğinde Gdańsk'ta yürütülmüş Dayanışma Sendikası Hareketi gibi semboller aracılığıyla – zorunlu bir yer tutuyorlar.

Liman olma özelliklerinin getirdiği dini çeşitlilik, kültürlerarası alış-verişte uzun geçmişleri ve göçmenlerin oturduğu çok sayıda mahalleleriyle kozmopolitan bir ruha sahipler. Örneğin Bremen'de geniş Türk mahalleleri veya Napoli'de Çinli, Ukraynalı, Tunuslu, Faslı, Nijeryalı, Somalili, Sri Lankalı ve daha pek çok etnik grubun oluşturduğu topluluklar mevcut. Çok etniklilik ırkçılıkla yan yana varoluyor; sivil hayattan dışlanmış ve dışlanmaya devam eden azınlık grupları mekansal tecrite tabi tutulabiliyor. Bremen'de Osterholz-Tenever, Liverpool'da Toxteth, Napoli'de Piazza Garibaldi'nin çevresi gibi belirli mahalleler yüksek oranda etnik azınlık nüfusu barındırıyor ancak bu gruplar sanat, müzeler gibi kamu sembolleri ya da kamusal alanların biçimlendirilmesinde görünür herhangi bir etkide bulunmayabiliyor. Örneğin bazı eleştirmenler Marsilya'nın – çağdaş kültürünün oluşumunda önemli pay sahibi – 'Arap' ruhunun, şehrin mamur çevresinde, kamusal alanlarında ve kültürel kodlamasında yeterince görülür olmadığını öne sürüyor.

Altı şehir de, temizlenmiş, yenilenmiş ve capcanlı merkezleriyle, sürekli bir yoksunluk hali içinde yaşayan (bazı durumlarda büyümeye devam eden) şehir merkezinin çevresi arasında büyüyen ayrımın da farkında. Altı şehrin her birinde toplumsal kutuplaşma apaçık belli bir olgu. Bremen'de örneğin, yerel ekonominin ileri teknolojiye yönelmesinin – yerel makamların çabalarına rağmen – işgücü dahilindeki uzun süreli işsiz, göçmen ve düşük vasıflı işçilere yeteri kadar faydası dokunmamıştır. Bir başka örnek olan Liverpool'da düşük vasıf gerektiren ve az ücret veren dağıtım, hotel ve restorant sektörlerinde yakın zamanda görülen büyümeye rağmen, ekonomik eşitsizlik sorunları yeterince duyurulamamıştır.

Toplumsal ayrılıklar çoğu kez şehir merkezlerinde yapılandırılan centrifikasyon süreçleri sonucu düşük seviyede gelir gruplarının çevrelere itilmesiyle şiddetlenir (İstanbul ve Napoli'nin bazı kesimleri ve Marsilya'nın çok etnikli mahallesi Belsunce'de olduğu gibi). Örneğin Avrupa'nın en zengin ve en başarılı futbol kulüplerinden Liverpool FC'nin evi Anfield ve kuzey Liverpool'da birçok mahalle çok çeşitli konularda (ekonomik, toplumsal, kültürel ve çevresel) ileri seviyede yoksulluk çekmektedir. Benzer bir yoksulluk, Marsilya'nın (çoğunlukla Cezayir ve diğer Kuzey Afrika ülkelerinden göçmen olarak gelmiş insanların yaşadığı) kuzey mahallelerinde de görülmektedir; ya da Napoli'de merkezin etrafında yapılanmış toplu konut gökdelenlerinin olduğu ve bölgeyi uyuşturucu ticareti için bir pazar olarak kullanan kanlı yerel mafya *Camorra*'nın neredeyse ekonominin tamamını kontrol altında tuttuğu Scampi'de olduğu gibi. Altı şehrin merkezlerinde gerçekleşen rönesans, düşük gelir gruplarının oturduğu merkez ve çevre mahallelerinde beraberinde sistemli olarak kaliteli okullar, kültürel merkezler ve sosyalleşme alanlarını getirmemiştir. Bu tür alanlar Sınırda Şehirler içinde daha da derin bir toplumsal dışlanmaya tanıklık eden kıyıları oluşturur.

Gezginlerin – Napoli'ye 1920'lerde gelen Walter Benjamin gibi örneğin – bu tarz şehirleri, kent yaşamının yarattığı sorunların, eşitsizlik ve

birbirine bağımlılığının açığa vurulması olarak deneyimlemeleri sıkça rastlanan bir olgudur: başka yerlere ait gerçeklerin açığa vurulması gibi. Benjamin 19 Ağustos 1925'te *Frankfurter Zeitung*'da çıkan bir makalesinde Napoli'yi 'gözenekli' diye tarif etmişti. Napoli'nin bu 'süngerimsi' yapısı belki diğer Sınırda Şehirlere de uyarlanabilir: bu tarifin odağında, yeni ve eski fikirlere açık olmaları, çelişen unsurları özümseyip hazmedebilmeleri, kültürler arasında sanal bir köprü vazifesi görmeleri ve sürekli sınırları sarsan deneyimlerin yaşanabileceği mekanlar olmaları bulunmaktadır. Bu şehirlerde zulüm, suç ve duyarsızlık vardır, ama aynı zamanda bolca insanlık da bulunur. Bu altı Sınırda Şehrin deneyimlerinin, başka şehirlerin onlardan öğrenebileceği bir çok olasılık sunduğunu düşünüyorum.

Yaygın bir güçsüzlük hissinden (ve geleneksel siyasi ideoloji ve parti politikalarına duyulan antipatinin gitgide artmasından) doğan konformizm ve kaderciliğin baskılarıyla şekillenen bu "uyurgezer" zamanlarda, bu şehirlerin riayetsiz ve aksi tavırları, kamusal alan ve sahaların özelleştirmelerle erozyona uğramasıyla tanımlanan insanlık-dışı, bürokrasiye yenik düşmüş, klonlanmışçasına birbirine benzeyen ve sürekli denetlenen şehirlerine bir alternatif oluşturabilir. Ancak bu altı şehrin her biri, uluslararası kentsel rekabet içerisinde yerlerini sağlamlaştırabilmek için tasarlanmış politikaların buyruklarının hatırı sayılır baskısı altındadır. Şehir planlamacılar yeni tek tip alışveriş merkezleri, "üstün nitelikli" ofis blokları ve plazalar, "uluslararası" hotel, bar ve restoranlar inşa ediyor ve yalıboyu mekanlarda bulunan depoları lüks dairelere dönüştürüyorlar. Bu tesisler, Brisbane'den Barselona'ya veya Baltimor'dan Bilbao'ya yenilenmekte olan tüm şehirlerde –tasarım ve duygu açısından- birbirlerine benzeme eğilimi gösteriyorlar. Tabii burada kentsel yenilenme stratejilerinin yerel ekonomiye bir çok yönden olumlu katkıları olduğunu da yadsımamak gerekir.

Bu kitaptaki şehirler, fotoğraflarının da belki gösterdiği gibi, hala belirgin bir değer dizisi ve dünya görüşüne sahip. "Sinirli Şehirler"

risalesinde Steve Higginson ve Tony Vailey, liman şehirlerinin, hinterland'ın üretici şehirlerinin egemen yapılandırıcı gücü olan saat zamanının esnemezliğine direnişine ve 'son derece düzensiz ve karışık' çalışma yapısına dikkat çeker.[1] Liman şehirlerinin zaman, ritm ve hareketinde ay zamanına benzer bir yan vardır; akışkan olma eğilimi gösterirler. Higginson ve Wailey'e göre bu durum Liverpool gibi gelgitsel limanlar için özellikle geçerlidir. Zamana karşı alınan bu tavır, altı şehrimizin insanlarını niteleyen doğaçlamacı, dikbaşlı ve bağımsızlığına düşkün, denetime ayak direyen özelliklerine birebir bağlıdır.

Sınırda Şehirler muhabbet ve iletişimin önemli olduğu konuşkan ve samimi mekanlardır. Gdańsk, Bremen ve Liverpool'da özellikle pub ve barlarda, Marsilya, Napoli ve İstanbul'daysa sokak, pazar, kahve ve diğer açık hava mekanlarında bunu görmek mümkündür. Altı şehri birbirine bağlayan bu değerler dizisi, belki de kısmen denizcilerin eğlence için karaya çıkmaları geleneğinin bir devamı olarak hedonizm ve oyunbazlıkla ilişkilidir. Buralarda yoğun, hızlı ve zaman tarafından kısıtlanmış hazların mekanı olarak fahişeler mahallesinin tarihi öneminin tanıklık yaptığı gibi, bir fiziksel dışavurum, ihtişam ve bedensel doyum kültürü hakimdir. Fıkır fıkır kaynayan sıkış tıkış sokaklarıyla İstanbul'un bazı merkezi bölgeleri veya Napoli'nin tarihi merkezinde bulunan İspanyol Mahallesi, Kuzey Amerika ve Avrupa zenginlerinin rağbet ettiği 'güvenlikli site'lerin yayılmasıyla görülen farklı olanın kirleteceği düşüncesine bir panzehir oluşturmaktadır.

Bu kendine özgü dünya görüşleri, yerel bağlamına uygun olduğu kadar başka yerlere de yararlı olup, küreselleşmeden daha az etkilenmiş kentsel politikaların oluşturulmasına kaynaklık edebilir. Ancak ne yazık ki kamusal tartışmalarda dahi bu tarz dünya görüşlerinin esamesi okunmamaktadır. Bu şehirlerin popüler geleneklerini politik tartışmalara eklemlendirme – ve bu şehirlerin kaderini tanımlamada söz sahibi olma – yolunda gereken entelektüel çalışmalara henüz girişilmemiştir. Bu şehirlerin 'sınırda'

özelliklerini geleceğin şehirleşme stratejileri adına bir kazanca dönüştürmek mümkün olabilecek mi? Ticari kaygılarla tasarlanan kültürel turizm stratejilerinin uygulamada eğilim gösterdiği ölçüsüz 'normalizasyon' ve aşırı temizleme olgularının tehlikelerine karşı bu özellikler belgeleniyor, korunuyor ve geliştiriliyor mu? Gerçekten de altı şehrimizin sorunlarından bir tanesi, kamu hizmetleri – örneğin sağlık, temizlik ve eğitim gibi – ıslahatlar yoluyla 'normalleştirilirken', dikbaşlı mizacı, kendine özgü ifade biçimleri ve diğer 'sınırda' özelliklerinin korunmasıdır. Böylesi bir çaba, kentin saldırgan ve yıkıcı geleneklerinin yol açtığı masraf ve zorlukların yanı sıra, aynı geleneklerin ürettiği değerleri de tanımaya ve böyle bir stratejiyi medya aracılığıyla halka yaymanın yollarını arayan cesur bir yaklaşıma ihtiyaç duyar.

Bu liman şehirlerinin tarihi boyutu, uyumsuzluğu ve 'serkeş dehası', bugün artık değişmiş olan limanların küresel işlevlerine yaslanıyordu. Dolayısıyla 'sınırdalık' halinin muhafaza edilmesi, bu şehirlerin ufuk açıcı yeni fikir ve insanların akışını kolaylaştıracak yeni uluslararası bağlantılar kurulmasıyla yakından illintilidir. Sınırda Şehirler kültürel yardımlaşma projesi işte tam da bu yeni uluslararasıcılığa bir katkıda bulunmayı hedeflemektedir.

Bugün çoğunluğu bir buhran geçirmekte olsa da geçmişte bu şehirlerin kendilerine özgü bir uluslararası ticaret stratejileri vardı. Altı şehrin her biri – farklı kademelerde de olsa – bulundukları ülkelerin ulus-devlet inşa sürecinin kurbanı olmuşlardır: örneğin Liverpool'un finans, bankacılık, sigorta, ticaret ve hukuk işlevlerinin Londra'ya kaydırılması; 19. Yüzyılda İtalya'nın birleşmesinden sonra Napoli'deki hizmet sektörünün benzer bir kaderle karşılaşması; ve Marsilya'nın Fransa ve Güney Akdeniz ilişkisinde sahip olduğu kilit rolün yavaş yavaş yokolması hep bu duruma örnek teşkil eder. Ancak altı şehrimizin popüler kültüründe bu uluslararasıcılığın varlığını hala hissetmek mümkün: Popüler müziklerini şekillendiren uluslararası etkileri, yahut spor kulüplerinin uluslarası taraftar kitlelerini – Liverpool (özellikle İskandinavya ve

İrlanda da konuşlanmış güçlü bir kitle), Napoli (Güney Amerika ve ABD'de belli bölgeler), Olympique Marseilles (Cezayir, Senegal ve Mali) ve İstanbul'un üç takımı (Almanya ve Londra dahil Avrupa'nın belli başlı şehirleri) gibi – bir düşünün.

Yeni bir uluslararasıcılık için iki önkoşul bu şehirlerdeki zihniyetin yeni gelenlere ve kültürel etkilere açık olması ve kentsel politikaların melez yerel gelenekler, yenilikçi kozmopolitanizm ve şeffaflık üzerine inşa edilmesi olarak görülebilir. Sınırda Şehirler arasında böyle uygulamaların örneklerine bolca rastlamak mümkün. Bunların arasında Bremen tarafından etnik azınlıkların bütünleşmesi için tasarlanan bölümler arası stratejinin benimsenmesi, Liverpool'un Toxteth bölgesinde 2004'te açılan Kuumba Imani Millenium Centre (bütünleşik mahalle ve eğitim tesisi), Napoli'nin İspanyol Mahallesi'nde Speranzella caddesi üzerinde 2006'da açılan kültürlerarası diyalog merkezi ve dinlerarası diyalog üzerine bir kuruluş olan Marseille Espérance'ın (hem mahalli gelişim hem de uyuşmazlık önleme açılarından) büyük başarısı sayılabilir. Aynı zamanda altı şehrin her biri şeffaflık, kültürlerarası diyalog ve uluslararasıcılıkta yeni bir kültürel vizyon oluşturma yolunda ilerliyorlar. Liverpool'un 2008 Avrupa Kültür Başkenti (EcoC) programı, İstanbul'un EcoC 2010 teşebbüsünde başarısı, 2013 ve 2016'da sırasıyla Marsilya ve Gdańsk'ın adaylıkları hep bu yönde çalışmaların bir parçasıdır. Benzer şekilde Napoli, Avrupa-Akdeniz yardımlaşmasını seçerek 2013'te UNESCO sponsorluğunda gerçekleşecek olan İslam Ülkeleri Evrensel Forum'una ev sahipliği yapmaya karar vermiştir. Son olarak Marseille-Provence'ın 2013 Avrupa Kültür Başkenti için teklifi de *Ateliers de la Méditerranée* (Akdeniz Atölyeleri) konseptiyle İslam diniyle kültürel alışveriş üzerine, aşağıda yer alan önemli gerekçenin ışığında yoğunlaşmaktadır.

Şehirleşme siyaset ve iktisadı artık kültürün etkisini göz ardı edemeyecek durumdadır. Kimliksel ve dini işlevlerde gerilemenin daha önce olmadığı kadar çok ortaya çıkması, ortak ve melez değerlerin oluşturulmasında başarısızlık hissinin giderek artıyor oluşu kültürel diyalog ve yardımlaşma yöntemlerinin oluşturulmasını acil ve zorunlu kılmaktadır.[2]

Franco Bianchini
Kültürel Siyaset ve Planlama Profesörü, Leeds Metropolitan University
Proje Danışmanı, Sınırda Şehirler

Teşekkür

Bu makale B.K.'ın Arts and Humanities Research Council (Sanat ve Beşeri Bilimler Araştırma Kurultayı) tarafından Araştırma İzni (Eylül 2005 – Nisan 2006) adı altında verdiği ödülün finanse ettiği, Avrupa liman şehirlerinde kültürel siyaset ve kentsel değişim konulu araştırma projesinin bir kısmını oluşturmaktadır. Bremen hakkında bilgiler çoğunlukla Jörg Plöger'in *Bremen. City Report* (Bremen. Şehir raporu)'undan derlenmiştir (London, London School of Economics, Centre for Analysis of Social Exclusion, 2007). Bu makalede yer alan bazı fikirler üzerine yaptığımız tartışmalar için Dr. Jude Bloomfield'e teşekkürlerimi sunarım.

1 Steve Higginson ve Tony Wailey, *Edgy Cities* (Liverpool, Northern Lights, 2006), 20.

2 Marseille-Provence 2013, *Marseille-Provence 2013 European Capital of Culture Application* (Marseilles, Marseille-Provence 2013, 2007).

La photographie des marges

Les photographies du présent ouvrage tracent certaines lignes de force de «Cities on the Edge» («Villes en marge»), un partenariat de coopération culturelle auquel participent les pouvoirs locaux et d'autres opérateurs urbains qui contribuent à la création de la politique culturelle de Brême, Gdańsk, Istanbul, Liverpool, Marseille, et Naples. Leurs créateurs y dévoilent plusieurs attributs des six villes: diversité ethnique et culturelle, stagnation économique, désindustrialisation et régénération, privatisation de l'espace public afin de construire de nouveaux centres commerciaux, ambiance particulière des «pubs» et des bars, complexité et caractère théâtral des paysages urbains anciens et nouveaux, modalités multiples et créatrices de l'utilisation et de l'adaptation par leurs habitants des espaces urbains, même les moins accueillants.

Des différences considérables séparent les six «villes en marge» : leur importance géographique, leur âge, leur fonction économique et leur système gouvernemental, entre autres; mais elles partagent aussi certaines caractéristiques. Ce sont sans exception des villes portuaires, orientées vers la mer plutôt que vers leur arrière-pays. Leurs relations avec la capitale de leur pays, centre du pouvoir politique, économique et médiatique, sont souvent tendues. Elles sont connues pour leur humour irrévérencieux, ainsi que leur attitude rebelle et leur pensée indépendante. Elles ont des problèmes sérieux en ce qui concerne le crime, le traitement des déchets, le chômage, le conflit, et parfois elles ont tendance à la paranoïa et à la victimisation. Certaines de ces questions sont considérées comme presque intraitables par les élites économiques et politiques – par exemple la crise prolongée de la collection et de l'élimination des ordures des années 2007 et 2008 à Naples. Pourtant, elles ont toutes les six la forte capacité de s'adapter aux circonstances défavorables, de se montrer inventives, et de ne pas se laisser abattre.

Les six villes sont doublement des «villes en marge». Construites dans un espace marginal, là où la terre et la mer se rencontrent, elles partagent aussi un état d'esprit provocateur, avant-gardiste. Chacune a le sentiment particulièrement aigu de sa propre identité culturelle, forgée par l'influence de l'immigration et de l'émigration, et par des religions et des traditions politiques particulières. Elles jouent en fait un rôle essentiel dans l'identité culturelle de leur pays, à travers les symboles des Beatles, de Liverpool Football Club, d'*O Sole Mio* et d'autres chansons napolitaines, de la *Marseillaise*, ou bien du mouvement syndicaliste Solidarité à Gdańsk, sous Lech Walesa.

Villes portuaires importantes, les six villes partenaires partagent un caractère cosmopolite et une histoire d'échanges interculturels et de pluralisme religieux. Plusieurs communautés d'origine étrangères y sont installées depuis longtemps. Par exemple, de grandes communautés turques se sont installées à Brême, et la ville de Naples accueille Chinois, Ukrainiens, Tunisiens, Marocains, Nigériens, Somalis, Sri Lankais, et plusieurs autres groupes ethniques. La multiplicité ethnique s'accompagne des problèmes de racisme et de la ségrégation socio-spatiale de groupes minoritaires, qui, dans maints cas, restent encore exclus de la vie civique. Certains quartiers – tels la cité d'Osterholz-Tenever à Brême, le quartier de Toxteth à Liverpool, où les alentours de la Piazza Garibaldi à Naples – ont de fortes densités de minorités ethniques, mais la présence de celles-ci n'a souvent pas d'influence visible sur les symboles civiques tels que l'art publique, les musées, ou la planification du domaine public. A titre d'exemple, certains critiques ont soutenu que les qualités «arabes» de Marseille – aspect important de l'identité contemporaine de la ville – ne se manifestent suffisamment ni dans le domaine public, ni dans le milieu construit de la ville, ni dans son programme culturel.

Ces villes partagent aussi la conscience du contraste entre leurs centres bourdonnants, propres, et revitalisés, et les quartiers toujours défavorisés qui les entourent, dont certains vont en se dégradant. La polarisation sociale est manifeste chez toutes les six. À Brême, par exemple, la réorientation de l'économie régionale vers la haute technologie n'a porté assez d'avantages – malgré les efforts de la municipalité – ni aux chômeurs de longue durée, ni aux immigrées, ni aux moins diplômés parmi les travailleurs. Dans d'autres cas, comme à Liverpool, l'augmentation récente des emplois dans les secteurs de la distribution, de l'hôtellerie, et de la restauration (secteurs où les effectifs sont moins qualifiés et les salaires sont moins élevés) ne répond pas entièrement aux problèmes d'inégalité économique.

Les divisions sociales sont souvent exacerbées par un processus d'embourgeoisement au cœur des villes, ce qui déplace les habitants aux revenus modestes vers les quartiers périphériques (tel est le cas dans certains quartiers du centre d'Istanbul et de Naples, et au quartier multiethnique de Belsunce à Marseille). Les privations (économiques, sociales, culturelles, et celles qui sont liées à l'environnement) se multiplient, par exemple, dans un secteur assez vaste du nord de Liverpool, et pourtant cette zone abrite le stade d'Anfield, siège

de Liverpool FC, l'un des clubs les plus richissimes et prestigieux de l'Europe. Ce modèle se voit reproduit dans les quartiers nord de Marseille (dont la plupart des habitants sont des immigrées, venant surtout de l'Algérie et des autres pays du Maghreb), ou dans les gratte-ciels sur la périphérie de Naples, comme par exemple à Scampia, où un pourcentage assez important de l'économie locale est contrôlé par la mafia meurtrière du coin, la Camorra, qui a transformé une partie de la cité en marché aux drogues. La renaissance des centres dans les six villes ne s'accompagne pas systématiquement de la mise en place de bonnes écoles, de centres culturels, ou de lieux de rencontre et de socialisation dans les quartiers populaires du centre-ville et de la périphérie. Ces secteurs deviennent des marges d'exclusion sociale plus profonde à l'intérieur des «villes en marge».

Souvent ce genre de ville provoque une révélation dans l'esprit du voyageur – par exemple dans celui de Walter Benjamin à Naples pendant les années vingt – qui s'étonne de la diversité et de l'enchevêtrement des problèmes urbains. Révelation de vérités dans des lieux étrangers. Dans un article du *Frankfurter Zeitung* du 19 août 1925, Benjamin qualifia l'architecture de Naples de «poreuse». Sa description des qualités «éponges» de Naples conviendrait peut-être aussi bien à certains aspects des autres «villes en marge». Elle est basée sur la notion d'un lieu ouvert aux idées, aussi bien anciennes que nouvelles, capable d'absorber et de métaboliser des éléments contradictoires, servant de pont virtuel entre cultures et de lieu d'expériences intenses où les limites sont constamment entamées. Dans ces villes on rencontre de la cruauté, de la criminalité, et de l'indifférence, mais aussi l'humanité. Il y a de fortes chances pour que les six «villes en marge» servent d'exemple à d'autres villes.

Nous vivons actuellement une époque «somnambule», poussés vers le conformisme et le fatalisme par un sentiment répandu d'impuissance (et une désaffection croissante par rapport aux idéologies politiques classiques

et à la politique politicienne). Or, le sale caractère de ces villes et leur manque de respect pour les convenances fourniront peut-être la réponse au problème des villes de plus en plus déshumanisées, bureaucratisées, clonées, et contrôlées, dont les caractéristiques sont une privatisation croissante et une diminution de l'espace et de la fonction publics. Toutes les six se sentent pourtant fortement contraintes de se plier aux demandes d'une politique qui rehausserait leur compétitivité internationale. Les promoteurs immobiliers construisent des centres commerciaux uniformisés, des immeubles de bureaux «haut de gamme», des complexes multifonctionnels «prestiges», des hôtels, des bars et des restaurants «internationaux», et des appartements de luxe dans d'anciens entrepôts au bord de l'eau. Ces installations ont tendance à se ressembler toutes – par leur dessin et par leur ambiance – dans les villes qui se régénèrent partout dans le monde, de Brisbane à Barcelone, où bien de Baltimore à Bilbao. Cela dit, nous ne nions bien sûr pas la contribution positive aux économies régionales des stratégies de régénération urbaine.

Les villes traitées ici jouissent toujours de certaines valeurs et visions du monde qui ont gardé leur caractère propre, dont on repérera peut-être quelques éléments dans les images qui suivent. Steve Higginson et Tony Wailey, dans leur plaquette *Edgy Cities* font la remarque très juste que les villes portuaires se caractérisent par des modèles d'emploi «extrêmement imprévisibles et irréguliers», et par une résistance aux rigidités temporelles du pointage, force organisatrice dominante des villes industrielles de l'arrière-pays.[1] La notion du temps, du rythme et du mouvement des villes portuaires est plutôt fluide, lunatique. Comme le soulignent Higginson et Wailey, cela est d'autant plus vrai pour les ports qui ont des marées, comme Liverpool. Ces notions du temps sont liées à la spontanéité, à l'indépendance féroce, et à l'hostilité à la discipline qui caractérisent les habitants des six villes.

Les «villes en marge» ont la parole facile, ce sont des lieux de communication, où la conversation et l'interaction sont primées, dans «les pubs» et les bars de Gdańsk, de Brême et de Liverpool, surtout, et encore dans la rue, dans les marchés, dans les cafés et dans les autres lieux de rencontre en plein air à Marseille, à Naples et à Istanbul. Cet ensemble de valeurs des six villes est lié à leur côté hédoniste et ludique, dû en partie à la tradition des matelots qui débarquent pour se distraire. Elles partagent une culture de l'expressivité physique, de la flamboyance, et de la satisfaction des sens, attestée par l'importance historique de leurs quartiers chauds, lieux de plaisir intense, rapide, et limité par le temps. Avec leurs rues animées et grouillantes, certains quartiers du centre d'Istanbul, ou les Quartiers Espagnols de Naples, par exemple, fournissent un antidote à la peur pudique d'être contaminé par ceux qui sont différents, peur qui se manifeste dans l'augmentation des *gated communities*, des communautés aisées qui se barricadent derrière des enclos, protégées par des portiers, en Amérique du Nord et en Europe.

Les visions du monde de ces villes pourraient engendrer des politiques urbaines moins globalisées, qui conviendraient mieux à leurs contextes spécifiques, mais qui pourraient aussi s'appliquer à d'autres villes. De telles visions, cependant, ne sont souvent même pas reconnues dans le débat public. La tâche intellectuelle de l'intégration des éléments de la tradition populaire de ces villes aux discussions stratégiques – contribuant ainsi à la définition du destin de ces lieux – n'est pas encore entièrement accomplie. Peut-on transformer les qualités «marginales» de ces villes en atouts pour les stratégies urbaines de l'avenir? De telles qualités, sont-elles actuellement documentées, nourries, et protégées contre les dangers de l'aseptisation et de la «normalisation» qui sont d'habitude les conséquences des stratégies de tourisme culturelles à but lucratif? L'un des défis auxquels nos six villes font face serait, effectivement, de trouver le moyen de se plier davantage aux normes en travaillant à

améliorer leur administration publique –les services de santé, le nettoyage des rues, ou l'éducation, par exemple – tout en retenant leur humour irrévérencieux, leur expressivité distincte, et les autres aspects positifs de leur «marginalité». Une telle démarche exigerait une approche audacieuse, qui saurait reconnaître à la fois la valeur des traditions transgressives et subversives, les sacrifices qu'elles nécessitent, et les difficultés qu'elles provoquent, y compris, bien sûr, le problème d'une communication clair et efficace auprès du public d'une telle stratégie en se servant des grands médias.

La dimension historique des ces villes portuaires, leur caractère difficile, et leur «génie incontrôlable» dépendaient de la fonction globale du port, dont la logique n'est plus la même. L'avenir de leur «marginalité» novatrice dépendra, donc, de la création de nouveaux liens internationaux qui assureront leur ouverture sur le monde ainsi que l'afflux d'idées et de personnes dynamisantes. Le partenariat culturel de «Cities on the Edge» cherche précisément à contribuer à cette nouvelle internationalisme.

Dans le passé chaque ville élaborait sa propre stratégie commerciale internationale, dont la plupart maintenant sont en état de crise. Toutes les six sont – plus ou moins – victimes de la construction de l'état nation dans leurs pays respectifs: par exemple, le déplacement des fonctions financières, banquières, des assurances, commerciales, et juridiques, de Liverpool à Londres, la disparition des industries de service analogues de Naples au dix-neuvième siècle lors de l'unification de l'Italie, et la diminution progressive du rôle de Marseille comme lieu privilégié de rencontre entre la France et la Méditerranée du Sud. Dans la culture populaire des six villes partenaires, la présence de cet internationalisme se fait toujours sentir: citons les influences internationales sur leur musique populaire, ou bien les supporters internationaux des clubs de foot de Liverpool (avec une forte proportion de Scandinaves et d'Irlandais), de Naples (dans

certains des pays de l'Amérique du Sud et aux États-Unis) l'Olympîque de Marseille (en Algérie, au Sénégal, et au Mali), et les trois équipes d'Istanbul (en Allemagne, et dans de grandes villes de l'Europe, y compris Londres).

Deux pré-conditions à remplir pour un nouvel internationalisme: que les esprits de ces villes s'ouvrent aux nouveaux venus et aux influences culturelles nouvelles, et que les dirigeants de la planification urbaine acceptent comme données de base la mixité culturelle et le cosmopolitisme ouvert et progressiste traditionnels des habitants. Les bonnes pratiques sont nombreuses dans les «villes en marge». A titre d'exemple: la collaboration louée des services de la Ville de Brême à la création d'une stratégie pour l'intégration des minorités ethniques, l'ouverture en 2004 du Centre Millénaire Kuumba Imani à Toxteth, Liverpool (qui a la fonction double de centre communautaire et de centre d'entraînement), la mise en place en 2006 du centre culturelle de la via Sperenzella dans les Quartiers Espagnols de Naples, et le succès (sur le plan du développement communautaire et de la prévention du conflit) du groupement interreligieux Marseille Espérance. Les six villes cherchent aussi à promouvoir de nouvelles visions culturelles de l'internationalisme, de l'ouverture, et du dialogue interculturel. Ces visions participent pleinement au programme de Capitale Européenne de la Culture 2008 de Liverpool, à la réussite d'Istanbul, lauréat du concours de 2010, et aux candidatures de Marseille et de Gdańsk pour les années 2013 et 2016. De même, la coopération euro-méditerranéenne ainsi que le dialogue avec les pays islamistes, seront comptés parmi les thèmes abordés par le Forum Universel des Cultures (soutenu par l'UNESCO) dont Naples sera le siège en 2013. Enfin, le projet de candidature au titre de Capitale Européenne de la Culture Marseille-Provence 2013 prône aussi le dialogue interculturel avec l'Islam, l'un des piliers du projet «Les ateliers de l'Euroméditerranée», au sujet duquel il propose l'explication importante suivante:

Aucune géopolitique de développement ne peut faire désormais l'économie de la culture. La mise en place d'armes culturelles de dialogue et de collaboration est d'autant plus urgente que le sentiment prévaut d'un échec dans la construction de valeurs communes et métissées, que la mécanique identitaire et les régressions religieuses sont plus que jamais à l'œuvre.[2]

Franco Bianchini
Professeur des politiques culturelles et urbaines, Université de Leeds Metropolitan
Conseiller du projet, «Cities on the Edge»

Remerciements

Cet essai est extrait, en partie, d'un projet de recherche sur les programmes culturels et l'évolution urbaine dans les villes portuaires européennes. Ce projet a reçu le soutien de l'Arts and Humanities Research Council britannique (programme de bourses de congé sabbatique, septembre 2005 – avril 2006). La plupart des détails sur Brême viennent de Plöger, Jörg, *Bremen. City Report* (Londres, London School of Economics, Centre for Analysis of Social Exclusion, 2007). Je tiens à remercier aussi Madame Jude Bloomfield pour ses commentaires sur certaines propositions ci-dessus.

1 Steve Higginson et Tony Wailey, *Edgy Cities* (Liverpool, Northern Lights, 2006), p. 20.

2 Marseille-Provence 2013, «Le partage des midis : un axe international et méditerranéen», *Marseille-Provence 2013 capitale européenne de la culture : candidature* (Marseille, 2007, www.marseille-provence2013.fr).

Zamieszczone w niniejszym zbiorze fotografie traktują o wielu zagadnieniach leżących u podstaw projektu „Miasta na Brzegu" – partnerskiego programu podjętego przez władze lokalne i inne organizacje odpowiedzialne za politykę kulturalną w Bremie, Gdańsku, Liverpoolu, Marsylii, Neapolu i Stambule. Fotografowie portretują różne aspekty funkcjonowania tych sześciu miast: ich etniczną i kulturową różnorodność; regres ekonomiczny, dezindustrializację i rekultywację; prywatyzację przestrzeni publicznej (do czego walnie przyczynia się powstawanie nowych centrów handlowych); wyjątkową atmosferę pubów i barów; złożoność i teatralność zarówno starego, jak i nowego pejzażu miejskiego; wielość sposobów i kreatywność adaptacji nawet najbardziej nieprzyjaznych przestrzeni miasta do potrzeb zamieszkujących ich ludzi.

„Miasta na Brzegu" znacznie różnią się między sobą wielkością, wiekiem, funkcjami ekonomicznymi, formami zarządzania i wieloma innymi cechami. Z drugiej strony, istnieje między nimi cały szereg podobieństw: są to miasta portowe otwarte bardziej na morze niż na ląd. Stosunki z centrami władzy politycznej i ekonomicznej oraz mediami ulokowanymi w stolicach ich krajów często pozostają napięte. Miasta słyną z nieokiełznanego poczucia humoru, buntowniczości i niezależności myśli. Doświadczają poważnych problemów z przestępczością, utylizacją odpadów, bezrobociem, lokalnymi antagonizmami; nie są im też obce tendencje do paranoi i wiktymizacji. Wiele z ich problemów uznawanych jest przez ekonomiczne i polityczne elity danego kraju za niemalże nierozwiązywalne (np. przedłużający się kryzys związany ze zbiórką i wywozem śmieci w Neapolu). Cała szóstka wykazuje się jednakże dużą

zdolnością adaptacji do niekorzystnych warunków oraz hartem ducha i inwencją.

Sześć miast usytuowanych „na brzegu" swych krajów charakteryzuje się wyrazistością postaw. Mają one wyjątkowo silne poczucie własnej tożsamości kulturowej, która została ukształtowana przez takie czynniki, jak migracje czy głęboko zakorzenione tradycje religijne i polityczne. Symbole takie jak zespół the Beatles, klub piłkarski FC Liverpool, *O Sole Mio* i inne pieśni neapolitańskie, Marsylianka czy też kierowany przez Lecha Wałęsę, wywodzący się z Gdańska ruch „Solidarność", nadały im charakter elementów w zasadniczy sposób określających kulturową tożsamość swych krajów.

Portowy charakter nadał całej szóstce kosmopolityczne oblicze; z niego wywodzi się również bogata historia wymiany międzykulturowej, pluralizm religijny oraz fakt istnienia licznych osiadłych społeczności o obcym rodowodzie. Bremę, dla przykładu, zamieszkuje liczna społeczność turecka, Neapol zaś – Chińczycy, Ukraińcy, Tunezyjczycy, Marokańczycy, Nigeryjczycy, Somalijczycy, Lankijczycy i wiele innych grup etnicznych. Zjawisko wielokulturowości sąsiaduje z takimi problemami, jak rasizm i przestrzenna izolacja grup mniejszościowych, które w wielu wypadkach cierpią z powodu wykluczenia z życia publicznego. Istnieją obszary – jak np. osiedle Osterholz-Tenever w Bremie, dzielnica Toxteth w Liverpoolu, czy okolice Piazza Garibaldi w Neapolu – o znacznej koncentracji mniejszości etnicznych, lecz ich obecność w wielu wypadkach ani nie kształtuje, ani w widoczny sposób nie wpływa na takie przejawy obywatelskiej aktywności, jak sztuka w miejscach publicznych, muzea czy kształtowanie przestrzeni publicznej. Jako przykład

niechaj posłuży Marsylia, której „arabski" charakter – istotny element współczesnej tożsamości miasta – nie jest, według krytyków, wystarczająco widoczny ani w przestrzeni publicznej, ani w środowisku miasta, ani w jego ofercie kulturalnej.

W miastach tych istnieje również świadomość rozziewu pomiędzy tętniącymi życiem, czystymi i zrewitalizowanymi centrami a utrzymującą się (a w niektórych przypadkach rozszerzającą się) strefą ubóstwa otaczającą śródmieście. Społeczna polaryzacja wyraźnie widoczna jest w całej szóstce. Np. w Bremie, pomimo wysiłków podejmowanych przez władze lokalne, przestawienie lokalnej gospodarki na zaawansowane technologie nie przyniosło wymiernych korzyści długotrwale bezrobotnym, imigrantom oraz grupom najgorzej wykształconym. W innych przypadkach – np. w Liverpoolu – widoczny ostatnio wzrost zatrudnienia w stosunkowo nisko opłacanych i niewymagających wysokich kwalifikacji sektorach, takich jak dystrybucja, hotelarstwo i gastronomia, nie stał się antidotum na problemy nierówności ekonomicznej.

Zachodzące w centrach miast procesy podnoszenia standardu nieruchomości często zaogniają podziały społeczne, wypychając mieszkańców o niższych dochodach na peryferie miast (jak ma to miejsce w centralnych częściach Stambułu i Neapolu oraz w wieloetnicznej dzielnicy Marsylii – Belsunce). Wysoki jest poziom ubóstwa w jego licznych formach: ekonomicznej, społecznej, kulturowej i środowiskowej (dotyczy to dużych obszarów północnego Liverpoolu, w tym w dzielnicy Anfield, gdzie ma swoją siedzibę FC Liverpool, jeden z najsłynniejszych i najbogatszych klubów piłkarskich w Europie). Podobny model biedy odnaleźć można w północnych dzielnicach Marsylii (zamieszkanych

głównie przez rodziny imigrantów z Algierii i innych krajów Afryki Północnej) lub w Neapolu, w peryferyjnych blokowiskach takich jak Scampia, w których znaczna część lokalnej gospodarki znajduje się pod kontrolą camorry, lokalnej mafii wykorzystującej część osiedla jako miejsce handlu narkotykami. Renesansowi centrów sześciu miast nie towarzyszy poprawa stanu szkolnictwa, czy budowa ośrodków kultury i miejsc społecznej integracji w zaniedbanych częściach śródmieścia i na peryferiach miast. Te miejsca wyznaczają w „Miastach na Brzegu" granice głębszego wykluczenia społecznego.

Wizyta w takich miastach nierzadko otwiera podróżnikowi oczy na nieregularność i złożoność miejskich uwarunkowań; objawia prawdę dotyczącą innych miejsc. Tak stało się np. z Walterem Benjaminem, który gościł w Neapolu w latach dwudziestych XX w. W artykule zamieszczonym we *Frankfurter Zeitung* z dnia 19 sierpnia 1925 r., Benjamin określił Neapol mianem „gąbczastego". Opis jego „chłonności" da się zapewne zastosować również i do innych „Miast na Brzegu": zasadza się on na koncepcji miejsca otwartego na stare i nowe idee, zdolnego przetrawić i zaabsorbować przeciwstawne elementy, stając się swego rodzaju pomostem pomiędzy kulturami, miejscem intensywnych doświadczeń, w którym granice ulegają nieustannym przesunięciom. Jest w tych miastach i okrucieństwo, i zbrodnia, i bezduszność; jest w nich jednak i człowieczeństwo. Z doświadczeń naszej szóstki inne miasta mogłyby zapewne niejednego się nauczyć.

Panujący obecnie swoisty „somnambulizm" znaczony jest naporem konformizmu i fatalizmu wynikających z szeroko rozpowszechnionego poczucia bezsilności (i rosnącego niezadowolenia z tradycyjnych ideologii politycznych i partyjnych form uprawiania polityki); tymczasem, typowe dla tych miast upór i niezależność mogłyby stać się alternatywą dla kolejnych klonów coraz to bardziej odhumanizowanych, zbiurokratyzowanych i poddanych coraz ściślejszej kontroli miast, w których procesy prywatyzacji i erozja zarówno

przestrzeni, jak i sfery publicznej postępują coraz głębiej. Cała szóstka znajduje się wszakże pod przemożną presją by dostosować się do imperatywów polityki, co ma zagwarantować im większą konkurencyjność na arenie międzynarodowej. W przebudowanych nadbrzeżnych magazynach deweloperzy stawiają nowe „standardowe" galerie handlowe, biurowce o „podwyższonym" standardzie, centrale firm, hotele klasy „international", bary i restauracje oraz luksusowe mieszkania. Zarówno same projekty, jak i atmosfera, jaką tworzą te obiekty, powodują, iż na całym świecie – od Brisbane po Barcelonę, od Baltimore po Bilbao – rewitalizowane miasta upodabniają do siebie. Nie da się jednocześnie zaprzeczyć, że miejskie strategie rewitalizacji na wiele sposobów przyczyniają się do rozwoju lokalnej gospodarki...

Miasta, o których traktuje niniejsze wydawnictwo, posiadają pewne wyróżniające je cechy i wartości, których elementy można będzie zapewne odnaleźć na tworzących album fotografiach. W niewielkiej książeczce pt. *Edgy Cities*, Steve Higginson i Tony Wailey zwracają uwagę na fakt, że miasta portowe charakteryzują się „wielce niekonsekwentnymi i nieujętymi w reguły" metodami pracy oraz oporem wobec nieelastyczności czasu odmierzanego zegarowo, co jest dominującą zasadą organizacyjną panującą w przemysłowych miastach położonych w głębi lądu.[1] Miasta portowe zdają się mieć płynne, mniej ortodoksyjne poczucie czasu, rytmu i ruchu. Jak przekonują Higginson i Wailey, jest to zwłaszcza prawdziwe w przypadku portów, których funkcjonowanie ściśle związane jest z pływami morza, a do takich należy Liverpool. Takie podejście do czasu wiąże się ze spontanicznością, bezkompromisowym poczuciem niezależności i niechęcią do zdyscyplinowania, które charakteryzują mieszkańców naszych sześciu miast.

„Miasta na Brzegu" to miejsca rozdyskutowane i gwarne, w których istotną rolę odgrywa rozmowa i interakcja tak w pubach i barach (zwłaszcza w Gdańsku, Bremie i Liverpoolu), jak i na ulicach, rynkach, w kafejkach i innych miejscach na

otwartym powietrzu (Marsylia, Neapol i Stambuł). Wiąże się to z panującą w sześciu miastach aurą hedonizmu i radości, jaka po części wywodzi się z tradycji miejsc, w których marynarze po zejściu na ląd poszukiwali rozrywki. Kultura fizycznej ekspresji, żywiołowości i zmysłowej satysfakcji znajduje swe odbicie w znaczeniu, jakie historia nadała dzielnicom czerwonych latarni – miejscom szybkich i intensywnych, acz krótkotrwałych uciech. Tętniące życiem i zatłoczone uliczki centrum Stambułu czy Dzielnica Hiszpańska w historycznym centrum Neapolu, stanowią antidotum na obawy pruderyjnych mieszczuchów (widoczne we wzroście ilości „wygrodzonych" miejskich enklaw dla bogatych w Ameryce Północnej i w Europie) lękających się zepsucia spowodowanego przez Obcych.

Spojrzenie „lokalne" może zaowocować mniej zglobalizowaną polityką miasta: nie tylko bardziej przystającą do lokalnych realiów, ale i mogącą znaleźć zastosowanie również w innych miejscach. Takie podejście często przechodzi jednak w publicznej debacie niezauważone. Nie podjęto jeszcze w pełnym zakresie intelektualnego wyzwania, jakim jest powiązanie elementów szeroko pojętej tradycji z debatą polityczną w celu nakreślenia wizji przyszłości tych miast. Czy możliwe jest przekształcenie ich „niepokornych" przymiotów w atuty wykorzystywane w przyszłych strategiach rozwoju? Czy owe cechy wyróżniające są dokumentowane, pielęgnowane i chronione przed niebezpieczeństwami „wysterylizowania" i przesadnego „unormowania" zwyczajowo propagowanymi przez komercyjnie zorientowane strategie rozwojowe turystyki kulturalnej? Bez wątpienia, jednym z wyzwań przed jakimi stoi naszych sześć miast jest zagwarantowanie postępującej „normalności" tj. poprawy działania służb publicznych (np. w dziedzinie ochrony zdrowia, utrzymania porządku i edukacji) przy jednoczesnym zachowaniu przewrotnego poczucia humoru, wielkiej wyrazistości i innych pozytywnych aspektów ich „nieposkromienia". Wymaga to odwagi i zajęcia stanowiska uznającego zarówno rangę nonkonformistycznych i wywrotowych

tradycji, jak i związane z nimi koszty i trudności (w tym, naturalnie, kwestię, w jaki sposób zaprząc media do prezentacji tego rodzaju strategii mieszkańcom).

Historyczne znaczenie tych portowych miast, jak również ich „trudny" charakter i „niesforny geniusz" wiązały się z globalnym charakterem portu; dzisiaj sytuacja wygląda zgoła inaczej. Przyszłość owej wyjątkowości zależy od stworzenia sieci nowych powiązań międzynarodowych, które umożliwią miastom zachowanie otwartego charakteru oraz zapewnią napływ inspirujących idei i osób. Celem projektu współpracy kulturalnej „Miasta na Brzegu" jest stworzenie warunków umożliwiających powstanie owego nowego internacjonalizmu.

W przeszłości miasta te wypracowały własne strategie handlu międzynarodowego; dzisiaj, w większej części przeżywają one kryzys. Cała szóstka – choć w różnym stopniu – padła ofiarą powstania państw narodowych: jako przykład może posłużyć utrata przez Liverpool na rzecz Londoynu funkcji finansowych, bankowych, ubezpieczeniowych, handlowych i prawnych, utrata podobnych funkcji po zjednoczeniu Włoch przez XIX-wieczny Neapol czy stopniowa utrata statusu głównego ośrodka kontaktów Francji z południową częścią basenu Morza Śródziemnego przez Marsylię. Wspomniany internacjonalizm nadal funkcjonuje w kulturze popularnej sześciu miast: wystarczy pomyśleć o międzynarodowych wpływach kształtujących ich muzykę pop, czy też o wielonarodowych rzeszach kibiców klubów piłkarskich, takich jak Liverpool (który ma wielu zwolenników poza granicami kraju, zwłaszcza w Skandynawii i w Irlandii), Napoli (Ameryka Południowa i USA), Olympique Marsylia (Algieria, Senegal i Mali) czy też trzy kluby ze Stambułu (Niemcy i główne miasta europejskie, w tym Londyn).

Dwa warunki konieczne dla powstania nowego internacjonalizmu to panująca w mieście atmosfera przychylności dla przybyszów i nowych wpływów kulturowych oraz polityka miasta budowana na bazie lokalnych tradycji postępowego

kosmopolityzmu, otwartości i krzyżowania się wpływów. W „Miastach na Brzegu" znajdziemy wiele przykładów tzw. dobrych praktyk: począwszy od cieszącej się wielkim uznaniem międzywydziałowej strategii integracji mniejszości etnicznych przyjętej przez władze miejskie Bremy, poprzez otwarcie w 2004 r. centrum kultury i sportu Kuumba Imani w Liverpoolskiej dzielnicy Toxteth oraz utworzenie w 2006 r. międzykulturowego centrum via Speranzella w Hiszpańskiej Dzielnicy Neapolu, aż po sukces (jakim jest zarówno wspieranie rozwoju lokalnych społeczności, jak i zapobieganie powstawaniu konfliktów) międzyreligijnego stowarzyszenia Marseille Espérance. Wszystkie sześć miast rozwija nowe kulturowe wizje internacjonalizmu, otwartości i dialogu między kulturami. Stanowią one istotny składnik programu działań przyjętego przez Liverpool na 2008 r., w którym miasto dzierży tytuł Europejskiej Stolicy Kultury; to również ważna część zgłoszenia dokonanego przez Stambuł, który uzyskał nominację do tego tytułu na rok 2010. Jest to wreszcie element kandydatur Marsylii i Gdańska opiewających odpowiednio na lata 2013 i 2016. Także i Neapol wybrał współpracę europejsko-śródziemnomorską oraz dialog z krajami islamskimi jako motyw przewodni Powszechnego Forum Kultur, imprezy finansowanej przez UNESCO, której miasto będzie gospodarzem w 2013 r. Na koniec, kandydatura Marsylii do tytułu Europejskiej Stolicy Kultury w 2013 r. (zgłoszona wspólnie z regionem Prowansji) również kładzie nacisk na wymianę kulturową z islamem w ramach programu *Ateliers de la Méditerranée* opartego o następujące założenie:

> Geopolityka rozwoju nie może już dłużej lekceważyć kwestii kultury. Opracowanie metod dialogu i współpracy kulturowej staje się coraz pilniejsze z powodu dojmującego poczucia porażki, jaką okazały się próby stworzenia powszechnych i wspólnych wartości, jak również przez wzgląd na fakt, iż mechanizmy tożsamości i religijnej regresji funkcjonują w chwili obecnej sprawniej niż kiedykolwiek przedtem.[2]

Franco Bianchini
Profesor polityki i planowania kulturowego Leeds Metropolitan University
Doradca ds. projektu Cities on the Edge

Podziękowania

Niniejsza praca w części oparta jest na projekcie badawczym dotyczącym polityki kulturalnej i zmian zachodzących w europejskich ośrodkach portowych. Projekt finansowany jest przez brytyjską organizację Arts and Humanities Research Council w formie stypendium naukowego przyznanego w ramach programu Research Leave (wrzesień 2005 r. – kwiecień 2006 r.). Informacje na temat Bremy pochodzą głównie z pracy Jörga Plögera pt. *Bremen. City Report* (Londyn, London School of Economics, Centre for Analysis of Social Exclusion, 2007 r.). Pragnę również podziękować Dr Jude Bloomfield za omówienie ze mną części idei zawartych w niniejszym referacie.

1 Steve Higginson i Tony Wailey, *Edgy Cities* (Liverpool, Northern Lights, 2006 r.), str. 20.

2 Marysylia-Prowansja 2013, *Marseille-Provence 2013 European Capital of Culture Application* (Marsylia, Marseille-Provence 2013, 2007 r.).

Fotografie geht an die Grenzen

Die Fotos in diesem Buch berühren mehrere zentrale Themen von 'Cities on the Edge' – einer Kultur-Partnerschaft bei der Stadtverwaltungen und politische Organisationen in den Städten Bremen, Danzig, Istanbul, Liverpool, Marseilles und Neapel zusammenarbeiten. Die Fotografen zeigen in ihren Arbeiten viele verschiedene Aspekte dieser sechs Städte: ethnische und kulturelle Vielfalt, ökonomischen Verfall, Entindustrialisierung und Erneuerung. Sie zeigen die Privatisierung öffentlichen Raums durch Einkaufszentren, die besondere Atmosphäre verschiedener Kneipen und Bars, die Komplexität und den theatralischen Charakter alter und neuer Stadtlandschaften, sowie die vielfältigen und fantasievollen Weisen, auf welche die Menschen sich selbst unwirtlichste städtische Räume aneignen.

Es gibt beträchtliche Unterschiede zwischen den sechs 'Cities on the Edge' in Bezug auf ihre Größe, ihr Alter, ihre ökonomische Rolle, ihre politische Führung und noch auf vielen anderen Gebieten. Aber diese Städte haben auch Gemeinsamkeiten: Sie sind alle Hafenstädte und mehr dem Meer zugewandt als dem Festland.

Sie haben oftmals angespannte Beziehungen zu den Zentren politischer, ökonomischer und medialer Macht in den Hauptstädten ihrer jeweiligen Länder. Sie sind bekannt für ihren respektlosen Humor, für Rebellion und unabhängiges Denken. Sie haben ernsthafte Probleme mit Kriminalität, Müll, Arbeitslosigkeit, sozialen Konflikten und manchmal eine Tendenz zur Paranoia und zur Opferhaltung. Diese Probleme werden von den ökonomischen und politischen Eliten in den jeweiligen Ländern bisweilen als unlösbar angesehen – beispielsweise die langwierige Abfallbeseitigungs- und Entsorgungskrise in Neapel

2007 und 2008. Trotzdem haben alle sechs Städte eine bemerkenswerte Fähigkeit, sich an widrige Umstände anzupassen und sind erfindungsreich und widerstandsfähig.

Diese sechs Städte liegen am Rande ihrer Länder, an der "Wasserkante", und können auch in ihrer Haltung in diesem Sinne als "kantig" bezeichnet werden. Sie teilen ein außergewöhnlich starkes Bewusstsein für ihre eigene kulturelle Identität, die geformt wurde durch die Ein-und Auswanderung und durch ureigene religiöse und politische Traditionen. Tatsächlich spielen die Städte eine entscheidende Rolle für die kulturelle Identität ihrer jeweiligen Länder: durch Symbolfiguren wie die Beatles, den Liverpooler Fußball Club, durch Neapolitanische Lieder wie *O Sole Mio*, durch die *Marseillaise* oder die Solidarnosc-Bewegung in Danzig, angeführt von Lech Walesa.

Wegen der Bedeutung ihrer Häfen besitzen all diese Städte einen kosmopolitischen Charakter, eine Geschichte des interkulturellen Austauschs und religiösen Pluralismus, sowie alteingesessene ausländischstämmige Gemeinden. In Bremen beispielsweise gibt es eine große türkische Gemeinde, in Neapel leben Menschen aus China, der Ukraine, aus Tunesien, Marokko, Nigeria, aus Somalia und Sri Lanka und noch viele weitere ethnische Gruppen. Dieses Völkergemisch koexistiert mit Rassismusproblemen. Minderheiten werden ausgegrenzt und leiden am Ausschluss vom bürgerlichen Leben. In bestimmten Wohngebieten – wie zum Beispiel die Siedlung Osterholz-Tenever in Bremen, Toxteth in Liverpool oder das Gebiet um die Piazza Garibaldi in Neapel – leben viele Einwohner, die ethnischen Minderheiten angehören. Doch deren Präsenz verändert oder beeinflusst kaum sichtbar die öffentliche Kunst, das Programm

der Museen oder die Gestaltung des öffentlichen Raums. So argumentieren beispielsweise einige Kritiker, dass der arabische Charakter von Marseilles – ein wichtiger Bestandteil der zeitgenössischen Identität der Stadt – im öffentlichen Bereich, in den Bauwerken und im Kulturprogramm zu wenig präsent sei.

Es existiert in den sechs Städten auch ein Bewusstsein für die Divergenz zwischen den schillernden, sauberen und neu belebten Stadtzentren und der fortschreitenden (und in manchen Fällen sich verschlimmernden) Verwahrlosung in den Bezirken jenseits des Stadtkerns. Soziale Polarisation findet in allen diesen Städten statt. In Bremen zum Beispiel hat die Orientierung der örtlichen Wirtschaftsbereiche hin zur Hochtechnologie, trotz der Anstrengungen der Lokalpolitik, nicht dazu geführt, dass Langzeitarbeitslose, Immigranten und niedriger Qualifizierte davon profitieren. Im Falle Liverpools hat die jüngste Verbesserung des Stellenangebots innerhalb des Niedriglohnbereichs, also im Hotel- und Gaststättensektor, kaum die Probleme ökonomischer Benachteiligung berücksichtigt.

Soziale Ausgrenzung wird oft verschlimmert durch Gentrifizierung oder Yuppisierung, also der Veredelung von Stadtzentren. Dadurch werden die weniger gut verdienenden Einwohnerschichten in die Randbezirke abgedrängt, wie es in den Zentren von Istanbul und Neapel und im multikulturellen Bezirk Belsunce in Marseilles geschieht. Es herrscht hochgradiger Mangel in vielen Bereichen gleichzeitig – ökonomisch, sozial, kulturell und die Umwelt betreffend – beispielsweise in weiten Teilen Nord-Liverpools, Anfield inbegriffen, dem Sitz des Liverpool FC, einer der reichsten und erfolgreichsten Fußballclubs Europas.

Vergleichbare Muster von Deprivation findet man in den nördlichen Quartieren von Marseille (hauptsächlich bewohnt von Immigranten aus Algerien und anderen nordafrikanischen Ländern), sowie in den aufstrebenden Siedlungen in den Randbezirken von Neapel wie Scampia, wo ein großer Teil der Wirtschaftsbereiche von der hochkriminellen lokalen Mafia kontrolliert wird: Die Camorra missbraucht Teile der Siedlung als Drogenumschlagplatz. Die Renaissance der Stadtzentren dieser sechs Städte wird nicht systematisch begleitet von der Einrichtung guter Schulen, Kulturzentren und sozialen Treffpunkten in den weniger gut situierten innerstädtischen und Außenbezirken. Diese Orte markieren einen tiefgreifenden sozialen Ausschluss innerhalb der 'Cities on the Edge'.

Reisende in Neapel, wie zum Beispiel Walter Benjamin in den Zwanzigerjahren, nehmen solche Städte oft als Offenbarung von Disparität und Verwobenheit urbaner Probleme wahr: Eine Enthüllung von Wahrheiten auch über andere Orte. In einem Artikel für die *Frankfurter Zeitung* vom 19. August 1925 definierte Benjamin Neapel als 'porös'. Die Beschreibung von Neapels "schwammartigen" Eigenschaften passt möglicherweise auch zu Attributen der anderen 'Cities on the Edge'. Diese Beschreibung basiert auf der Vorstellung eines offen Ortes – offen für alte und neue Ideen. Ein Ort, der fähig ist, widersprüchliche Elemente in sich aufzunehmen und umzubauen zu einer virtuellen Brücke zwischen den Kulturen. Ein Ort also, an dem man intensive Erfahrungen machen kann, wo Grenzen immer wieder unterminiert werden. Es gibt Gewalt, Verbrechen und Kälte in diesen Städten, aber auch Menschlichkeit. Andere Städte könnten viel lernen von den Erfahrungen dieser sechs 'Cities on the Edge'.

In unseren "schlafwandlerischen" Zeiten, unter dem Druck von Konformismus und Fatalismus, resultierend aus einem umfassenden Gefühl der Ohnmacht (und steigender Unzufriedenheit mit traditionellen politischen Ideologien und dem Parteiensystem), kann die Sturheit und

Respektlosigkeit dieser Städte vielleicht eine Alternative sein zur fortschreitenden Dehumanisierung, Bürokratisierung, Gleichschaltung und Kontrolle von Städten, in denen durch die Privatisierung öffentlichen Raums diese Sphäre langsam aber sicher erodiert. Alle sechs Städte stehen dennoch unter einem ziemlich hohen Druck, politische Forderungen zu erfüllen, um im internationalen Wettbewerb der Städte mithalten zu können. Stadtsanierer bauen standardisierte Einkaufszentren, hochkomfortable Bürokomplexe und öffentliche Plätze, "internationale" Hotels, Bars, und Restaurants schießen aus dem Boden und alte Lagerhäuser werden umgebaut zu Luxus-Wohnungen in Hafennähe. Diese neuen Orte und Gebäude ähneln sich weltweit in sämtlichen Städten in Design und Lebensgefühl – von Brisbane bis Barcelona, von Baltimore bis Bilbao. Es soll aber durchaus nicht abgestritten werden, dass Stadtsanierungsprogramme in vielen Fällen einen positiven Beitrag zur lokalen Wirtschaft leisten.

Die Städte in diesem Buch besitzen alle noch besondere Werte und Weltanschauungen, von denen man auf einigen Fotos in diesem Band eine Vorstellung bekommen kann. Steve Higginson und Tony Wailey beobachten in ihrem "Edgy Cities"-Pamphlet ganz richtig, dass Hafenstädte sich durch ihre "sprunghaften und unregelmäßigen" Arbeitsmuster auszeichnen, sowie durch die Ablehnung einer strikten Zeiteinteilung, wodurch die Warenproduktion in den Städten des Hinterlandes hauptsächlich organisiert wird.[1] Hafenstädte haben eher ein fließendes, lunares Gefühl für Zeit, Rhythmus und Bewegung. Dies, so Higgins und Wailey, gilt besonders für Häfen, die von den Gezeiten abhängig sind, wie Liverpools Hafen. Ihr Verhältnis zur Zeit geht einher mit Spontaneität, einem heftigen Unabhängigkeitsbedürfnis und einer Weigerung, sich zu disziplinieren – Attribute, welche die Menschen in unseren sechs Städten gut charakterisieren.

Die 'Cities on the Edge' sprechen eine deutliche Sprache und sind kommunikative Orte, an denen Konversation und Interaktion sehr wichtig sind: in

Pubs und Bars besonders in Danzig, Bremen und Liverpool, und mehr auf Straßen, Märkten, in den Cafés und anderen Plätzen unter freiem Himmel in Marseilles, Neapel and Istanbul. Diese Werte der sechs Städte sind verbunden mit ihrem Hedonismus und ihrer Verspieltheit, was vielleicht auch auf die Tradition der Seeleute zurückzuführen ist, an Land zu gehen, um ihr Vergnügen zu suchen. Es gibt dort einen expressiven Körperkult, eine Kultur der Üppigkeit, der Extravaganz und der sinnlichen Befriedigung, wofür die historische Bedeutung der Rotlichtbezirke als Orte von schnellem und zeitlich limitiertem Vergnügen zeugt. Mit ihrem dichten Gewühl auf den Straßen stellen zum Beispiel Teile von Istanbuls Zentrum oder die Spanischen Viertel im Stadtzentrum von Neapel ein Gegenstück dar zur prüden Furcht vor Kontaminierung durch das Fremde, das Andere. Eine Furcht, wie sie in den ständig wachsenden städtischen 'gated communities', den abgegrenzten Bezirken der Reichen in Nordamerika und Europa, existiert.

Solche lokalen Weltsichten könnten eine weniger globalisierte Städtepolitik hervorbringen, die dem lokalen Kontext mehr entspricht und gleichzeitig für andere Orte der Welt ein Beispiel sein kann. Trotzdem werden solche Weltanschauungen in den öffentlichen Debatten nicht berücksichtigt. Die intellektuelle Herausforderung, Elemente der populären Traditionen dieser Städte in die politische Diskussion einzubringen und so dazu beizutragen, das Schicksal dieser Orte mitzubestimmen, wurde bis jetzt noch nicht angenommen. Ist es möglich, die "kantigen" Eigenschaften dieser Städte nutzbringend einzusetzen für zukünftige Strategien der Stadtentwicklung? Werden solche Eigenschaften dokumentiert, gefördert und geschützt gegen die Gefahren der Säuberung und exzessiven "Normalisierung" durch den kommerziellen Kulturtourismus? Eine der tatsächlichen Herausforderungen für unsere sechs Städte ist es dennoch, "Normalität" zu erlangen: vor allem durch verbesserte staatliche Leistungen vorrangig im Gesundheitsbereich, bei der Stadtreinigung und in der Bildung. Dabei sollten sie sich aber ihren

Humor, ihre besonderen Ausdrucksformen und andere Seiten ihrer 'Kantigkeit' erhalten. Ein kühner Schritt ist hier nötig, der den Wert von entgrenzten und subversiven Traditionen erkennt und der die Kosten und Widerstände berücksichtigt, auf die ein derartiges Unternehmen stoßen kann, einschließlich der Schwierigkeit, ein solches Vorgehen der Öffentlichkeit über die Medien zu vermitteln.

Die historische Dimension dieser Hafenstädte, ihre schwierige Art und ihr "regelloses Genie" bezog sich auf die globale Rolle des Hafens, die sich aber verändert hat. Somit ist die Zukunft dieser Kantigkeit abhängig davon, dass neue internationale Verbindungen geknüpft werden, welche diese Städte offen halten und den Einfluss von stimulierenden Ideen und Menschen garantieren können. Das kooperative 'Cities on the Edge'-Kulturprojekt will zu einem solchen neuen Internationalismus einen Beitrag leisten.

In der Vergangenheit hatten diese Städte ihre eigenen internationalen Handelsstrategien, die aber heute in den meisten Fällen in die Krise geraten sind. Denn alle sechs Städte sind in gewisser Weise Opfer des Nation-Buildings ihrer jeweiligen Nationen geworden. So hat Liverpool seine Bedeutung an London verloren: im Finanz- und Bankensektor, im Versicherungsgewerbe, im Handel und im Rechtswesen. Von Neapel sind die Dienstleistungs-Industrien während des 19. Jahrhunderts, nach der Vereinigung Italiens, abgewandert und Marseilles verlor die Schlüsselrolle in den Beziehungen zwischen Frankreich und der südlichen mediterranen Welt. In der Populärkultur der sechs Städte aber spürt man den Geist dieses Internationalismus immer noch: Denkt man nur an die internationalen Einflüsse auf die Unterhaltungsmusik, an das Gefolge von Fußballclubs wie Liverpool (mit einer starken Fanbasis in Skandinavien und Irland), Napoli (mit Fans aus Südamerika und den USA), Olympic Marseilles (Fans aus Algerien, Senegal und Mali) und den drei Istanbuler Teams (Fans aus Deutschland und vielen europäischen Großstädten, einschließlich Londons).

Zwei Vorbedingungen für diesen neuen Internationalismus gibt es: erstens, dass die Köpfe in diesen Städten offen sind für Newcomer und neue kulturelle Einflüsse, und zweitens, dass die Stadtpolitik auf die lokalen Traditionen des Hybriden, des fortschrittlichen Weltbürgertums und der Offenheit aufbaut. Es gibt viele gute Beispiele dafür in den 'Cities on the Edge': Diese reichen von den viel gepriesenen ressortübergreifenden Integrationsmaßnahmen für ethnische Minderheiten in Bremen, über die Eröffnung des Kuumba Imani Millennium Centre im Liverpooler Bezirk Toxteth 2004, (eine integrative Gemeinde- und Ausbildungseinrichtung), die Gründung des interkulturellen Zentrums von Via Speranzella in den Spanischen Quartieren von Neapel 2006 und den Erfolg (bei der Gemeinschaftsförderung und Konfliktprävention) der religionsübergreifenden Vereinigung 'Marseille Espérance'. Alle sechs Städte entwickeln zusätzlich neue kulturelle Visionen von Internationalismus, Offenheit und interkulturellem Dialog. Diese Visionen sind ein wichtiger Teil von Liverpools Programm als europäische Kulturhauptstadt (ECoC) 2008, von Istanbuls erfolgreicher Bewerbung als europäische Kulturhauptstadt 2010 und ebenfalls für die Kandidaturen von Marseille und Danzig um diesen Titel für 2013 und 2016. Parallel dazu hat Neapel sich als zentrales Thema für das 2013 dort stattfindende und von der UNESCO geförderte 'Universal Forum of Cultures' die euro-mediterrane Zusammenarbeit und den Dialog mit islamischen Ländern gewählt. Marseille-Provence konzentriert sich in seiner Bewerbung als europäische Kulturhauptstadt 2013 auf den kulturellen Austausch mit dem Islam innerhalb des Konzeptes des *Ateliers de la Méditerranée* und mit folgender Begründung:

> Der geopolitische Entwicklungsbereich sollte Kultur nicht länger auf die leichte Schulter nehmen. Kulturellen Dialog und Zusammenarbeit zu fördern wird noch dringendlicher durch das vorherrschende Gefühl, bei der Schaffung von kommunalen- und Mischwerten gescheitert zu sein und durch

die Tatsache, dass Identitätsbildungsprozesse zusammen mit religiöser Regression mehr und mehr am Werk sind.[2]

Franco Bianchini
Professor für Kulturpolitik und Planung, Leeds Metropolitan University
Projektberater von 'Cities on the Edge'
Danksagungen

Dieses Papier basiert in Teilen auf einem Forschungsprojekt zu Kulturpolitik und städtischem Wandel in europäischen Hafenstädten, gefördert vom britischen *Arts and Humanities Research Council* durch Preisgelder innerhalb seines *Research Leave*- Programms (September 2005 – April 2006). Die Informationen über Bremen entstammen hauptsächlich Jörg Plögers *Bremen. City Report* (London, London School of Economics, Centre for Analysis of Social Exclusion, 2007). Mein Dank geht an Dr. Jude Bloomfield für die gemeinsamen Diskussionen einiger in diesem Papier enthaltener Gedanken.

1 Steve Higginson und Tony Wailey, *Edgy Cities* (Liverpool, Northern Lights, 2006), S. 20.

2 Marseille-Provence 2013, *Marseille-Provence 2013 European Capital of Culture Application* (Marseilles, Marseille-Provence 2013, 2007).

Le fotografie raccolte nel presente libro, trattano molti dei temi affrontati da "Cities on the Edge, Città di Frontiera", una collaborazione che ha coinvolto autorità locali e altre organizzazioni con poteri decisionali nell'ambito culturale cittadino di Brema, Danzica, Istanbul, Marsiglia e Napoli. I fotografi ritraggono diversi aspetti delle sei città: la diversità etnica e culturale, il declino economico, la deindustrializzazione e la rigenerazione, la privatizzazione dello spazio pubblico in favore di nuovi centri commerciali, le atmosfere speciali di pub e bar, la complessità e la teatralità dei paesaggi cittadini vecchi e nuovi, i molteplici e fantasiosi modi in cui gli individui utilizzano gli ambienti urbani più inospitali e spesso vi si adattano.

Tra le sei Cities on the Edge le differenze sono notevoli: diverse sono le dimensioni, le epoche di fondazione, le attività economiche, le forme di governo e molto altro. Tuttavia le città hanno anche molte caratteristiche in comune. Sono tutte città portuali orientate verso il mare, piuttosto che verso l'interno. Vivono spesso tensioni nei rapporti con i centri di potere politico, economico e mediatico delle capitali dei paesi in cui sono ubicate. Sono città ben note per l'irriverente senso dell'umorismo, per lo spirito di ribellione e per la libertà di pensiero. Hanno seri problemi di criminalità, di rifiuti urbani, di disoccupazione, sono caratterizzate da conflitti sociali e, talora, mostrano tendenze paranoiche e vittimistiche. Le élite economiche e politiche dei loro paesi, a volte, ritengono che queste problematiche siano pressoché irrisolvibili; un esempio è la lunga crisi della raccolta e dello smaltimento dei rifiuti a Napoli nel 2007 e nel 2008. Ciononostante le sei città possiedono tutte una spiccata abilità nell'adattarsi alle circostanze più avverse, nel reinventarsi e nel ricominciare.

Esse si trovano ai limiti geografici dei loro paesi e hanno delle qualità speciali che contraddistinguono il loro carattere. Condividono un senso d'identità culturale particolarmente forte, influenzato da fenomeni quali l'immigrazione, l'emigrazione e dalle distintive tradizioni religiose e politiche. Ed in effetti sono luoghi essenziali a definire l'identità culturale della rispettiva nazione, utilizzando alcuni simboli: i Beatles, il Liverpool Football Club, *O Sole Mio* e altre canzoni napoletane, la *Marsigliese*, il movimento Solidarnosc a Danzica, promosso da Lech Walesa.

Proprio perché sono porti importanti, le sei città hanno un carattere cosmopolita, un passato di scambi interculturali e di pluralismo religioso per la presenza ben radicata di molte comunità straniere. Da ricordare le nutrite comunità turche a Brema, le comunità cinesi, ucraine, tunisine, marocchine, nigeriane, somale, cingalesi e i molti altri gruppi etnici a Napoli. Le diverse culture coesistono con problemi di razzismo e di segregazione spaziale di minoranze etniche che, in molti casi, continuano a rimanere escluse dalla vita cittadina. Determinati quartieri, come il quartiere di edilizia popolare di Osterholz-Tenever a Brema, o il Toxteth a Liverpool, o la zona che circonda Piazza Garibaldi a Napoli, sono caratterizzati da un'alta concentrazione di minoranze etniche, ma la loro presenza, in molti casi, non sembra, all'apparenza, condizionare e influenzare i simboli cittadini quali le opere d'arte pubbliche, i musei, o il design dello spazio pubblico. Ad esempio alcuni critici sostengono che l'indole "araba" di Marsiglia, che è una componente importante dell'identità contemporanea della città, non si nota abbastanza in ambito pubblico,

nell'ambiente costruito e nella programmazione culturale.

Le città hanno consapevolezza della differenza tra le zone centrali in fermento, ripulite e riqualificate, e le aree che le circondano caratterizzate da un permanente (e in alcuni casi crescente) stato di povertà. Il processo di polarizzazione sociale è evidente in tutte e sei le città: a Brema il nuovo orientamento dell'economia locale verso le tecnologie più avanzate, nonostante gli sforzi delle autonomie locali, non ha tratto sufficiente vantaggio dalla possibilità di impiegare i disoccupati di lungo termine, gli immigrati e il personale meno qualificato della forza lavoro. In altri casi, come è avvenuto a Liverpool, la recente crescita occupazionale nei settori che richiedono personale relativamente meno qualificato e remunerato (il settore della distribuzione, l'alberghiero e della ristorazione) non ha pienamente superato le problematiche della disuguaglianza economica.

Le divisioni sociali spesso sono esacerbate da fenomeni di gentrificazione nei centri città che portano all'espulsione degli abitanti a basso reddito, costretti a spostarsi verso le aree più periferiche (come nel caso di alcuni quartieri centrali di Istanbul, di Napoli e del quartiere multietnico Belsunce di Marsiglia). Molteplici sono i livelli di grave povertà che riguardano sia gli aspetti economici, sociali e culturali, sia quelli ambientali. Tali livelli sono particolarmente alti in ampie zone a nord di Liverpool, come ad Anfield, patria della squadra di calcio Liverpool FC, considerata una delle società calcistiche più ricche ed apprezzate d'Europa. Simili situazioni di disagio si osservano nei quartieri più a nord di Marsiglia (abitati principalmente da gruppi di

immigrati, provenienti soprattutto dall'Algeria e da altri paesi dell'Africa settentrionale), o nei quartieri popolari della periferia di Napoli, caratterizzati da edifici altissimi, come Scampia, dove gran parte dell'economia è controllata dalla mafia locale, la *Camorra*, un'organizzazione criminale che usa parte del quartiere come mercato per trafficare droga. La rinascita dei centri cittadini nelle sei città non è regolarmente sostenuta dalla disponibilità di scuole valide, di centri culturali e di luoghi per la socializzazione nelle aree a basso reddito del centro e delle periferie. Queste aree rappresentano le frontiere di un'esclusione sociale più profonda all'interno delle "Città di Frontiera".

È comune tra i viaggiatori, come è stato per Walter Benjamin a Napoli negli anni Venti, vivere queste città come una rivelazione della disparità e dell'interconnessione delle problematiche urbane: realtà che riguardano anche altri luoghi. Benjamin ha definito Napoli una città "porosa" in un articolo del *Frankfurter Zeitung* pubblicato il 19 agosto 1925. La descrizione di una Napoli dalle qualità "spugnose" si addice forse ad alcuni aspetti delle altre "Città di Frontiera": alla base di tale ritratto è il concetto di un luogo aperto ad idee vecchie e nuove, capace di assorbire e metabolizzare gli elementi di contraddizione, un ponte virtuale tra le culture, un luogo di esperienze intense dove i confini sono sempre messi a repentaglio. In queste città c'è crudeltà, crimine e insensibilità, ma allo stesso tempo umanità. Altre città avrebbero probabilmente molto da imparare dalle esperienze delle sei "Città di Frontiera".

In questi anni di "sonnambulismo", sotto le pressioni del conformismo e del fatalismo che sono derivati da un diffuso senso d'impotenza (e da un crescente malcontento per le ideologie e le forme tradizionali della politica dei partiti), l'ostinazione e la sfrontatezza di queste città potrebbero offrire un'alternativa alla creazione di città ancor più disumanizzate, burocratizzate, clonate, controllate e caratterizzate da fenomeni crescenti di privatizzazione ed erosione dello spazio pubblico e della sfera pubblica. Le sei città stanno tuttavia

subendo pressioni considerevoli per conformarsi agli imperativi politici onde valorizzare la loro competitività cittadina a livello internazionale. Le imprese di costruzioni edificano nuovi centri commerciali standardizzati, palazzi per uffici "d'alta qualità", corporate plaza, hotel "internazionali", bar, ristoranti e appartamenti di lusso in zone litoranee ottenuti ristrutturando vecchi edifici una volta adibiti a magazzini. Il design e le sensazioni che queste strutture suscitano, le rendono simili tra loro, e ciò è evidente in tutte le città del mondo soggette ad opere di risanamento. Così a Brisbane, a Barcellona, a Baltimora o a Bilbao. Con questo ovviamente non si vuole negare che le strategie di risanamento urbano abbiano, in molti casi, contribuito positivamente allo sviluppo delle economie locali.

Le città prese in esame da questo libro tuttavia possiedono ancora dei valori e una visione del mondo che le distingue; tali elementi si possono forse scorgere in alcune delle immagini presentate. Steve Higginson e Tony Wailey nel loro opuscolo *Edgy Cities*, giustamente osservano come le città portuali siano caratterizzate da modelli del mercato del lavoro "notevolmente imprevedibili ed irregolari" e da una capacità di resistere all'inflessibilità dell'orologio marcatempo che rimane la forza organizzatrice dominante delle città manifatturiere dell'hinterland.[1] Le città portuali hanno un senso del tempo, del ritmo e del movimento più fluido, quasi lunare. E ciò, sottolineano Higginson e Wailley, si rivela vero in particolare per i porti che, come Liverpool, sono accessibili solo con l'alta marea. Tale concezione del tempo va di pari passo con la spontaneità, la fiera indipendenza e l'indomabilità che caratterizzano gli abitanti delle sei città.

Le Cities on the Edge sono luoghi articolati e aperti alla comunicazione ove è fondamentale conversare ed interagire nei pub e nei bar specialmente a Danzica, a Brema e a Liverpool, ma anche per le strade, nei mercati, nei caffè e in altri locali all'aperto come a Marsiglia, Napoli e Istanbul. Il bagaglio di valori delle sei città è

legato all'edonismo e all'allegria che in parte possono ricondursi alle consuetudini dei marinai che attraccavano in questi porti alla ricerca di divertimento. Propria di questi luoghi è la cultura dell'espressività fisica, dell'esuberanza e della gratificazione dei sensi, come testimonia l'importanza storica dei quartieri a luci rosse: luoghi di piacere intenso, veloce e a tempo limitato. Alcune aree centrali di Istanbul o i quartieri Spagnoli nel centro storico di Napoli, con le loro strade brulicanti e densamente affollate, forniscono un antidoto al timore moralista di essere contaminati dalla diversità degli altri, timore comprovato dall'aumento dei quartieri residenziali privati urbani realizzati per i ceti abbienti in America settentrionale e in Europa.

Questa visione localistica del mondo potrebbe portare all'adozione di politiche urbane meno ispirate alla globalizzazione, mentre una maggiore globalizzazione sarebbe più appropriata allo scenario locale e decisiva in altri contesti. Tuttavia il dibattito pubblico spesso non prende neanche in considerazione visioni del mondo simili. Il compito intellettuale di collegare gli elementi delle tradizioni popolari di queste città ai dibattiti politici, al fine di contribuire a definire il destino di questi luoghi, non è stato ancora pienamente adempiuto. È possibile trasformare le qualità "di frontiera" di queste città in risorse utili ad avviare strategie urbane future? Ci stiamo preoccupando di documentare, coltivare e proteggere dette qualità contro i pericoli del risanamento e dell'eccessiva "normalizzazione" che le strategie del turismo culturale, determinato da ragioni commerciali, tendono a produrre? Una delle sfide che le sei città propongono è infatti quella di "normalizzarsi", attraverso il miglioramento dei servizi pubblici (ad esempio del servizio sanitario, del servizio di pulizia stradale e dell'educazione), pur mantenendo l'umorismo irriverente, la spiccata espressività e gli altri aspetti positivi propri del loro essere città "di frontiera". Per questo è necessario un approccio coraggioso che riconosca il valore delle tradizioni trasgressive e ribelli e, allo stesso tempo, prenda in considerazione i costi e le difficoltà che ne conseguono, compreso

naturalmente il problema di informare il pubblico in merito ad una strategia simile attraverso i media.

La dimensione storica di queste città portuali, l'essere città difficili e lo "spirito di disobbedienza" sono legati al fatto che una volta solo il porto fungeva da collegamento con il mondo. Pertanto il futuro di queste peculiarità dipenderà dalla realizzazione di nuovi collegamenti internazionali che mantengano quell'apertura necessaria ad assicurare una continua affluenza di idee e di visitatori stimolanti. Il progetto di collaborazione culturale "Cities on the Edge" si prefigge appunto di contribuire a questo nuovo internazionalismo.

In passato ciascuna città aveva le proprie strategie internazionali per il commercio che oggi sono per la maggior parte in crisi. Le città sono, in misura diversa, vittime della costruzione di uno stato-nazione nel loro paese. Così Liverpool, che nel passato era sede delle attività finanziarie, bancarie, assicurative, commerciali e legali, ha dovuto abdicare in favore di Londra; così Napoli che ha perduto industrie del settore terziario durante il Diciannovesimo secolo, dopo l'unità d'Italia; così Marsiglia che ha gradualmente perso importanza come punto chiave nelle relazioni tra la Francia e il Mediterraneo meridionale. La presenza di questo internazionalismo è ancora tangibile nella cultura popolare delle sei città: basti pensare alle influenze internazionali sulla musica popolare, o alle tifoserie calcistiche internazionali come quella del Liverpool (che ha sostenitori convinti soprattutto in Scandinavia e in Irlanda), del Napoli (con tifoserie in Sud America e negli Stati Uniti), dell' Olympique Marsiglia (con fan in Algeria, Senegal e a Mali) e delle tre squadre di Istanbul (con tifosi in Germania e in altre città importanti d'Europa, inclusa Londra).

Sono due i presupposti per la creazione di un nuovo internazionalismo: il primo è che la mentalità di queste città rimanga aperta a nuovi visitatori e a nuove influenze culturali; il secondo è che le politiche urbane riescano a lavorare su una base di tradizioni locali d'ibridismo, di cosmopolitismo progressista e di apertura. Sono

molti gli esempi di procedure efficienti adottate in queste città "di frontiera": la molto apprezzata strategia interdipartimentale per l'integrazione delle minoranze etniche adottata dalla città di Brema; l'inaugurazione, nel 2004, del Kuumba Imani Millennium Centre nel quartiere di Toxteth, a Liverpool (comunità integrata e centro per la formazione); la fondazione, nel 2006, del centro interculturale di via Speranzella nei quartieri spagnoli di Napoli e il successo (sia riguardo allo sviluppo comunitario, sia riguardo alla prevenzione dei conflitti) dell'associazione interreligiosa Marseille Espérance. Nelle città stanno inoltre sviluppandosi delle nuove visioni culturali di internazionalismo, di apertura e di dialogo interculturale. Tali visioni hanno un ruolo fondamentale nel programma del 2008 che vede Liverpool come Capitale Europea della Cultura (ECoC), in quello del 2010 per il quale Istanbul si è aggiudicata il titolo ECoC e nei programmi del 2013 e 2016 che vedono candidate al titolo Marsiglia e Danzica. Allo stesso modo Napoli ha scelto la cooperazione Euro-Mediterranea e il dialogo con i paesi islamici come tema centrale dell'Universal Forum of Cultures che è sponsorizzato dall'UNESCO e che la città ospiterà nel 2013. Infine, anche la candidatura di Marsiglia e della Provenza al titolo di Capitale Europea della Cultura 2013 è concentrata sullo scambio culturale con l'Islam, attraverso il concetto Ateliers de la Méditerranée con la seguente fondamentale motivazione:

Non è più ammissibile che le geopolitiche dello sviluppo sottovalutino la cultura. La promozione di strumenti di dialogo culturale e di collaborazione diventa sempre più urgente, considerato il dominante senso di sconfitta evidenziatosi nel creare valori comuni e ibridi, e per il fatto che i meccanismi di regressione religiosa e d'identità sono, più che mai, in atto.[2]

Franco Bianchini
Professore di *Cultural Policy and Planning* alla Leeds Metropolitan University
Project Advisor, "Cities on the Edge, Città di Frontiera"

Citazioni e ringraziamenti

Questo saggio ha preso spunto, in alcune sue parti, da un progetto di ricerca sulla trasformazione delle politiche culturali e urbane nelle città portuali europee, finanziato dall'Arts and Humanities Research Council del Regno Unito e assegnato nell'ambito del Research Leave scheme (settembre 2005–aprile 2006). Le informazioni raccolte su Brema provengono principalmente da *Bremen* di Jörg Plöger. *City Report* (London, London School of Economics, Centre for Analysis of Social Exclusion, 2007). Si desidera inoltre ringraziare la Dottoressa Jude Bloomfield per aver contribuito all'esame di alcuni tra i temi trattati in questo saggio.

1 Steve Higginson e Tony Wailey *Edgy Cities* (Liverpool, Northern Lights, 2006), p. 20.

2 Marseille-Provence 2013, *Marseille-Provence 2013 European Capital of Culture Application* (Marseilles, Marseille-Provence 2013, 2007).

Artists' biographies

Ali Taptik spent his time in Liverpool walking around the neighbourhoods of Everton, Anfield and Kensington. As with the work he has produced in Istanbul he is interested in finding environments where he feels people can connect and harmonise with the space. He searches for places with a sense of familiarity and an organic creation of space, where strangers can feel comfortable. Taptik comes from Istanbul, a city with a population of 18 million people, and he regards Liverpool as a relatively small city at less than half a million but commented that both cities have a similar type of energy.

Taptik's first love is Istanbul and he draws upon his home city and culture for inspiration. He has a fascination with the multiplicity of the city and how people change and exist within the space of the city. He reflects that his portrait of Istanbul is also autobiographical and he is aware of his Turkish sensibility of often leaving things to chance – accident and fate. However, he is an organised and skilled practitioner.

Ali Taptik was born in Istanbul, Turkey, in 1983. He currently works as a project advisor at the newly established photography school in Istanbul. He was a student at the Faculty of Architecture in Istanbul for a period of over five years until 2008 and during this time he became a self-taught photographer. His first solo exhibition was called *Remembering Me* (2005) which travelled to various European and Asian venues including Noorderlicht in Holland. *Kaza ve Kader – Accident and Fate* (2004–2007) was shown in Atelier de Visu in Marseille where he had been a resident artist. *Familiar Stranger* is his latest body of work about urban structures and encounters with strangers. He has also produced work in the other cities within the Cities on the Edge project.

Philippe Conti has made a visual investigation of housing schemes and neighbourhoods in both Marseilles and Liverpool. He has worked to engage with immigrant communities in both cities and is interested in the environments in which people live. In Marseilles he photographed a large housing regeneration scheme of modern apartment blocks in the north of the city, Plan d'Aou. In Liverpool he was interested in the boarded-up areas of Victorian terraced housing due for demolition. He chose to concentrate on the area known as the Little Granby Triangle in Toxteth and in particular focused on the people of Somali origin in Liverpool. For Conti the difference between Liverpool and the South of France was shocking, and he noted that in Marseilles the immigrant population is more widely integrated throughout the whole city. However, in both cities, he was fascinated by the intimate places where people live and in revealing the history of people's lives.

Conti's family background is of mixed origin and he has developed a social documentary reportage style to investigate the lives of people who have a variety of differing backgrounds and religions. He is interested in understanding the local politics and cultures of immigrant populations in different regions by engaging with people. He is also interested in working in areas of conflict and has made several visits to the Middle East.

Philippe Conti was born in Marseilles, France, in 1972 and lives in Marseilles. After studying History of Art in 1995 he worked on photographic projects with organisations such as L'Association Médecins Sans Frontières in Palestine in 2001. He has produced two books: *On dirait le sud*, on immigrant workers, in 2004 and *Djelem, djelem*, about exiled Romanians, in 2007. Since his work for Cities on the Edge he has continued to work on the theme of immigrant populations in Jordan.

Wojtek Wilczyk is interested in the post-industrial landscape of both Gdańsk and Liverpool. This was his first visit to England and he was surprised to discover a very close resemblance between areas he saw in North-West England and Poland. He therefore decided to show the similarities between Liverpool and Gdańsk. He was interested in the older places and spaces that are about to change and in imagining how these places might have looked thirty years ago – isolated buildings that speak about the past. In Gdańsk he photographed the areas very close to the city centre and the former port. In Liverpool he mostly worked north of the city in areas not yet redeveloped, particularly in the streets of Walton, Bootle and Kirkdale. He also reflected on the industries that have been lost since World War II in both cities.

Through his work, Wilczyk is interested in revealing an industrial history and a story of a people's past. He believes it is important to record historic landmarks and buildings of social significance before these post-industrial scenes disappear and are replaced by modern developments.

Wojtek Wilczyk was born in Krakow, Poland, in 1961 and he lives and works in Krakow as a photographer, curator and art critic. He has made several documentary photographic cycles depicting changes in the Polish landscape after the collapse of the communist regime: these include *Black and White Silesia* (1999–2002), *Life After Life* (2002–) and *Postindustrial* (2003–). Currently, he is working on a new series entitled *Innocent Eyes Do Not Exist* concerning former synagogues and their new functions in contemporary Poland.

Sandy Volz spent a month exploring parts of Liverpool and like many of the other visiting artists she found the city to be an extremely friendly place in spite of its harsh appearance. She decided to search for a common theme to produce work in both Liverpool and Bremen, so as to study the differences based on similarities. She was interested that both cities were once significant ports and reflected on how both can now look back on a long history of pub culture. Public houses and

bars have a social significance and she decided to concentrate on traditional pubs as spaces where local residents meet. In her pictures she focused on the interiors of public houses to investigate the idea of 'the public' and to question where the public meets the private. She was interested in the look, feel and style of these interiors and in examining the different physical materials, symbols and cultural codes of the two cities.

As an artist Volz uses photography as a documentary medium but she also makes work that is involved with staged situations. She is more interested in using photography to investigate the things that are concealed rather than showing what is revealed. Through this way of working she uses photography to provoke questions.

Sandy Volz was born in Heidelberg, Germany, in 1974 and has lived in both Bremen and Berlin for the past twelve years. She worked as a photo assistant in New York before graduating from the University of the Arts, Bremen, in 2006. She has taken part in various group exhibitions and projects since 2000, notably the published work with City.Crime.Control, in *A Lucky Strike – Kunst Findet Stadt* (2005) about urban planning and city development and *Calcutta, Chitpur Road Neighbourhoods* (2007) for the Kolkata Heritage Photo Project.

Gabriele Basilico is fascinated by the architectural structures of the built environment and in the impact they have on the industrial and post-industrial ports of Naples and Liverpool. He is also attracted by modern developments and the statements made through the graphic impact of commercial buildings. He has worked extensively throughout continental Europe and in other parts of the world but has rarely worked in the UK, and he very much welcomed the opportunity to explore and produce new work in Liverpool.

During the course of his work Basilico's interests have gradually shifted from architecture to an exploration of the complexities of the urbanised landscape. He is also interested in showing a view of the cityscape that presents dramatic structures and scenes of urbanisation that capture sculptural and textual detail through the transient quality of light – to create a visual documentation that celebrates the built environment.

Gabriele Basilico was born in Milan, Italy, in 1944 and he lives and works in Milan. In the early seventies, after graduating from the Faculty of Architecture in Milan, he first began to photograph the urban and industrial landscape, *Milano ritratti di fabbriche* (1978–80). In 1984 he worked on a substantial project for *Mission Photographique de la DATAR* to record the contemporary French landscape. In 1991 he took part in the *Mission Photographique Beirut* at the end of the civil war in Beirut. Since then he has worked on many solo and group exhibition and publication projects covering different cities around the world, notably, *Porti di mare* (1990), *Bord de mer* (1992), *L'esperienza dei luoghi* (1994), *Italy, cross-sections of a country* (1998), *Interrupted City* (1999), *Cityscapes* (1999), *Scattered city* (2005), *Intercity* (2007). His latest works are from *Silicon Valley* for the San Francisco Museum of Modern Art and *Roma 2007* for the Rome International Photography Festival.

John Davies chose to work in two areas in central Liverpool that reflect his interest in the transformation of our social and post-industrial landscape: the Ropewalks area and the recently built landmark developments in the city centre. He was particularly engaged by the new Liverpool One retail complex as the single largest development in Liverpool, involving the privatisation of a large section of the city centre including the former public open space of Chavasse Park. The nearby Ropewalks is one of the oldest industrialised areas of Liverpool and he was interested in the transformation of the buildings that were once small factories, workshops and warehouses.

Davies's work is concerned with development and change in the social and industrial architecture of the urban cityscape. He is interested in revealing the historical layers and the changes people make to our environment. He often takes photographs from a high vantage point, where buildings and structures can be seen in the context of the wider environment. He appears coolly detached from his topographical studies but, over the years, he has begun to question, as well as celebrate, our collective responsibility in shaping the environments in which we live.

John Davies was born in Sedgefield, England, in 1949 and moved from Cardiff to Liverpool in 2001. He has worked throughout Europe since the mid-1980s and his

photographs have been widely exhibited in museums and galleries across the world including the Museum of Modern Art, New York, Pompidou Centre, Paris, and Tate Britain, London. His first major publication, *A Green & Pleasant Land*, was published in 1986 and his latest exhibition and book, *The British Landscape* (2006), was short-listed for the Deutsche Börse Photography Prize 2008. He continues to work on his *Our Ground* project and to question the political process regarding the changes from public open space to private use.

Sanatçı Biyografileri

Ali Taptik Liverpool'da zamanını Everton, Anfield ve Kensington mahallelerini dolaşarak geçirmiştir. İstanbul'da sergilediği işlerde görüldüğü gibi Taptik'in ilgisi insanların aralarında bir bağ kurarak mekanla uyumlu bir beraberlik yakaladıkları alanlara yoğunlaşmaktadır. Yabancıların kendilerini rahat hissettikleri, samimiyet ve organik bir yaratının mekana eşlik ettiği yerleri aramaktadır. Taptik 18 milyonluk bir şehir olan İstanbul'dan gelmektedir ve yarım milyondan az nüfuslu Liverpool'u nispeten küçük bir şehir olarak değerlendirmesine rağmen her iki şehrin de birbirine benzer bir enerjiye sahip olduğunu belirtmiştir.

Taptik'in ilk aşkı İstanbul'dur; ilhamını memleketi ve kültüründen almaktadır. Şehrin çeşitliliği ve insanların şehir içinde varlıklarını nasıl sürdürdükleri ve geçirdikleri değişimler kendisini büyüleyen unsurlardandır. Betimlediği İstanbul'da otobiyografik yönlerin bulunduğunun bilincinde olsa da, aynı zamanda bazı şeyleri şansa, kazaya ve kadere bırakmasını sağlayan Türk duyarlılığının da farkındadır. Yine de uygulamada becerikli ve titiz bir sanatçıdır.

Ali Taptik, Türkiye'nin İstanbul şehrinde 1983'te doğdu. Halen İstanbul'da yeni açılmış bir fotoğrafçılık okulunda proje danışmanı olarak çalışmaktadır. 2008 yılına kadar İstanbul Mimarlık Fakültesi öğrencisiyken, bir yandan da fotoğrafçılığı kendi başına öğrenmiştir. İlk solo sergisi *Remembering Me* (Beni hatırlamak) (2005) adını taşımakta ve Hollanda, Noorderlicht galerisi de dahil olmak üzere Avrupa ve Asya'da pek çok galeride sergilenmiştir. *Kaza ve Kader – Accident and Fate* (2004–2007) adlı sergisi, Marsilya'da yaşarken Atelier de Visu'da sergilenmiştir. En yeni çalışması *Familiar Stranger* (Tanıdık Yabancı), kentsel yapılar ve yabancılarla rastlaşma üzerinedir. Sınırda Şehirler projesi kapsamında diğer şehirlerle ilgili çalışmaları da bulunmaktadır.

Phillipe Conti hem Marsilya hem de Liverpool'da konut şemaları ve mahalleler üzerine görsel incelemeler yaptı. Her iki şehirde göçmen topluluklarla çalıştı ve insanların yaşadıkları çevreler üzerine yoğunlaştı. Marsilya'nın kuzeyinde, Plan d'Aou'da büyük modern bir apartman bloğunun yenilenme projesini çekti. Liverpool'da yıkımı planlanan Viktoryen dönemi sıralı binalarla ilgilendi. Toxteth'de Küçük Granby Üçgeni diye az bilinen bir alan ve özellikle Liverpool'daki Somali kökenli göçmenler üzerine odaklandı. Conti'ye göre Liverpool ile Güney Fransa arasında çarpıcı farklar bulunmaktadır ve Marsilya'daki göçmen nüfusun Liverpool'a oranla şehirle daha geniş çapta bütünleşmiş olduğunu belirtmiştir. Ancak her iki şehrin insanlarını barındıran gizli mekanlarının, aynı insanların hayatlarının tarihini açığa vurmasından etkilenmiştir.

Conti'nin ailesi etnik köken bakımından çeşitlilik gösterir ve etnik ve dini çeşitliliğe sahip insanların hayatlarını incelemede toplumsal belgeselci bir röportaj tarzı geliştirmiştir. Değişik bölgelerden göçmen topluluklarla iletişime geçerek yerel siyaset ve kültürlerini anlamaya çalışmaktadır. Çalışmalarını çatışma bölgelerine de yaymış ve Orta Doğu'ya pek çok yolculuk yapmıştır.

Philippe Conti 1972'de Fransa'nın Marsilya kentinde doğdu ve halen Marsilya'da yaşamaktadır. 1995'te Sanat Tarihi eğitimini bitirdikten sonra L'Association Médecins Sans Frontières (Sınır Tanımayan Doktorlar Birliği) 'le 2001 yılında Filistin'de yaptığı gibi çeşitli kuruluşlarla fotoğraf projeleri üzerinde çalışmıştır. Bugüne dek iki kitap yayınlamıştır: Göçmen işçiler üzerine 2004'te çıkan *On dirait le sud* (Güney Denirse) ve 2007'de çıkan sürgün Romanyalılar üzerine hazırladığı *Djelem, djelem* (Roman Milli Marşı). Sınırda Şehirler için çıkardığı işlerden beri Ürdün'de göçmen topluluklar temalı çalışmalarına devam etmektedir.

Wojtek Wilczyk Liverpool ve Gdańsk'ın post-endüstriyel manzarasıyla ilgilenmektedir. İngiltere'ye bu ilk ziyareti sırasında Kuzey Batı İngiltere'de gözlemlediği mekanlarla Polonya arasındaki yakın benzerlikleri keşfetmenin onu şaşırtmasıyla Gdańsk ve Liverpool arasındaki benzerlikleri göstermeye karar verdi. Yakında değişecek olan eski mekan ve alanları ve bu mekanların, geçmişi dillendiren bu münferit binaların 30 sene önce nasıl göründüğünü hayal etmeye çalıştı. Gdańsk'da şehir merkezine çok yakın duran mekanların ve eski limanın fotoğraflarını çekti. Liverpool'da ise çoğunlukla şehrin yeniden bayındırlaşmaya henüz açılmamış kuzey bölgelerinde, özellikle Walton, Bootle ve Kirkdale sokaklarında çalıştı. Ayrıca iki şehirde de 2. Dünya Savaşı sonrası kaybedilen sanayi kuruluşları üzerine gözlem ve incelemelerde bulundu.

Wilczyk eserlerinde bir sanayi tarihi ve toplum geçmişini göz önüne sermekle ilgilenmektedir. Tarihsel simgelerin ve toplumsal değere sahip binaların, post-endüstriyel görünümün modern gelişmelere yerini bırakmasından önce belgelenip korunması gerektiğini düşünmektedir.

Wojtek Wilczyk 1961'de Polonya'nın Krakow kentinde dünyaya geldi ve halen Krakow'da fotoğrafçı, küratör ve sanat eleştirmeni olarak hayatını sürdürüyor. Komünist rejimin yıkılmasından sonra Polonya'nın geçirdiği değişimleri konu alan bir çok belgesel fotoğraf dizisi yaratmıştır: bunların arasında *Black and White Silesia* (Silesia, Siyah-Beyaz) (1999–2002), *Life After Life* (Hayattan sonra Yaşam) (2002–) ve *Postindustrial* (Sanayi Sonrası/Post-Endüstriyel) (2003–) bulunmaktadır. Bugünlerde *Innocent Eyes Do Not Exist* (Masum Göz Yoktur) adı altında eski sinagogların günümüz Polonyasında gördükleri yeni işlevi konu alan bir dizi üzerinde çalışıyor.

Sandy Volz bir ayını Liverpool'un çeşitli bölgelerini inceleyerek geçirdi ve birçok başka sanatçı gibi şehri haşin dış görünüşüne rağmen son derece canayakın buldu. Bremen ve Liverpool'da çalışmalarını sürdürmek suretiyle iki şehirdeki benzerlikler üzerinden bulabileceği farklılıkları araştırabileceği ve iki şehirde de sergilenebilecek bir çalışma için bir tema arayışına girdi.

İki şehrin de bir zamanlar önemli birer liman olmaları ve geride bıraktıkları uzun yıllar boyunca süregiden bir pub kültürü paylaşmalarıyla ilgilendi. Pub ve barlar toplumsal bir öneme sahiptir; Volz civar sakinlerinin toplandığı bir mekanlar olarak geleneksel publar üzerine yoğunlaşmaya karar verdi. Fotoğraflarında publarin iç düzenine odaklanan Volz, 'kamu' kavramını sorguluyor ve kamunun özele döndüğü noktayı araştırıyor. Pub içlerinin görünüm, doku ve tarzlarıyla, iki şehirde publarda kullanılan değişik malzeme, simge ve kültürel kodlarla ilgileniyor.

Bir sanatçı olarak Volz fotoğrafçılığı bir belgesel aracı olarak kullanmakta, ancak sahneleme kullandığı durumlar da oluyor. Fotoğrafçılığı belli olanı göstermekten ziyade gizli olanı araştırmak için kullanmakla ilgileniyor. Bu çalışma şekliyle fotoğrafçılığı izleyene sorgulatmak için kullanıyor.

Sandy Volz 1974'te Almanya'nın Heidelberg şehrinde doğdu ve son 12 yıldır hem Bremen hem de Berlin'de yaşamaktadır. Bremen'deki Sanat Üniversitesinden 2006'da mezun olduktan sonra bir süre New York'ta fotoğrafçı asistanı olarak çalıştı. 2000 yılından beri çeşitli toplu sergi ve projelerde yer almıştır. Belli başlı çalışmaları City.Crime.Control'un şehir planlama ve bayındırlık üzerine yayımladığı *A Lucky Strike – Kunst Findet Stadt* (Şanslı bir Vuruş – Sanat Meydana Geliyor) (2005) ve Kolkata Mirası Fotoğraf Projesi için 2007'de yayınlanan *Calcutta, Chitpur Road Neighbourhoods* (Kalküta, Chitpur Caddesi Mahalleleri)'da görülebilir.

Mamur çevreleri oluşturan mimari yapılar ve bu yapıların Napoli ve Liverpool gibi iki şehrin endüstriyel ve post-endüstriyel limanları üzerinde yarattığı etki **Gabriele Basilico**'yu büyülemektedir. Ticari binaların çarpıcı etkilerinin ifade ettikleri ve modern gelişmeler de ilgi alanları arasındadır. Kıta Avrupası ve dünyada kapsamlı çalışmalarda bulunmuş ancak Birleşik Krallık'ta neredeyse hiç bulunmamış olduğundan Liverpool'da çalışma ve araştırmalarda bulunma şansını memnuniyetle kabul etmiştir.

Çalışmaları boyunca Basilico'nın ilgisi gitgide mimariden şehirleşmiş çevrenin karmaşıklığına doğru kaymaya başladı. Aynı şekilde çarpıcı yapılardan oluşmuş kent manzaraları, heykelsi ve metinsel ayrıntılar yakalayan şehir karelerini ışığın geçiciliğine vurgu yaparak göstermekle ilgilenmektedir. Böylece mamur çevreyi öven görsel bir belge yaratmaya çalışmaktadır.

Gabriele Basilico İtalya'nın Milan kentinde 1944 yılında dünyaya geldi ve halen Milan'da yaşam ve çalışmalarını sürdürmektedir. 1970'lerin başlarında Milan Mimarlık Fakültesinden mezun olduktan sonra ilk olarak *Milano ritratti di fabbriche* (Milano Fabrika Manzaraları) (1978–80)'yle kent ve sanayi manzaraları görüntülemeye başladı. 1984'te *Mission Photographique de la DATAR*'ın çağdaş Fransız peyzajını görüntüleme projesinde önemli rol oynadı. Beyrut iç savaşının sonlarına doğru 1991'de *Mission Photographique Beirut* projesinde görev aldı. O zamandan beri değişik şehirleri kapsayan solo ve toplu sergiler ve yayınlarda çalıştı; bunların başlıcaları *Porti di mare* (Denizden bir İkram) (1990), *Bord de mer* (Deniz Kıyısı) (1992), *L'esperienza dei luoghi* (Bir yerin deneyimi) (1994), *Italy, cross-sections of a country* (İtalya, bir ülkeden arakesitler) (1998), *Interrupted City* (Aksak Şehir) (1999), *Cityscapes* (Şehir Manzaraları)(1999), *Scattered city* (Dağınık Şehir) (2005) ve *Intercity* (Şehirlerarası) (2007)'dir. En son çalışması San Francisco Museum of Modern Art'ta sergilenen *Silicon Valley* (Silikon Vadisi) ve *Rome International Photography Festival* için yaptığı Roma 2007 sergileridir.

John Davies günümüzün değişmekte olan toplumsal ve post-endüstriyel manzarasına duyduğu ilgiyi yansıtan Liverpool'un merkezinden iki alanda çalışmayı seçti: Ropewalks mahallesi ve şehir merkezinde yeni yapılan şehrin simgesel binaları. Özellikle ilgilendiği mekanlardan bir tanesi kamusal bir alan olan Chevasse Park'ın da dahil olduğu merkezde geniş bir alan özelleştirilerek yapılan, şehrin tek en büyük yeni yapısı olan Liverpool One ticaret merkeziydi. Yakındaki Ropewalks ise Liverpool'un en yaşlı sanayii alanlarından biridir ve Davies bir zamanlar küçük fabrikalar, atölyeler ve depolardan oluşmuş bu alanın geçirdiği dönüşümle ilgilendi.

Davies'in çalışmaları, kent görünümünün toplumsal ve endüstriyel mimari açılarından geçirdiği değişim ve kentsel kalkınma ile yakından ilişkili. Özellikle ilgilendiği konular kentin tarihsel katmanları ve insanların yaşadıkları mekanları nasıl değiştirdiği. Fotoğraflarını çoğunlukla binaların ve yapıların geniş çevreyle olan bağlamını vurgulayacak yükseklikten çekiyor. Her ne kadar topografya çalışmaları soğukkanlı bir mesafe sergiler gibi görünse de yıllar içerisinde yaşadığımız mekanların değişiminde sahip olduğumuz müşterek sorumluluğu hem sorguluyor, hem de tebcil ediyor.

John Davies İngiltere'nin Sedgefield kentinde 1949 yılında doğdu ve 2001 yılında Cardiff'ten Liverpool'a taşındı. 1980'lerin ortalarından beri Avrupa içinde çalışmış ve fotoğrafları New York'ta Museum of Modern Art, Paris'te Pompidou Centre, ve Londra'da Tate Britain gibi dünya çapında müze ve sergilerde yer almıştır. Başlıca kitabı olan *A Green & Pleasant Land* (Yeşil ve Hoş Bir Diyar) 1986'da yayınlandı; en son eseri ve sergisi *The British Landscape* (Britanya Manzarası) (2006) 2008 Deutsche Börse Fotoğrafçılık Ödülünün son elemelerine seçilmiştir. Kamusal alanların özel kullanıma açılmasını sağlayan politik süreci sorgulayan *Our Ground* (Toprağımız) çalışması halen sürmektedir.

Présentation des artistes

Ali Taptik a passé son séjour à Liverpool à flâner dans les quartiers d'Everton, d'Anfield et de Kensington. Comme point de départ dans cette ville, ainsi qu'à Istanbul, il a recherché des milieux où il ressentait un rattachement et une harmonie entre habitants et habitat. Ce sont des lieux où l'ambiance est intime, la création de l'espace se fait de façon spontanée, et l'étranger peut se sentir à l'aise. Taptik vient d'Istanbul, dont la population monte jusqu'à 18 millions. Liverpool dont la population n'atteint même pas un demi-million, lui semble donc petite, mais selon lui ces villes partagent une énergie pareille.

Le premier amour de Taptik est la ville d'Istanbul et il puise son inspiration dans sa ville natale et dans sa culture. L'hétérogénéité de la ville, et les modalités d'occupation multiples et changeantes de cet espace urbain le fascinent. Il reconnaît que son portrait d'Istanbul est aussi le portrait de sa propre vie, et il est conscient qu'en tant que Turque, il laisse souvent les choses au hasard – à l'accident et au destin. Dans sa vie professionnelle, par contre, ce sont l'organisation et l'habileté qui priment.

Ali Taptik est né à Istanbul, Turquie en 1983. Il est actuellement conseiller de programme à la nouvelle École de la Photographie à Istanbul. Il a poursuivi ses études à la Faculté d'Architecture d'Istanbul pendant plus de cinq ans (jusqu'en 2008), et pendant cette période il est devenu autodidacte en matière de photographie. Sa première exposition personnelle, *Remembering Me (En se souvenant de moi)* (2005), se produit en Europe et en Asie, y compris au festival de Noorderlicht au Pays Bas. Suite à un séjour d'artiste en résidence en 2008, l'Atelier de Visu à Marseille expose sa série *Kaza ve Kader – Accident and Fate (Accident et destin)* (2004 – 2007). Sa série la plus récente a pour titre *Familiar Stranger (Inconnu familier)*, et met en scène le tissu urbain et les rencontres avec les inconnus. Il a réalisé aussi des photographies dans les autres villes partenaires du projet «Cities on the Edge».

Philippe Conti a poursuivi ses recherches visuelles pour ce volume dans les cités et les quartiers de Marseille et de Liverpool. Ce travail l'a engagé avec les communautés immigrées dans les deux villes où c'est surtout le cadre immédiat de la vie quotidienne qui l'intéresse. A Marseille il a photographié un grand projet de rénovation qui vise les immeubles modernes du Plan d'Aou dans la Zone Franche Urbaine Nord Littoral. A Liverpool, il s'est intéressé aux quartiers de maisons contiguës typiquement anglaises du dix-neuvième siècle qui ont été barricadées en attendant l'arrivée des démolisseurs. Il a choisi l'ensemble de rues dans le quartier de Toxteth connu sous le nom de «Little Granby Triangle», et c'est surtout chez la population de Liverpool d'origine Somali qu'il a puisé ses images. Conti a été choqué par l'écart entre Liverpool et le Midi, constatant qu'à Marseille la population immigrée s'est éparpillée à travers la ville entière, au lieu de se cantonner dans des enclaves. Malgré ces différences, dans les deux cas, il a été fasciné par les espaces intimes où ces gens mènent leur vie, et par ce que leur propre histoire a pu lui révéler.

Conti bénéficie lui-même d'un héritage pluriculturel, et il a développé un style de reportage socio-documentaire afin d'étudier la vie de ceux qui viennent de milieux et de religions différents. Il cherche à comprendre la politique et la culture des populations immigrées dans des régions différentes en s'engageant directement avec les gens chez eux. Il cherche aussi à travailler dans des zones de conflit, et il s'est rendu plusieurs fois au Moyen Orient.

Philippe Conti est né à Marseille en 1972, et y vit toujours. Suite à des études d'Histoire des Arts en 1995 il se lance dans des projets photographiques avec diverses organisations, par exemple, l'association Médecins Sans Frontières en Palestine en 2001. Il a réalisé deux livres de photographies: *On dirait le sud* (2004) qui traite des travailleurs immigrés, et *Djelem, djelem* (2007) qui raconte la vie des exilés roumains. Depuis sa participation à «Cities on the Edge», il

continue à travailler sur le thème des populations immigrées, cette fois en Jordanie.

Wojtek Wilczyk s'intéresse aux paysages postindustriels de Gdańsk et Liverpool. Sa participation à ce projet a occasionné sa première visite en Angleterre, au cours de laquelle il a été frappé par la grande ressemblance entre les régions du Nord Ouest de l'Angleterre et celles de la Pologne. Il a donc décidé de démontrer les ressemblances entre Liverpool et Gdańsk. Attiré par les lieux et les espaces d'autrefois qui vont bientôt se transformer, il a imaginé ces constructions isolées, vestiges du passé, dans leur état de jadis. A Gdańsk, il a photographié les quartiers à proximité du centre-ville et de l'ancien port. A Liverpool il a travaillé surtout au nord de la ville dans des quartiers qui, jusque-là, ont échappé à la réhabilitation, surtout dans les rues des faubourgs de Walton, de Bootle, et de Kirkdale. Ses photographies nous permettent aussi d'accéder à une réflexion sur les industries des deux villes qui ont disparu depuis la deuxième guerre mondiale.

Par l'intermédiaire de ses photographies, Wilczyk cherche à dévoiler une histoire industrielle et l'histoire du passé des individus. Pour lui, l'important est de documenter les sites historiques et les constructions qui s'inscrivent dans la vie des habitants avant que ces scènes postindustrielles ne disparaissent, remplacées par des projets contemporains.

Wojtek Wilczyk est né en 1961 à Krakow, Pologne, où il vit actuellement. Il est photographe, conservateur, et critique d'art. Il a réalisé plusieurs cycles photographiques documentaires qui dessinent les transformations du paysage polonais depuis l'écroulement du régime communiste, y compris *Black and White Silesia (La Silésie noire et blanche)* (1999–2002) *Life After Life (La Vie après la vie)* (2002–), et *Postindustrial (Postindustriel)* (2003–). En ce moment il est en train de réaliser une nouvelle série qui a

pour titre *Innocent Eyes Do Not Exist (Les Regards innocents n'existent pas)* et qui prend pour sujet les ex-synagogues et leurs nouvelles fonctions dans la Pologne contemporaine.

Sandy Volz est partie pendant un mois à la découverte de certains quartiers de Liverpool et, comme bien d'autres artistes invités, elle y a trouvé un accueil très chaleureux, malgré l'apparence sévère de la ville. Elle a cherché un thème qui lierait ses démarches dans les villes de Liverpool et Brême, lui permettant d'étudier leurs différences à partir de traits partagés. En partant du passé portuaire partagé des deux villes maritimes, le fil de sa réflexion l'a amenée vers leurs longues histoires culturelles du «pub» et du bar. Lieux privilégiés de la vie sociale du peuple, ce sont des «pubs» et des bars traditionnels, servant de lieux de rencontre aux habitants du quartier, qu'elle a sélectionnés. Dans ses photographies elle s'est concentrée sur les intérieurs des «pubs» («*public houses*», «maisons publiques»), afin d'explorer la notion du «public», et d'interroger la rencontre entre l'espace public et l'espace privé. Sensible aux apparences, à l'ambiance, et au style des intérieurs, elle a cherché à examiner les matières physiques, les symboles, et les codes culturels divers des deux villes.

Dans son entreprise artistique, la photographie lui sert d'outil documentaire, mais Volz réalise aussi son œuvre en se servant de mises en scène créées par elle-même. Ce sont les choses cachées qu'elle cherche à étudier dans ses images, plutôt que de montrer ce qui est déjà en évidence. En travaillant ainsi, elle utilise la photographie pour susciter des questions dans l'esprit d'autrui.

Sandy Volz est née à Heidelberg, Allemagne en 1974, et partage sa vie entre Brême et Berlin depuis douze ans. Avant de recevoir son diplôme de l'Université des Arts de Brême en 2006 elle a travaillé à New York comme assistante photographique. Elle a collaboré à plusieurs expositions et projets de groupe depuis 2000, notamment *A Lucky Strike – Kunst Findet Stadt (Coup de veine – l'art retrouve la ville)* (2005), ouvrage sur l'aménagement urbain et la croissance des villes, avec le groupe City.Crime.Control, et *Calcutta, Chitpur Road Neighbourhoods (Calcutta, les quartiers de Chitpur Road)* (2007) pour le Kolkata Heritage Photo Project.

Gabriele Basilico s'est laissé séduire par les structures architecturales du bâti ainsi que par leur impact sur les villes portuaires industrielles et postindustrielles de Naples et Liverpool. Son regard s'est porté également sur les projets d'aménagement contemporains et les affirmations qui peuvent se lire à travers l'impact graphique des constructions commerciales. Dans sa vie professionnelle il s'est déplacé dans l'Europe continentale et dans d'autres régions du monde, mais ses projets en Grande Bretagne ont été rares. Il a donc été très heureux de pouvoir profiter de cette occasion pour pouvoir envisager et réaliser de nouveaux projets à Liverpool.

Au cours de son travail, le regard de Basilico s'est détourné petit à petit de l'architecture pour interroger les complexités du paysage urbanisé. La conception de la ville qu'il cherche à exposer propose des structures dramatiques et des scènes de l'urbanisation dont les détails sculpturaux et texturaux sont captés à travers la qualité éphémère de la lumière: réalisation d'une documentation visuelle qui fête le bâti.

Gabriele Basilico est né à Milan, Italie en 1944 où il vit et travaille toujours. Au début des années 70, ayant obtenu son diplôme de la Faculté d'Architecture à Milan, il commence à photographier les paysages urbains et industriels (voir *Milano ritratti di fabbriche, Milan, portraits d'usines*, 1978–80). En 1984 il réalise un projet important de documentation du paysage français contemporain pour la *Mission Photographique de la DATAR*. En 1991 il participe à la *Mission Photographique Beirut* à la fin de la guerre civile. Par la suite, il mène à bien plusieurs projets d'exposition et de publication personnels et collectifs, traitant diverses villes à travers le monde, dont *Porti di mare (Villes portuaires)* (1990), *Bord de mer* (1992), *L'esperienza dei luoghi (L'expérience des lieux)* (1994), *Italy, cross-sections of a country (Italie, échantillons d'un pays)* (1998), *Interrupted City (La Ville interrompue)* (1999), *Cityscapes (Paysages urbains)* (1999), *Scattered city (La Ville éclatée)* (2005), *Intercity (Interville)* (2007). Ses réalisations les plus récentes sont *Silicon Valley* pour le San Francisco Museum of Modern Art, et *Roma 2007* pour le Festival International Photographique de Rome.

John Davies a porté son regard sur l'architecture de deux quartiers du centre de Liverpool où la transformation de notre paysage social et postindustriel (l'un des leitmotivs de son œuvre) s'impose: le quartier de Ropewalks (quartier des corderies) et les travaux de grand prestige, réalisés récemment au centre-ville. Le nouveau centre commercial, Liverpool One, l'a particulièrement attiré. Cette opération d'envergure est le projet unique le plus important de Liverpool, au cours duquel une partie considérable des biens fonciers publics du centre-ville a été cédée aux acteurs privés, y compris l'espace vert public de Chavasse Park. Le quartier de Ropewalks, qui se situe non loin de Liverpool One, fut l'un des premiers quartiers industrialisés de Liverpool, et c'est la réhabilitation de ses anciens ateliers, petites usines, et entrepôts qui a attiré le photographe.

L'œuvre de Davies expose l'évolution et les mutations de l'architecture sociale et industrielle du paysage urbain. Il cherche à dévoiler les couches historiques de notre environnement, et les actions humaines qui le modifient. Souvent ses photographies sont prises d'un point de vue en hauteur, ce qui permet d'observer les édifices et les structures dans un contexte plus large. Il semble adopter une attitude imperturbable et désintéressée envers ses études topographiques, mais au cours des années il s'est engagé davantage, cherchant à interroger notre responsabilité à tous pour les formes de notre cadre bâti, tout en les fêtant.

John Davies est né à Sedgefield, Angleterre en 1949. Il quitte par la suite Cardiff (pays de Galles) pour Liverpool en 2001. Au cours des années 80 il travaille en Europe, et il expose dès lors ses photographies dans des musées et des galeries à travers le monde, notamment au Museum of Modern Art à New York, au Centre Pompidou à Paris, et au Tate Britain à Londres. Sa première publication majeure, *A Green and Pleasant Land (Un Pays verdoyant et agréable)*, date de 1986, et son livre le plus récent, *The British Landscape (Le Paysage britannique)* (2006), tiré de l'exposition du même nom, a figuré sur la liste des livres sélectionnés pour le prix photographique de Deutsche Börse de 2008. En ce moment, il continue à élaborer son projet, *Our Ground (Nos terrains)*, et à remettre en question la politique de la privatisation des espaces publics.

Noty biograficzne

Podczas pobytu w Liverpoolu **Ali Taptik** szczególnie upodobał sobie dzielnice Everton, Anfield i Kensington. Podobnie, jak w wypadku prac powstałych w Stambule, poszukuje on środowisk, w których ludzie potrafią związać się i zharmonizować z przestrzenią. Szuka miejsc posiadających pewien walor swojskości, w których przestrzeń zorganizowana jest w sposób organiczny, a obcy mogą poczuć się jak u siebie. Taptik pochodzi z osiemnastomilionowego Stambułu, stąd też uważa Liverpool z jego niecałym pół milionem mieszkańców za miasto stosunkowo nieduże; przyznaje jednak, iż oba przenika podobny rodzaj energii.

Pierwszą miłością i źródłem inspiracji artysty jest jego rodzinne miasto i jego kultura. Taptik jest zafascynowany różnorodnością Stambułu, zamieszkujących go ludzi oraz sposobami ich funkcjonowania w miejskiej przestrzeni. Dodaje również, iż jego portret miasta posiada pewien rys autobiograficzny oraz, że świadom jest swej jakże tureckiej przypadłości częstego pozostawiania rzeczy przypadkowym zrządzeniom losu. Jest wszakże dobrze zorganizowanym i wprawnym praktykiem.

Ali Taptik urodził się w 1983 r. w Stambule w Turcji. Tam też pracuje w charakterze doradcy ds. projektu w nowopowstałej szkole fotografii. W trakcie pięcioletnich studiów architektonicznych w Stambule samodzielnie opanował sztukę fotografii. Jego pierwsza indywidualna wystawa nosząca tytuł *Remembering Me* (2005) prezentowana była w różnych miejscach Europy i Azji, m. in. w galerii Noorderlicht w Holandii. *Kaza ve Kader – Accident and Fate* (2004–2007) pokazywana była w Atelier de Visu w Marsylii, gdzie Taptik był artystą-rezydentem. *Familiar Stranger* to najnowszy zbiór prac na temat budowli miejskich oraz przypadkowych spotkań z nieznajomymi. Taptik jest również autorem prac powstałych w innych miastach biorących udział w projekcie „Miasta na Brzegu".

Philippe Conti przeprowadził fotograficzne śledztwo dotyczące budownictwa i polityki mieszkaniowej Marsylii i Liverpoolu. We współpracy ze społecznościami imigrantów obu miast pogłębia swoje zainteresowania zamieszkanymi przez nich środowiskami. W Marsylii sfotografował rewitalizację współczesnych bloków mieszkalnych w północnej części miasta, Plan d'Aou. W Liverpoolu zainteresowały go pozabijane deskami i przeznaczone do rozbiórki wiktoriańskie szeregowce. Postanowił skoncentrować się na obszarze znanym jako Little Granby Triangle w dzielnicy Toxteth, a zwłaszcza na zamieszkujących Liverpool Somalijczykach. Contiego uderzyła różnica pomiędzy Liverpoolem a południem Francji: zwrócił uwagę, że w Marsylii społeczność imigrantów jest znacznie bardziej zintegrowana. W obu jednak miastach, zafascynowała go intymność miejsc zamieszkiwanych przez ludzi oraz możliwość ukazania historii życia ich mieszkańców.

Ponieważ Conti sam wywodzi się z mieszanej rodziny, rozwinął styl dokumentalnego reportażu społecznego koncentrującego się na śledzeniu losów ludzi wywodzących się z różnych środowisk i religii. Za sprawą bezpośrednich kontaktów z ludźmi, próbuje zrozumieć lokalne uwarunkowania polityczne oraz kulturę środowisk imigrantów. Interesują go również obszary konfliktów – stąd jego liczne podróże na Bliski Wschód.

Philippe Conti urodził się w 1972 r. w Marsylii, gdzie mieszka do dzisiaj. W 1995 r. ukończył studia w zakresie historii sztuki, a w 2001 r. w Palestynie podjął fotograficzną współpracę z organizacją Lekarze Bez Granic. Wydał dwa albumy: *On dirait le sud* (2004) o robotnikach-imigrantach, oraz *Djelem, djelem* (2007) o wychodźcach z Rumunii. Po zakończeniu pracy nad projektem „Miasta na Brzegu" podjął temat społeczności imigrantów w Jordanii.

Wojtka Wilczyka interesuje postindustrialny krajobraz Gdańska i Liverpoolu. Podczas pierwszej wizyty w Anglii ze zdziwieniem odkrył wiele cech wspólnych północno-zachodniej Anglii i Polski, dlatego też postanowił skupić się na podobieństwach pomiędzy Liverpoolem a Gdańskiem. Zainspirowały go stare miejsca i przestrzenie, które wkrótce mają ulec całkowitej przemianie; zaciekawiło go, jak te budowle – świadectwa przeszłości – mogły wyglądać trzydzieści lat temu. W Gdańsku fotografował miejsca położone w bezpośredniej bliskości centrum miasta oraz stare zabudowania portowe. W Liverpoolu pracował głównie w północnej części miasta, w niezrewitalizowanych jeszcze dzielnicach Walton, Bootle i Kirkdale. Ponadto, skoncentrował się na gałęziach przemysłu, które zanikły w obu miastach po II wojnie światowej.

W swych pracach Wilczyk ukazuje historie związane z rozwojem przemysłu i przeszłością narodu. Wierzy bowiem, iż rejestracja historycznych osiągnięć budowlanych oraz ważnych społecznie budowli jest doniosłym zadaniem, które koniecznie trzeba wykonać zanim te postindustrialne obrazy znikną zastąpione nowoczesnymi konstrukcjami.

Wojtek Wilczyk urodził się w 1961 r. w Krakowie, gdzie mieszka i pracuje jako fotograf, kurator i krytyk sztuki. Jest autorem dokumentalnych cykli fotograficznych obrazujących zmiany w polskim krajobrazie po upadku komunizmu: *Black and White Silesia* (1999–2002), *Life After Life* (2002–) oraz *Postindustrial* (2003–). W chwili obecnej pracuje nad nowym cyklem zatytułowanym *Innocent Eyes Do Not Exist* traktującym o budynkach byłych synagog i funkcjach, jakie pełnią w dzisiejszej Polsce.

Sandy Volz przez cały miesiąc odkrywała różne zakątki Liverpoolu; pomimo „szorstkiego" oblicza, miasto zrobiło na niej – podobnie, jak na wielu innych goszczących tutaj artystach – bardzo przyjazne wrażenie. Postanowiła poszukać dla Liverpoolu i Bremy

wspólnego tematu, który umożliwiłby jej prześledzenie różnic w oparciu o podobieństwa. A ponieważ oba miasta były niegdyś ważnymi ośrodkami portowymi, artystka zainteresowała się współczesnym spojrzeniem na długą historię kultury tawern, pubów i barów. Miejsca te odgrywają istotną społecznie rolę, stąd Volz postanowiła skoncentrować się na tradycyjnych pubach jako miejscach spotkań okolicznych mieszkańców. Prezentując wnętrza tych przybytków, śledzi ideę lokali „publicznych"; przygląda się miejscom, w których to, co publiczne, styka się z tym, co prywatne. Interesuje ją ich wygląd, styl i panująca w nich atmosfera, jak również wykorzystane materiały, symbole i kulturowe kody obu miast.

Chociaż jako artystka, Volz wykorzystuje fotografię w charakterze medium dokumentalnego, nie stroni również w swych pracach od inscenizacji. Bardziej interesuje ją użycie fotografii do wytropienia tego, co ukryte, niż ukazania tego, co odkryte. Taka metoda wykorzystania fotografii prowokuje do stawiania pytań.

Sandy Volz urodziła się w Heidelbergu w Niemczech w 1974 r., a od dwunastu lat mieszka na przemian w Bremie i w Berlinie. Zanim w 2006 r. ukończyła bremeńską Akademię Sztuk Pięknych, pracowała w charakterze asystentki fotograficznej w Nowym Jorku. Od 2000 r. bierze udział w licznych wystawach i przedsięwzięciach zbiorowych, takich jak wspólne publikacje z grupą City.Crime.Control, projekt *A Lucky Strike – Kunst Findet Stadt* (2005) poświęcony urbanistyce i kształtowaniu przestrzeni miejskiej oraz projekt *Calcutta, Chitpur Road Neighbourhoods* (2007) wykonany dla Kolkata Heritage Photo Project.

Gabriele Basilico fascynują architektoniczne struktury obszarów zabudowanych oraz wpływ wywierany przez nie na industrialne i postindustrialne obszary portowe Neapolu i Liverpoolu. Pociąga go również nowoczesna zabudowa, a wizualne wrażenie, jakie sprawiają budowle o charakterze komercyjnym, traktuje w kategoriach estetycznych deklaracji. Basilico pracował w wielu krajach Europy i świata. Rzadko miał jednak okazję do pracy w Wielkiej Brytanii, stąd z radością przyjął zaproszenie do pracy w Liverpoolu.

W trakcie tego pobytu, zainteresowania Basilico stopniowo przesuwały się od architektury ku analizie złożoności miejskiego krajobrazu. Chciałby również ukazać pejzaż miasta z jego pełnymi dramatyzmu

konstrukcjami i scenami ilustrującymi proces urbanizacji; scenami, w których – dzięki ulotnym walorom światła – możliwe jest uchwycenie rzeźbiarskiego szczegółu i faktury, a wszystko po to, by stworzyć wizualną dokumentację-hołd złożony środowisku miasta.

Gabriele Basilico urodził się w 1944 r. w Mediolanie we Włoszech, gdzie do dziś mieszka i pracuje. Po studiach architektonicznych w Mediolanie na początku lat 70. zaczął fotografować krajobraz miejski i przemysłowy, czego efektem była wystawa *Milano ritratti di fabbriche* (1978–80). W 1984 r. przygotował duży projekt dla *Mission Photographique de la DATAR* obejmujący zapis współczesnego pejzażu Francji. W 1991 r., po zakończeniu wojny domowej w Bejrucie, wziął udział w przedsięwzięciu *Mission Photographique Beirut*. Od tamtej pory pracował nad wieloma indywidualnymi i grupowymi projektami wystawienniczymi i wydawniczymi obejmującymi różne miasta na całym świecie, m. in. *Porti di mare* (1990), *Bord de mer* (1992), *L'esperienza dei luoghi* (1994), *Italy, cross-sections of a country* (1998), *Interrupted City* (1999), *Cityscapes* (1999), *Scattered city* (2005), *Intercity* (2007). Najnowsze prace to projekty *Silicon Valley* (przygotowany dla Muzeum Sztuki Nowoczesnej w San Francisco) oraz *Roma 2007* (przygotowany dla Międzynarodowego Festiwalu Fotografii w Rzymie).

John Davies dał wyraz swoim zainteresowaniom transformacją przestrzeni społecznej i postindustrialnej dokonując wyboru dwóch śródmiejskich obszarów Liverpoolu: dzielnicy Ropewalks oraz niedawno ukończonych wielkich inwestycji w centrum miasta. Szczególnie zaintrygował go nowy kompleks handlowy Liverpool One, największe przedsięwzięcie budowlane w mieście. Wiązało się ono z prywatyzacją znacznego obszaru położonego w centrum miasta, w tym dużej przestrzeni publicznej znanej jako Chavasse Park. Położona w pobliżu dzielnica Ropewalks jest jednym z najstarszych obszarów przemysłowych Liverpoolu. Davies skupił się tutaj na dokumentowaniu transformacji budynków pełniących niegdyś funkcje fabryczek, warsztatów i składów.

John Davies koncentruje się na rozwoju i zmianach zachodzących w architekturze oraz społecznym i przemysłowym krajobrazie miasta. Interesuje go odkrywanie kolejnych poziomów historycznych oraz zmian, jakie człowiek wprowadza w swym

środowisku. Często fotografuje z pewnej wysokości, co pozwala postrzegać budynki i konstrukcje w szerszym kontekście otaczającego je środowiska. Mimo pozornego niezaangażowania w przedmiot swych topograficznych studiów, z czasem zaczął bacznie analizować – i nagłaśniać – kwestię wspólnej odpowiedzialności za kształtowanie środowiska, w którym żyjemy.

Urodzony w 1949 r. w Sedgefield w Anglii, John Davies przeniósł się w 2001 r. z Cardiff do Liverpoolu. Od połowy lat 80. pracuje w wielu krajach Europy, a jego fotografie prezentowane są w muzeach i galeriach całego świata, m. in. w nowojorskim Muzeum Sztuki Nowoczesnej, paryskim Centrum Pompidou oraz w londyńskiej galerii Tate. Pierwszy liczący się album pt. *A Green & Pleasant Land* opublikował w 1986 r.; ostatnia wystawa i towarzyszący jej album pt. *The British Landscape* (2006), były w 2008 r. nominowane do do Nagrody Fotograficznej Deutsche Börse. Davies kontynuuje prace nad swym projektem *Our Ground*; jest krytykiem procesu politycznego umożliwiającego przekazywanie przestrzeni publicznych w prywatne ręce.

Künstler-Biografien

Ali Taptik verbrachte seine Zeit in Liverpool spazierengehend: in den Wohnsiedlungen von Everton, Anfield und Kensington. Genau wie bei seinen Istanbuler Arbeiten will er Orte finden, an denen er spürt, dass die Menschen mit dem Stadtraum harmonisieren und in Berührung treten können. Er sucht Plätze, die Vertrautheit ausstrahlen und einen organischen Raum schaffen, wo Fremde sich wohl fühlen können. Taptik kommt aus Istanbul, einer Stadt mit achtzehn Millionen Einwohnern. Liverpool, mit kaum einer halben Million Einwohnern, ist für ihn also eine eher kleine Stadt. Trotzdem haben beide Städte für ihn ein ähnliches energetisches Potenzial.

Taptiks große Liebe ist Istanbul und immer wenn er Inspiration sucht, greift er auf seine Heimatstadt und deren Kultur zurück. Er ist begeistert von der Vielfältigkeit der Stadt und davon, wie die Menschen sich innerhalb des städtischen Raums verändern und leben. Er weiß, dass sein Bild der Stadt autobiografisch gefärbt ist und er ist sich seiner türkischen Mentalität durchaus bewusst, die Dinge dem Glück zu überlassen, dem Zufall, dem Schicksal. Doch selbstverständlich ist er ein gut organisierter und versierter Praktiker.

Ali Taptik wurde 1983 in Istanbul geboren. Er arbeitet zurzeit als Projektberater an der neu gegründeten Schule für Fotografie in Istanbul. Er studierte fünf Jahre lang, bis 2008, Architektur in Istanbul und brachte sich während dieser Zeit das Fotografieren selbst bei. Seine erste Einzelausstellung trug den Titel *Remembering Me* (2005) und wanderte zu verschiedenen europäischen und asiatischen Veranstaltungsorten, einschließlich Noorderlicht in Holland. *Kaza ve Kader – Accident and Fate* (2004–2007) wurde im Atelier de Visu in Marseille gezeigt, wo er als Gastkünstler arbeitete. *Familiar Stranger* ist der Titel seiner neuesten Gruppe von Arbeiten über urbane Strukturen und Begegnungen mit Fremden. Er fotografierte auch in den anderen Städten des 'Cities on the Edge'-Projektes.

Philippe Conti fertigte eine visuelle Studie an von Siedlungen und Vierteln in Marseille und Liverpool. So baute er Beziehungen auf innerhalb der Immigranten-Gemeinden in beiden Städten, denn Conti interessiert besonders das Lebensumfeld der Menschen. In Marseilles fotografierte er beispielsweise ein großes Sanierungsprogramm mit modernen Wohnblocks im Norden der Stadt, den Plan d'Aou. In Liverpool wiederum beschäftigten ihn die Viertel der mit Brettern vernagelten, zum Abriss bestimmten viktorianischen Reihenhäuser. In Toxteth setzte er sich mit dem Gebiet 'Little Granby Triangle' intensiv auseinander. Die Menschen somalischen Ursprungs in Liverpool interessieren Conti am meisten. Darüber hinaus war für ihn der Unterschied zwischen Liverpool und dem Süden Frankreichs schockierend. Er beobachtete beispielsweise, dass die Immigranten in Marseilles viel stärker in das Stadtleben integriert sind. Jedoch faszinierten ihn in beiden Städten die den Menschen vertrauten Orte, an denen er ihre Lebensgeschichten ablesen konnte.

Conti stammt aus einer ethnisch gemischten Familie. Seinen sozial-dokumentarischen Reportagestil entwickelte er, um das Leben von Menschen unterschiedlichster Herkunft und Religionen zu erforschen. Er will die Lokalpolitik und die Kultur der Immigranten-Bevölkerung in den verschiedenen Regionen verstehen lernen, indem er zu den Menschen auf Augenhöhe geht. Sein Interesse gilt dabei auch der Arbeit in Konfliktgebieten und so besuchte er schon mehrmals den Mittleren Osten.

Philippe Conti wurde 1972 in Marseilles geboren und lebt heute dort. Nach Beendigung seines Studiums der Kunstgeschichte 1995 arbeitete er an Fotografie-Projekten innerhalb von Organisationen wie 'Ärzte ohne Grenzen' (2001 in Palästina). Er veröffentlichte zwei Bücher: 2004 *On dirait le sud*, über Immigranten-Arbeiter and 2007 *Djelem, djelem*, über Exil-Rumänen. Während seiner Arbeit für 'Cities on the Edge' beschäftigte er sich weiterhin mit seinem Thema über Immigranten in Jordanien.

Wojtek Wilczyk interessiert sich für die post-industriellen Landschaften von Danzig und Liverpool. Dies war sein erster Aufenthalt in England und es überraschte ihn, so viele Ähnlichkeiten zu entdecken zwischen den Gebieten im Nord-Westen Englands und Polen. Hierauf entschloss er sich, die Gemeinsamkeiten von Liverpool und Danzig darzustellen. Wilczyk beschäftigen die älteren Plätze und Räume, die in Veränderung begriffen sind und es fasziniert ihn, sich vorzustellen, wie diese Orte vor 30 Jahren ausgesehen haben mögen – isolierte Gebäude also, die von der Vergangenheit erzählen. In Danzig fotografierte er die Plätze nahe des Stadtzentrums und den alten Hafen. In Liverpool arbeitete er hauptsächlich im Norden der Stadt, in Gegenden, die noch nicht wieder erschlossen sind, vornehmlich in den Straßen von Walton, Bootle und Kirkdale. Er reflektiert auch über die Industrien, die seit dem zweiten Weltkrieg in beiden Städten untergegangen sind.

Mit seiner Arbeit will Wilczyk eine Geschichte der Industrie und der Vergangenheit eines Volkes zeigen. Unbedingt möchte er die Erinnerung wach halten an Baudenkmäler und öffentliche Gebäude, bevor diese post-industrielle Szenerie verschwindet und durch moderne Entwicklungen verdrängt wird.

Wojtek Wilczyk wurde 1961 im polnischen Krakau geboren und lebt und arbeitet dort als Fotograf, Kurator und Kritiker. Er entwickelte verschiedene dokumentarische Fotoserien, die die Veränderungen in der polnischen Landschaft seit dem Zusammenbruch des kommunistischen Regimes darstellen: *Black and White Silesia* (1999–2002), *Life After Life* (2002–) und *Postindustrial* (2003–). Derzeit arbeitet er an einer neuen Serie mit dem Titel *Innocent Eyes Do Not Exist*, was sich auf alte Synagogen und ihre neue Bedeutung im zeitgenössischen Polen bezieht.

Sandy Volz verbrachte einen Monat damit, Teile von Liverpool zu erkunden und fand heraus, wie so viele andere Gast-Künstler, dass die Stadt ein äußerst freundlicher Ort ist – ihrem rauen Erscheinungsbild zum Trotz. Sie beschloss, ein allgemeines Sujet zu wählen, um sowohl in Liverpool als auch in Bremen daran arbeiten zu können und um die Unterschiede im Ähnlichen zu suchen: Sie bemerkte, dass beide Städte einst bedeutende Häfen hatten und beide zurückblicken können auf eine lange Tradition der Kneipenkultur. Gaststätten und Bars haben eine gesellschaftliche Funktion und so konzentrierte sie sich auf traditionelle Pubs und Kneipen, in denen sich die Einheimischen treffen. In ihren Bildern liegt der Fokus auf der Inneneinrichtung der Gaststätten. Sie will die darin sich ausdrückende Vorstellung von "Öffentlichkeit" untersuchen und sehen, wo und wie die Öffentlichkeit sich eine private Atmosphäre schafft. Sie interessiert sich für den Look, das Gefühl und den Stil dieser Innenräume und untersucht in ihren Bildern die Sinnlichkeit von Materialien, die unterschiedlichen Symbole und kulturellen Codes der zwei Städte.

Als Künstlerin verwendet Volz die Fotografie als dokumentarisches Medium, arbeitet aber auch mit inszenierten Motiven. Statt Offenliegendes zu zeigen, ist sie mehr daran interessiert, mit ihrer Arbeit Verborgenes zu untersuchen und somit Fragen aufzuwerfen.

Sandy Volz wurde 1974 in Heidelberg geboren und lebte in den letzten zwölf Jahren in Bremen und Berlin. Sie arbeitete als Fotoassistentin in New York bevor sie 2006 ihr Studium an der Kunsthochschule in Bremen abschloss. Sie nahm Teil an verschiedenen Gruppenausstellungen und Projekten seit 2000, von denen die in *A Lucky Strike – Kunst Findet Stadt* (2005) publizierte Arbeit mit der Bremer Projektgruppe City. Crime.Control über Stadtplanung und Stadtentwicklung und *Calcutta, Chitpur Road Neighbourhoods* (2007) für das Kolkata Heritage-Fotoprojekt hervorzuheben sind.

Gabriele Basilico ist fasziniert vom Aufeinanderprallen der architektonischen Strukturen des baulichen Umfeldes mit den industriellen- und post-industriellen Häfen von Neapel und Liverpool. Ihn ziehen auch moderne Entwicklungen an und die grafische Struktur, welche die neuen Geschäftsgebäude der Gegend einprägen. Er arbeitete schon an vielen Orten weltweit, doch nur selten in Großbritannien. Deshalb war ihm die Möglichkeit sehr willkommen, sich in Liverpool mit neuen Arbeiten zu beschäftigen.

Während seiner Arbeit verlagerten sich Basilicos Interessen nach und nach von der Architektur hin zur Komplexität einer verstädterten Landschaft. Seine Stadtansichten sollen die dramatischen Strukturen und Szenen der Urbanisierung zeigen und er will skulpturale und textliche Details in der Vergänglichkeit des Lichts einfangen. So will er eine Art visueller Dokumentation schaffen, die das bauliche Umfeld ins Zentrum stellt.

Gabriele Basilico wurde 1944 in Mailand geboren und lebt und arbeitet heute dort. In den frühen Siebziger Jahren, nach dem Abschluss seines Architekturstudiums, begann er, die städtische und industrielle Landschaft zu fotografieren. So entstand *Milano ritratti di fabbriche* (1978–80). 1984 arbeitete er an einem bedeutenden Projekt für *Mission Photographique de la DATAR*, bei dem er die zeitgenössische französische Landschaft dokumentierte. 1991 nahm er Teil an der *Mission Photographique Beirut* gegen Ende des Bürgerkriegs in Beirut. Seitdem war er an vielen Einzel- und Gruppenausstellungen und an Buchprojekten beteiligt, die sich mit verschiedenen Städten weltweit auseinandersetzen: *Porti di mare* (1990), *Bord de mer* (1992), *L'esperienza dei luoghi* (1994), *Italy, cross-sections of a country* (1998), *Interrupted City* (1999), *Cityscapes* (1999), *Scattered city* (2005), *Intercity* (2007). Seine jüngsten Arbeiten zeigen *Silicon Valley* für das San Francisco Museum of Modern Art und *Roma 2007* für das römische Internationale Festival der Fotografie.

John Davies wählte für seine Arbeiten zwei Gebiete in Liverpools Zentrum, die sein Interesse an der Transformation unserer sozialen und post-industriellen Landschaft widerspiegeln: das Ropewalks-Viertel und die jüngst fertiggestellten stadtbildprägenden Bauprojekte im Stadtzentrum. Von Letzteren beschäftigte ihn besonders der neue 'Liverpool One'-Einzelhandelskomplex, das größte Bauvorhaben in Liverpool, welches die Privatisierung eines großen Teils des Stadtzentrums, einschließlich der Fläche des früheren öffentlichen Chavasse Parks, zur Folge hatte. Im nahe gelegenen Ropewalks, einem der ältesten Industriegebiete Liverpools, setzte sich Davies mit dem Umbau ehemaliger kleiner Fabriken, Werkstätten und Lagerhallen auseinander.

Davies Arbeiten beschäftigen sich mit der Entwicklung und dem Wandel innerhalb der sozialen und industriellen Architektur der Stadtlandschaft. Er möchte die historischen Schichten freilegen und die Veränderungen zeigen, die Menschen an unserer Lebenswelt vornehmen. Aus diesem Grund geht er zum Fotografieren oft an einen hohen Aussichtspunkt, von wo aus Gebäude und Strukturen im Kontext zur weiteren Umgebung gesehen werden können. Das strahlt oft eine kühle Distanz zu seinen topografischen Studien aus, aber über die Jahre konnte er auf diese Weise die kollektive Verantwortung bei der Gestaltung unseres Lebensumfeldes hinterfragen und ihre Bedeutung hervorheben.

John Davies wurde 1949 in Sedgefield, in England, geboren und zog 2001 vom walisischen Cardiff nach Liverpool. Er arbeitet seit Mitte der Achtziger Jahre in ganz Europa und seine Fotografien wurden schon häufig in Museen und Galerien weltweit ausgestellt, zum Beispiel im New Yorker Museum of Modern Art, im Centre Pompidou in Paris und der Tate Britain in London. Seine erste größere Publikation, *A Green & Pleasant Land*, wurde 1986 veröffentlicht und seine neueste Ausstellung mit dem Katalog *The British Landscape* (2006) stand auf der Auswahlliste für den Deutsche Börse-Fotografie-Preis 2008. Er arbeitet derzeit an seinem Projekt *Our Ground* und will weiterhin den politischen Prozess der Privatisierung öffentlichen Raums hinterfragen.

Biografie degli artisti

Ali Taptik trascorre il suo tempo a Liverpool passeggiando per i quartieri di Everton, Anfield e Kensington. Come per il lavoro prodotto ad Istanbul, anche qui l'artista è alla ricerca di ambienti dove, a suo parere, le persone possano connettersi e armonizzare con lo spazio. È alla scoperta di luoghi che trasmettano un senso di familiarità, dove lo spazio circostante è fatto di elementi naturali e i forestieri possano sentirsi a loro agio. Taptik è originario di Istanbul, città con una popolazione di 18 milioni di abitanti e pertanto considera Liverpool una città relativamente piccola, con meno di mezzo milione di abitanti. Tuttavia afferma che entrambe le città hanno energie simili.

Il primo amore di Taptik è Istanbul e proprio dalla sua città e dalla sua cultura trae ispirazione. È affascinato dai molteplici aspetti della città e da come le persone si trasformano e come vivono all'interno dell'area urbana. L'artista osserva come il suo ritratto di Istanbul abbia anche una connotazione autobiografica ed è consapevole della sensibilità turca che lo contraddistingue e lo porta spesso a lasciarsi andare alla ventura, al caso e al destino. Tuttavia è un professionista organizzato ed esperto.

Ali Taptik nasce ad Istanbul, in Turchia, nel 1983. Al momento lavora come consulente progettuale presso una scuola di fotografia recentemente avviata ad Istanbul. Ha studiato alla Facoltà di Architettura di Istanbul per più di 5 anni, fino al 2008 ed è divenuto, durante questo periodo, un fotografo autodidatta. La sua prima mostra personale, dal titolo *Remembering Me* (2005), è stata ospitata da diverse gallerie europee ed asiatiche tra cui la Noorderlicht in Olanda. *Kaza ve Kader – Accident and Fate* (2004–2007) è stata esposta all'Atelier de Visu di Marsiglia, dove Taptik ha vissuto come artista residente. *Familiar Stranger* è la sua più recente raccolta di opere che trattano il tema delle strutture urbane e degli incontri con stranieri. Ha lavorato anche nelle altre città che partecipano al progetto "Cities on the Edge, Città di Frontiera".

Philip Conti conduce un'indagine visiva dei complessi residenziali e dei quartieri nelle città di Marsiglia e Liverpool. Egli lavora interagendo con le comunità di immigrati in entrambe le città e rivolge il suo interesse alle aree abitate. A Marsiglia fotografa un ampio progetto di rigenerazione urbana relativo a palazzi moderni situati nella zona nord della città, nel quartiere Plan d'Aou. A Liverpool si interessa delle aree contraddistinte da palazzine a schiera di epoca Vittoriana, con assi inchiodate alle porte e alle finestre, ormai destinate alla demolizione. Il fotografo sceglie di concentrare la sua attenzione su un'area conosciuta come il Little Granby Triangle a Toxteth e soprattutto sugli abitanti di origine somala di Liverpool. Considera impressionanti le differenze tra Liverpool e il sud della Francia e sottolinea come la popolazione di immigrati, a Marsiglia, si sia integrata meglio in ogni zona della città. Tuttavia, in entrambi i luoghi, rimane affascinato dai siti più nascosti dove si svolge la vita urbana e dall'opportunità di svelare la storia celata dietro le esistenze di questi individui.

La famiglia di Conti ha origini miste, di conseguenza egli sviluppa uno stile da documentario sociale proprio per esplorare le vite di quegli individui che hanno provenienze sociali e religioni diverse. La sua finalità è comprendere le politiche locali e le culture delle popolazioni immigrate nelle diverse regioni, interagendo con esse. Inoltre, proponendosi di svolgere il suo lavoro nelle aree di conflitto, visita in diverse occasioni il Medio Oriente.

Philippe Conti nasce a Marsiglia, in Francia, nel 1972 dove è tuttora residente. Dopo aver studiato Storia dell'Arte nel 1995, lavora a diversi progetti fotografici per alcune organizzazioni come L'Association Médecins Sans Frontières in Palestina nel 2001. Pubblica due libri: *On dirait le sud*, sui lavoratori immigrati, nel 2004 e *Djelem, djelem*, libro sui Romeni in esilio, nel 2007. Dopo aver collaborato a "Cities on the Edge, Città di Frontiera", ha continuato a lavorare sul tema dell'immigrazione in Giordania.

L'interesse di **Wojtek Wilczyk** è rivolto allo scenario post-industriale di Danzica e Liverpool. Durante questo suo primo viaggio in Inghilterra, Wilczyk, con sua sorpresa, scopre un'impressionante somiglianza tra la Polonia e le aree, da lui visitate, nel Nord-Ovest dell'Inghilterra e pertanto decide di evidenziare le similitudini tra Liverpool e Danzica. Si occupa dei siti più antichi e delle aree in via di trasformazione, immaginando come questi luoghi sarebbero apparsi trenta anni fa: edifici isolati che parlano di tempi lontani. A Danzica, fotografa le aree più vicine al centro e il vecchio porto. A Liverpool si concentra soprattutto sulle aree a nord della città non ancora risanate e, in particolare, sulle strade di Walton, Bootle e Kirkdale. Inoltre, egli si ferma a riflettere sulle industrie distrutte nella seconda guerra mondiale in entrambe le città.

Attraverso il suo lavoro Wilczyk si propone di far luce sulla storia dello sviluppo industriale e sulla storia del passato umano. L'artista è convinto che sia importante tenere memoria dei monumenti storici e degli edifici di rilievo sociale prima che questi scenari post-industriali scompaiano e siano sostituiti da complessi moderni.

Wojtek Wilczyk nasce a Cracovia, in Polonia, nel 1961; vive e lavora a Cracovia come fotografo, curatore e critico d'arte. Ha filmato diversi cicli di documentari fotografici che descrivono le trasformazioni subite dal paesaggio polacco dopo la caduta del regime comunista: tra questi *Black and White Silesia* (1999–2002), *Life After Life* (2002) e *Postindustrial* (2003). Attualmente lavora ad una nuova serie dal titolo *Innocent Eyes Do Not Exist* che tratta delle ex-sinagoghe e di quale sia la loro funzione nella Polonia contemporanea.

Sandy Volz, per un mese, ha esplorato alcune zone di Liverpool e, come tanti altri artisti in visita, ha trovato il luogo estremamente piacevole, malgrado l'apparenza di città difficile. Ha deciso di andare alla ricerca di un tema comune per poter lavorare sia a

Liverpool che a Brema, allo scopo di esaminarne le differenze, prendendo spunto proprio dalle similitudini. La Volz è rimasta colpita dal fatto che, un tempo, le due città fossero state porti importanti e ha meditato su come, oggi, possano ricordare la storia passata che, per entrambe, appare connessa alla lunga tradizione dei pub. I pub e i bar sono luoghi di socializzazione e l'artista decide di concentrare il lavoro sui pub tradizionali, punti d'incontro dei residenti locali. Nelle immagini fotografiche mette a fuoco gli spazi interni di questi locali per indagare sul concetto di "pubblico" e per scoprire qual è il punto d'incontro tra pubblico e privato. La sua attenzione va all'aspetto, alle sensazioni, allo stile degli interni e ad un esame attento dei materiali, dei simboli e dei codici culturali di ciascuna città.

La Volz, in qualità di artista, utilizza la fotografia come mezzo documentaristico, ma si serve anche di scenari allestiti per eseguire le sue opere. Il suo interesse primario è quello di utilizzare la fotografia per investigare su ciò che è nascosto, più che per mostrare ciò che è già manifesto. Attraverso tale metodo di lavoro, ella usa la fotografia per provocare interrogativi.

Sandy Volz nasce a Heidelberg, in Germania, nel 1974 e da dodici anni vive tra Brema e Berlino. Lavora a New York come assistente alla fotografia, prima di laurearsi alla University of the Arts di Brema nel 2006. Dal 2000 l'artista partecipa a varie mostre collettive e a vari progetti: da ricordare, il lavoro pubblicato con il City.Crime.Control, *A Lucky Strike – Kunst Findet Stadt* (2005) che tratta di pianificazione e di aree di sviluppo urbane e *Calcutta, Chitpur Road Neighbourhoods* (2007) per il Kolkata Heritage Photo Project.

Le strutture architettoniche dell'ambiente costruito e il loro impatto sui porti industriali e post-industriali di Napoli e Liverpool affascinano **Gabriele Basilico**. L'artista è anche attratto dalle costruzioni moderne e da ciò che l'impatto grafico degli edifici commerciali esprime. Ha lavorato molto in tutta l'Europa continentale e in altre parti del mondo, ma raramente nel Regno Unito ed ha accolto con entusiasmo l'opportunità di lavorare e di esplorare Liverpool.

Durante la sua carriera, l'interesse di Basilico si è spostato dall'architettura all'esplorazione delle complessità del paesaggio urbano. Inoltre egli desidera rappresentare un paesaggio cittadino che presenti strutture sensazionali e scenari urbani, catturando il dettaglio scultoreo e testuale attraverso la variabile natura della luce. Tutto ciò al fine di creare un documento visivo che celebri l'ambiente costruito.

Gabriele Basilico nasce a Milano, in Italia, nel 1944 dove risiede e lavora. Nei primi anni Settanta, dopo la laurea presso la Facoltà di Architettura di Milano, inizia la sua carriera fotografando le aree urbane e il paesaggio industriale; *Milano ritratti di fabbriche* (1978–80). Nel 1984 lavora ad un importante progetto per la *Mission Photographique de la DATAR* a documentare il paesaggio contemporaneo francese. Nel 1991 prende parte alla *Mission Photographique Beirut* alla fine della guerra civile a Beirut. Da allora lavora a progetti personali, mostre collettive e pubblicazioni che interessano diverse città in tutto il mondo: ricordiamo *Porti di mare* (1990), *Bord de mer* (1992), *L'esperienza dei luoghi* (1994), *Italy, cross-sections of a country* (1998), *Interrupted City* (1999), *Cityscapes* (1999), *Scattered city* (2005), *Intercity* (2007). I suoi ultimi lavori sono stati prodotti nella *Silicon Valley* per il San Francisco Museum of Modern Art il primo, e il secondo, *Roma 2007*, a Roma per l'International Photography Festival.

John Davies sceglie di concentrare il suo lavoro su due quartieri nel centro di Liverpool: il quartiere di Ropewalks e i nuovi complessi di spicco, recentemente costruiti nel centro cittadino. Questa scelta rivela il suo interesse per la trasformazione dello scenario sociale e post-industriale. Davies si dedica in modo particolare alla nuova struttura commerciale Liverpool One che è il più grande complesso edilizio della città e coinvolge la privatizzazione di una vasta sezione del centro cittadino, compresa l'area all'aperto di Chavasse park che prima era area pubblica. Il vicino quartiere di Ropewalks è una delle più vecchie aree industrializzate di Liverpool e Davies pone la sua attenzione sulla trasformazione subita dalle costruzioni del quartiere che una volta erano piccole fabbriche, laboratori e magazzini.

Si occupa dello sviluppo e dei cambiamenti dell'architettura sociale ed industriale nello scenario urbano. Il suo scopo è scoprire i vari strati storici e le trasformazioni che l'uomo ha apportato all'ambiente. Spesso scatta fotografie da posizioni dominanti, dalle quali gli edifici e le strutture possono essere osservate nel contesto di un ambiente più ampio. Appare freddo e distaccato da questi suoi studi topografici tuttavia, nel corso degli anni, ha iniziato a chiedersi se esista, pur celebrandola, una nostra responsabilità collettiva nel manipolare l'ambiente in cui viviamo.

John Davies nasce nel 1949 a Sedgefield, in Inghilterra, per poi trasferirsi a Cardiff e successivamente a Liverpool nel 2001. Dalla metà degli anni '80 ha lavorato in ogni parte d'Europa e alle sue fotografie è stato garantito ampio spazio con mostre in musei e gallerie di tutto il mondo, inclusi il Museo di Arte Moderna di New York, il Pompidou Centre di Parigi e la Tate Britain di Londra. La prima pubblicazione importante di Davies, *A Green & Pleasant Land*, è del 1986; *The British Landscape* (2006), titolo della più recente sua mostra fotografica e del suo ultimo libro, lo iscrive nella rosa dei candidati per il Premio Fotografico Deutsche Börse 2008. L'artista lavora ancora al progetto *Our Ground* e continua a contestare il processo politico alla base delle trasformazioni di aree pubbliche all'aperto in aree ad uso privato.